Live Forever
Elizabeth Peyton

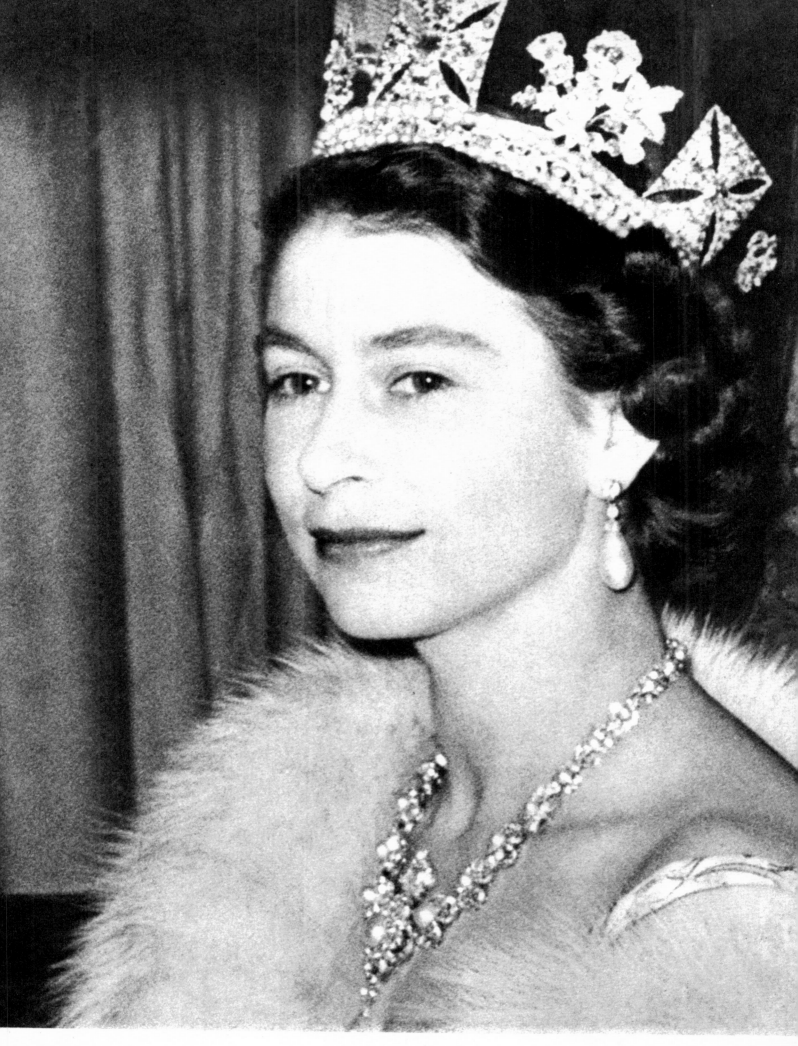

izabeth I Queen Elizabeth II

ker
his
rs and
anic in
est
is Is

Wisdom of Wilde:
"I can resist everything except temptation."

The importance of being Oscar:
Jude Law (left) as Lord Alfred Douglas
with Stephen Fry's Wilde

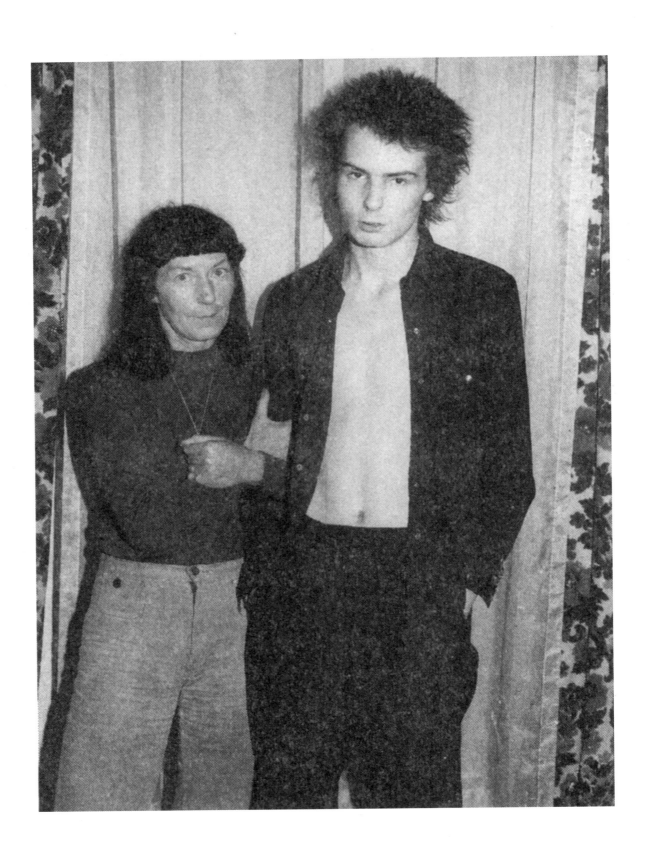

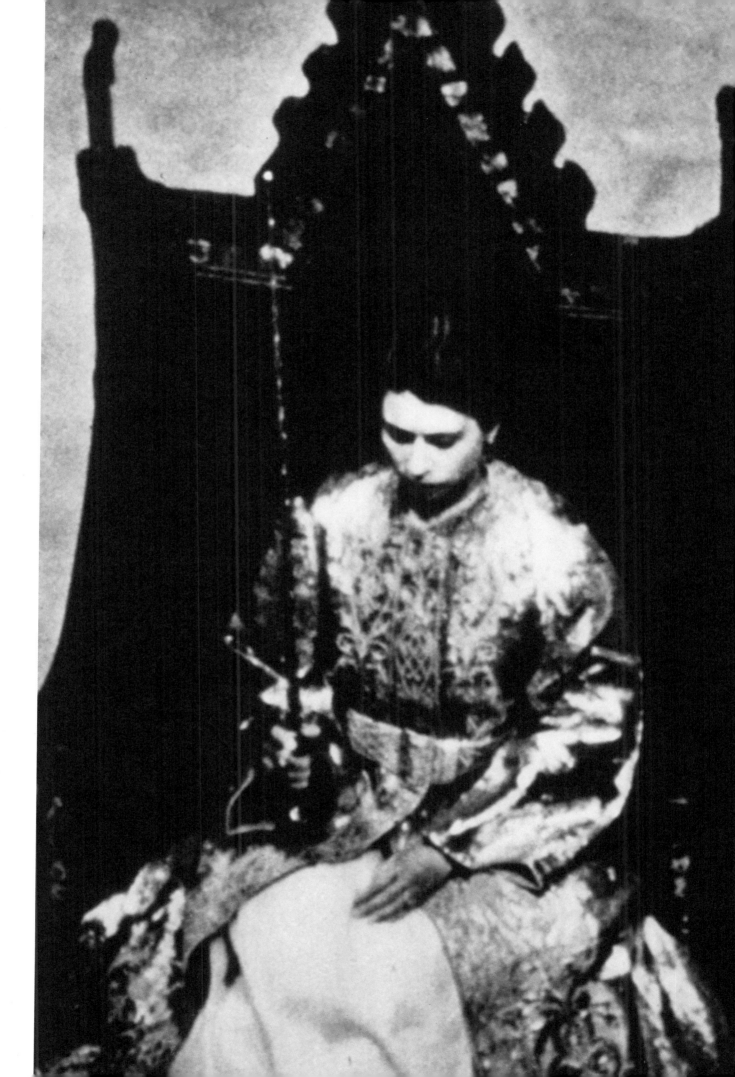

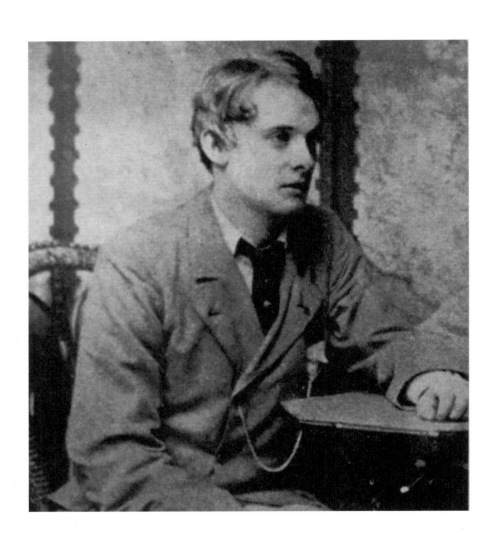

BY THE TIME I
CELEBRATES HI
BIRTHDAY NEX
HE SHOULD
VERY MUCH A
IN HIS NEW S

the same mistake, Pri
leant down and sai
"Make sure you sign it
place." He need not ha
Without looking up,
prince said fondly: "O

As Harry was signir
ster, the Prince of W
secretary Sandy Henn
an unprecedented ap
nation from both
William.

She handed out to
direct but brief messag
Diana's boys thanked
for its sympathy, but
wish for everyone to

The statement read
out the last year, sinc
of their mother, Prir
and Prince Harry
comforted enormo
public sympathy and s
have been given; it h
great deal to them an
asked me to express
once again to everyon

"They have also ask
that they believe th
would want people n
on – because she
known that constant r
her death can create r
pain to those she left

"They therefore
much that their mot
memory will now
allowed to rest in peac

A Palace official ex
it was not the young I
to attack legitimate n
the late Princess. It w
ted at the Diana Mer
or the openning of Al

Instead, they were
put an end to the floo
and tasteless souvenir
These include every
fluffy Diana loo seat c
Japan to more ordina
Diana plates, key fe
Internet game cal
Tunnel Racer in wh
speed along an under

Both William and H
cussed the statement
Charles over the previ
at Balmoral. They v
mined to make the
known after studying
mous number of com
features and news s
newspapers and the
specials screened a
anniversary of thei
death.

One royal source
time now to draw a li
sad time, and to ren
endless public grie
setting to William an
"They see the new

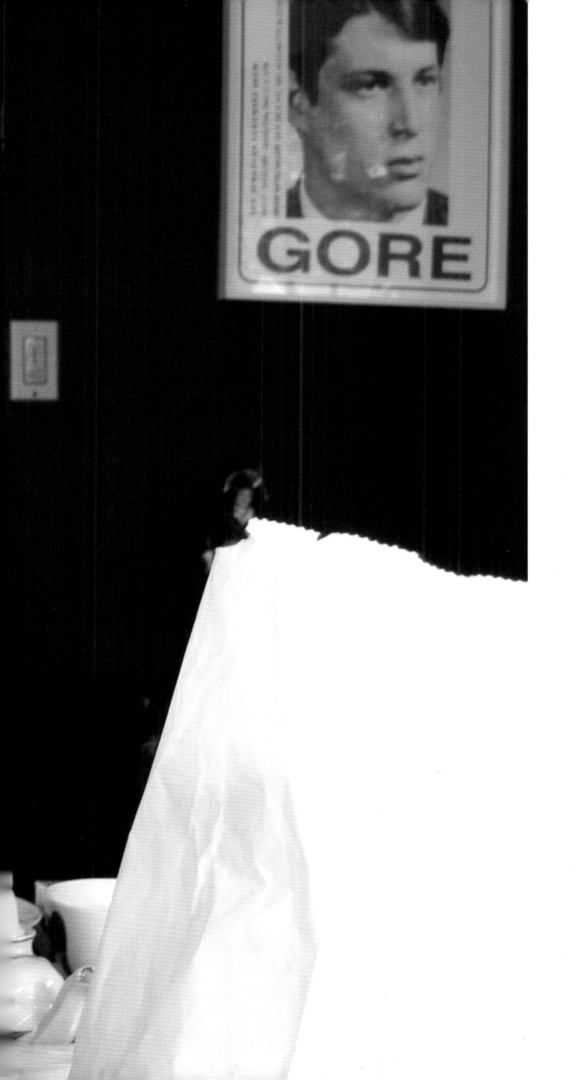

Not marble nor the gilded monuments
Of princes shall outlive this powerful rhyme,
But you shall shine more bright in these contents
Than unswept stone, besmeared with sluttish time. 4
When wasteful war shall statues overturn,
And broils root out the work of masonry,
Nor Mars his sword nor war's quick fire shall burn
The living record of your memory. 8
'Gainst death and all oblivious enmity
Shall you pace forth; your praise shall still find room
Even in the eyes of all posterity
That wear this world out to the ending doom. 12
 So, till the judgement that yourself arise,
 You live in this, and dwell in lovers' eyes.

56

Sweet love, renew thy force; be it not said
Thy edge should blunter be than appetite,
Which but today by feeding is allayed,
Tomorrow sharpened in his former might. 4
So, love, be thou; although today thou fill
Thy hungry eyes even till they wink with fullness,
Tomorrow see again, and do not kill
The spirit of love with a perpetual dullness. 8
Let this sad interim like the ocean be
Which parts the shore where two contracted new
Come daily to the banks, that, when they see
Return of love, more blest may be the view; 12
 As call it winter, which being full of care
 Makes summer's welcome thrice more wished, more rare.

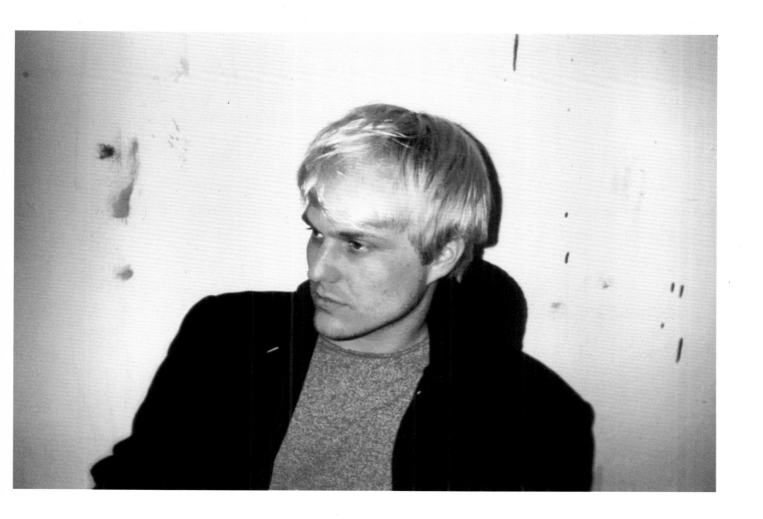

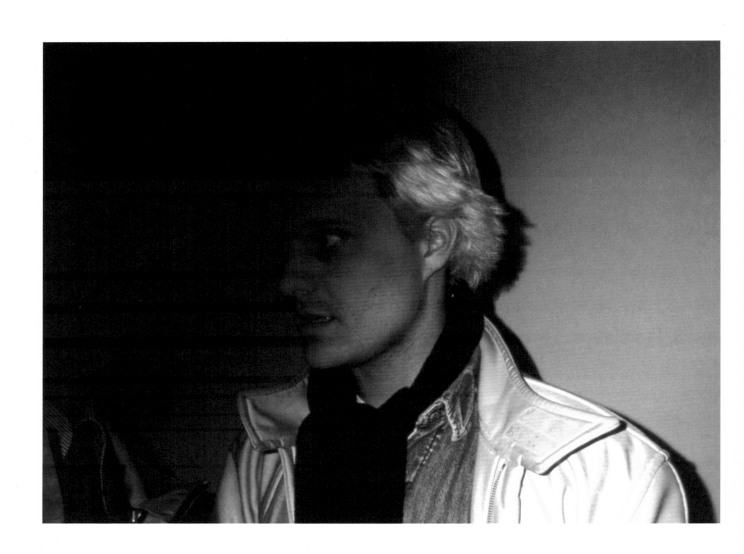

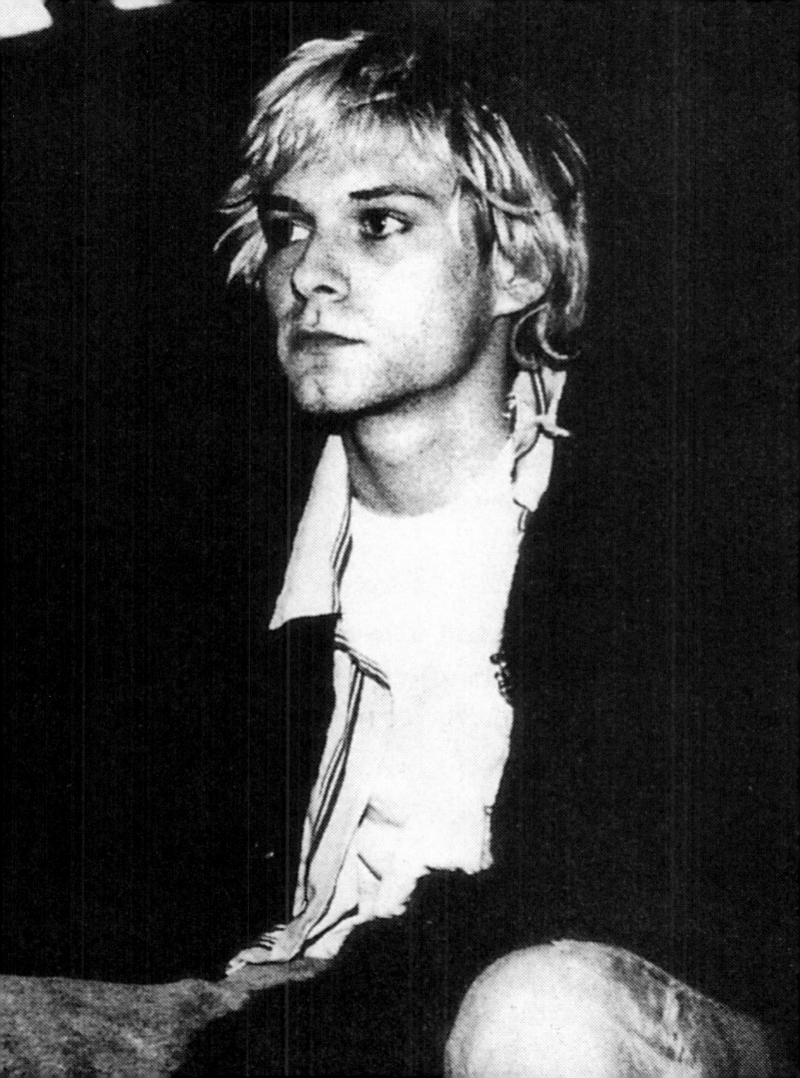

NME
MUSICAL EXPRESS

HALLELUJAH!

s the wondrous Christmas double issue with...

BLUR ✸ OASIS ✸ PULP
UPERGRASS ✸ PAUL WELLER
EM ✸ FOO FIGHTERS ✸ THE PRODIGY

's THE STORY

The records, news, films, quotes, TV and vibes of the year

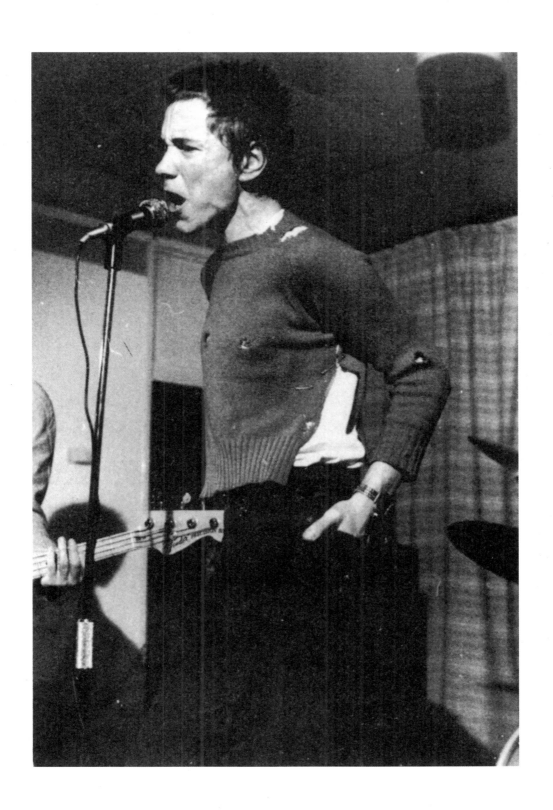

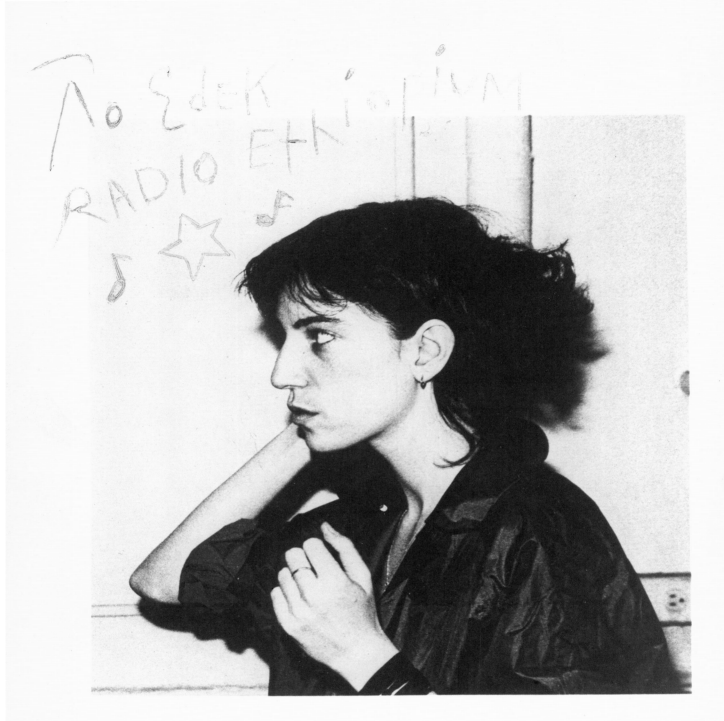

patti smith

Photo Credit: Judy Linn

WARTOKE CONCERN, INC.

NEW YORK CITY | 1545 BROADWAY | NEW YORK 10036 | (212) 245-5587
HOLLYWOOD | 6606 SUNSET BLVD. | CALIF. 90028 | (213) 466-8586

ARISTARECORDS

ELLIOTT SMITH

HE'S MR. DYINGLY SAD, AND YOU'RE MYSTIFYINGLY GLAD

- [X] person
- () group
- () trend
- () big-ass trend

by RJ SMITH | photographs by MARK ALESKY

- [X] HEARTTHROB
- [X] UNKEMPT
- () WILY
- [X] SAD
- () JIGGY
- () MERSH
- [X] PERIPATETIC

(6) **IMPACT RATING**

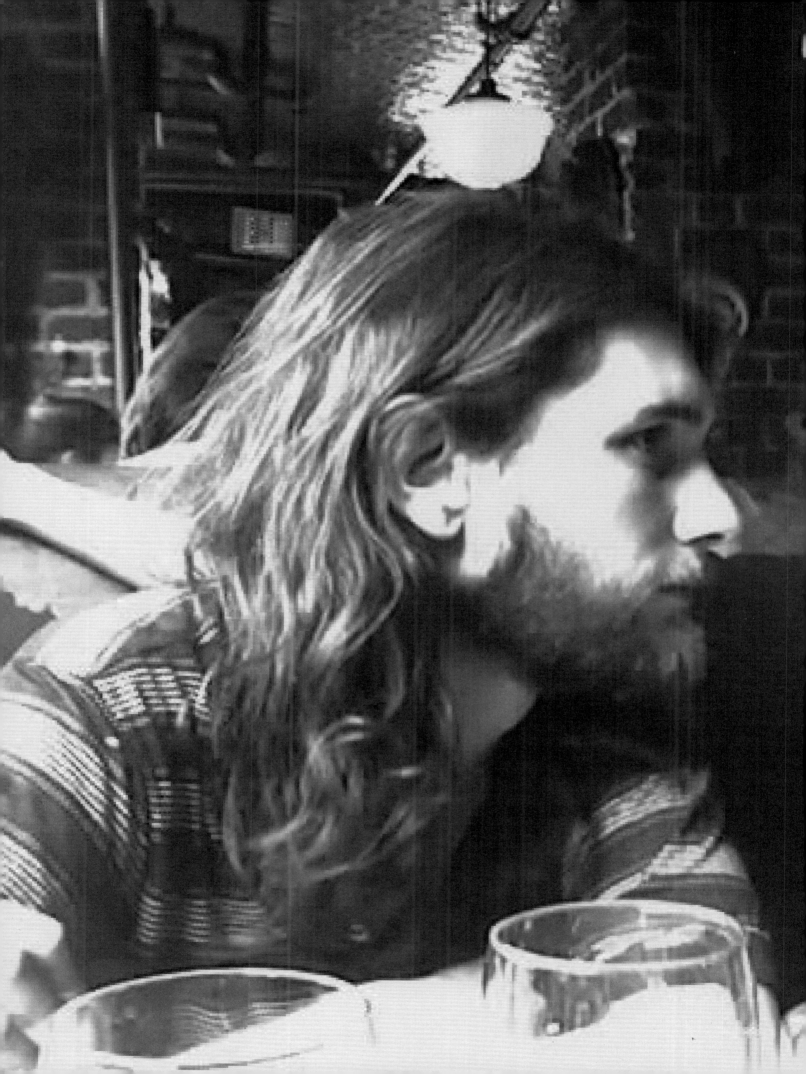

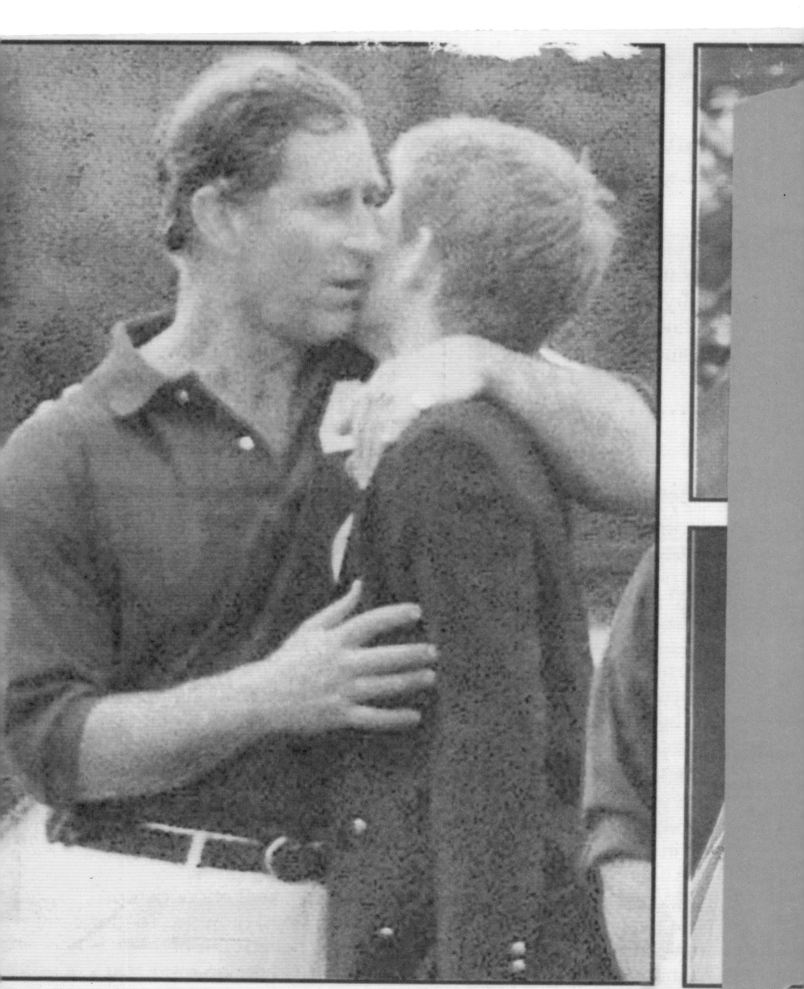

MILY AFFAIRS: *Prince Charles and Harry; Prince Edward and Sophie Rhys-Jones; th*

ends in tears after goalkeeper's error ● Don't make him a

an says sorry to E

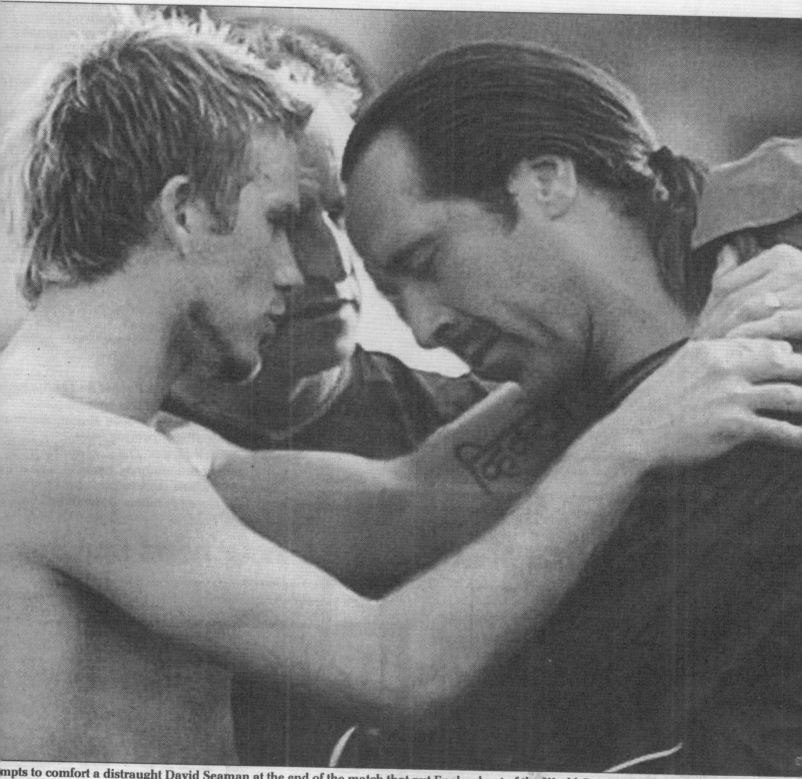

mpts to comfort a distraught David Seaman at the end of the match that put England out of the World Cup. With them is Ray Clemence, the t

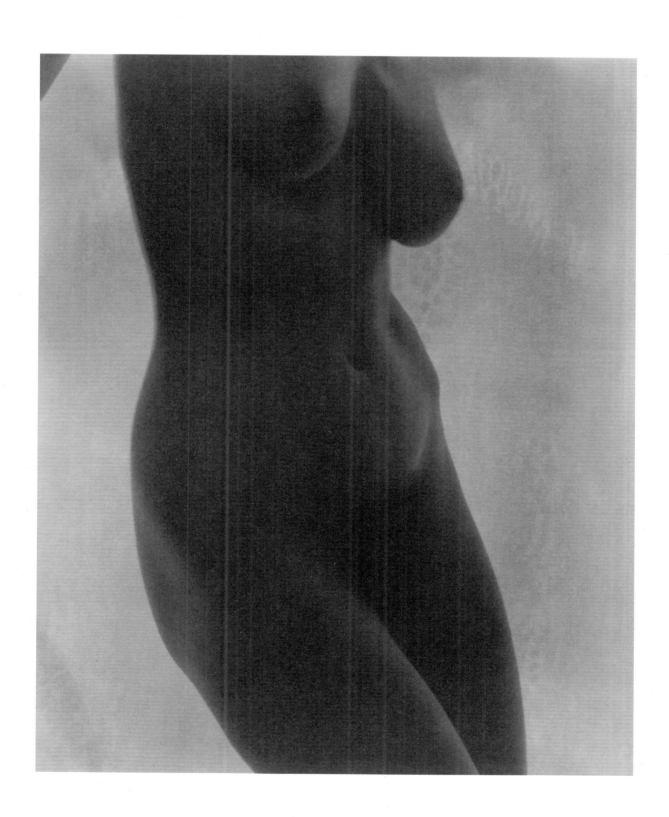

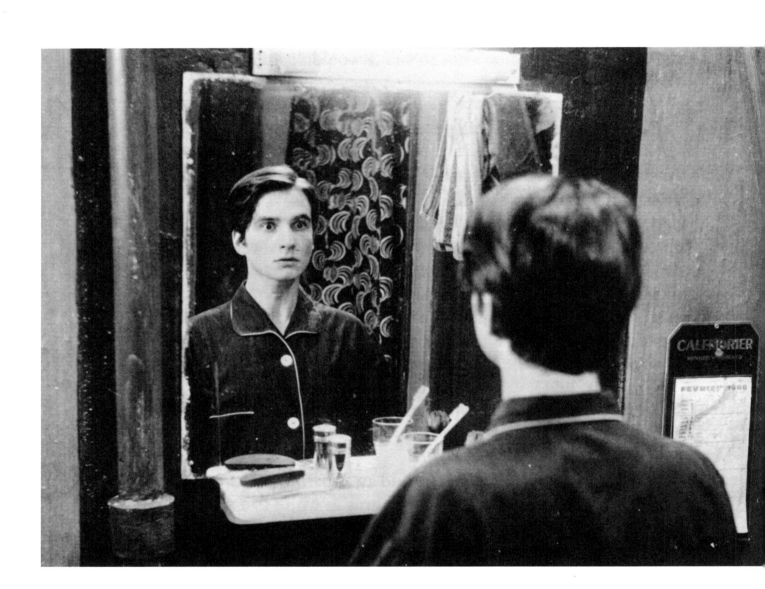

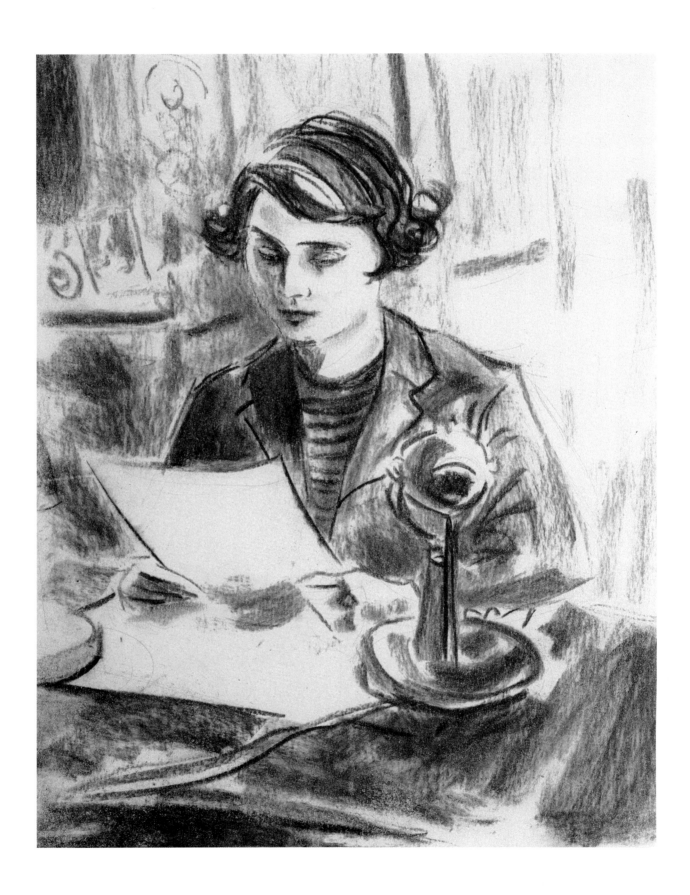

NAPOLEON

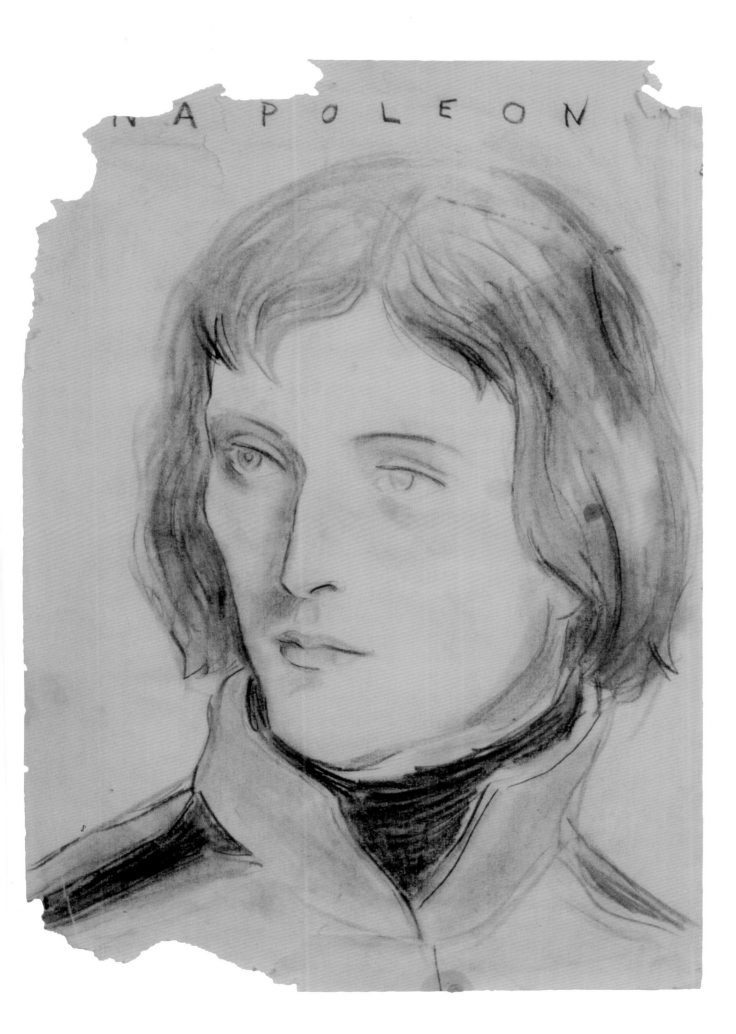

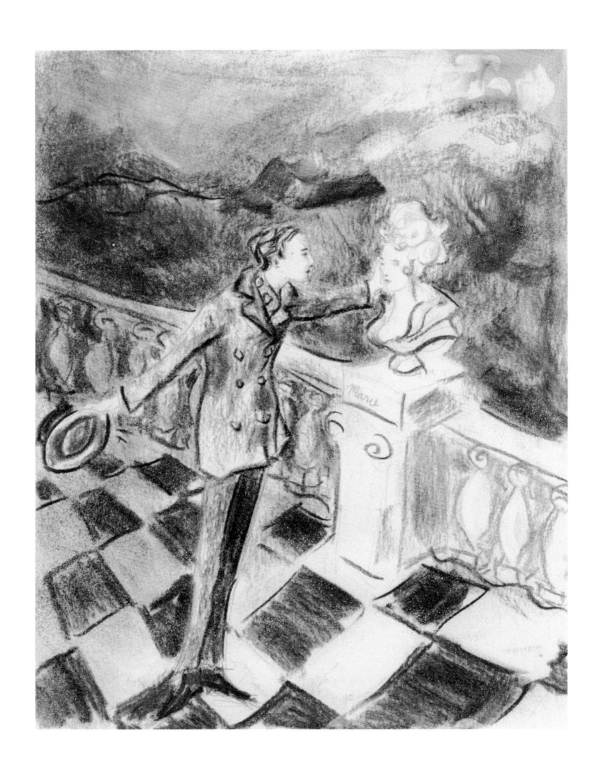

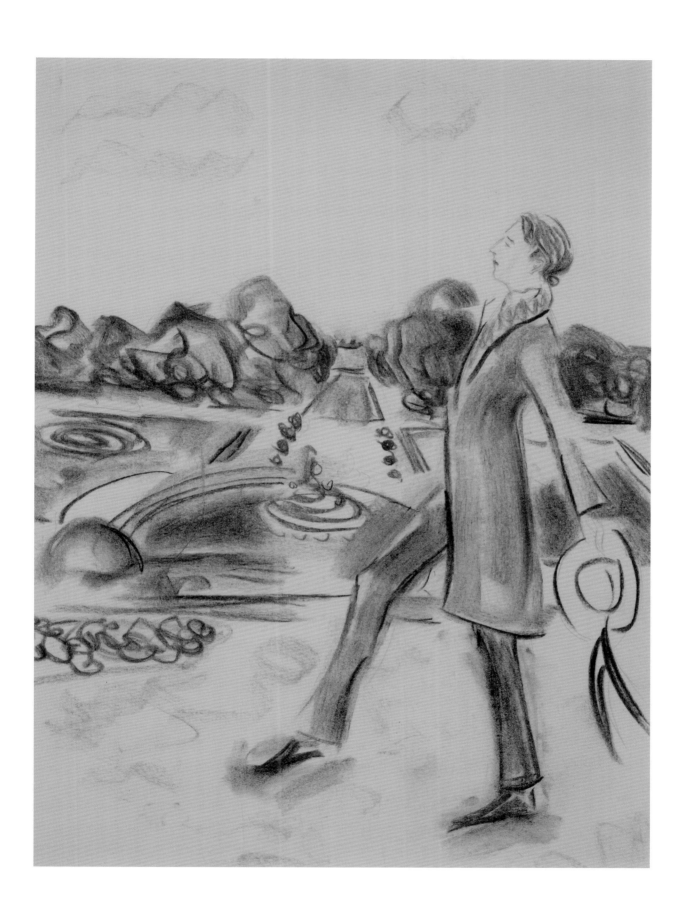

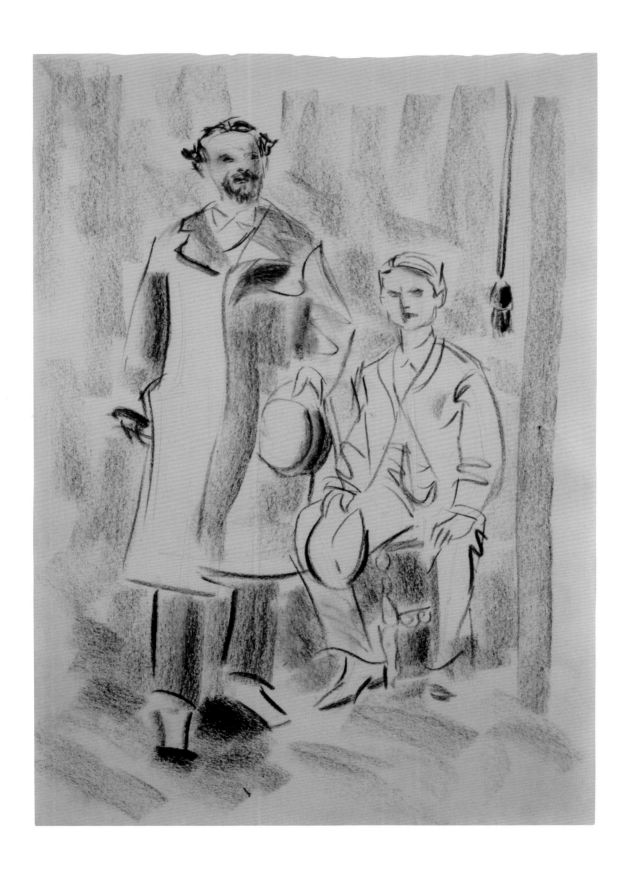

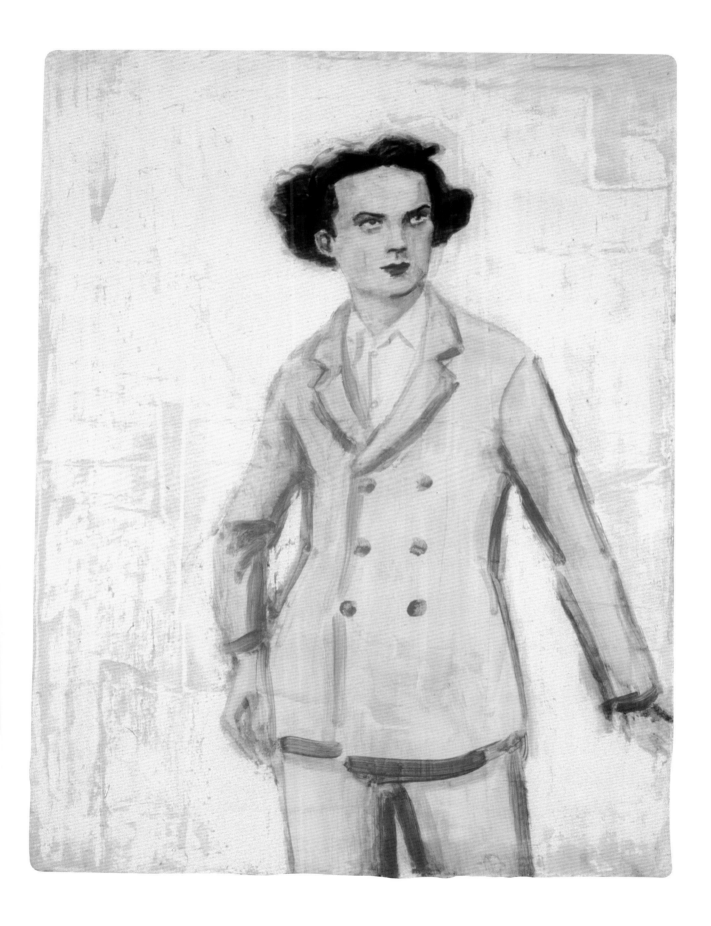

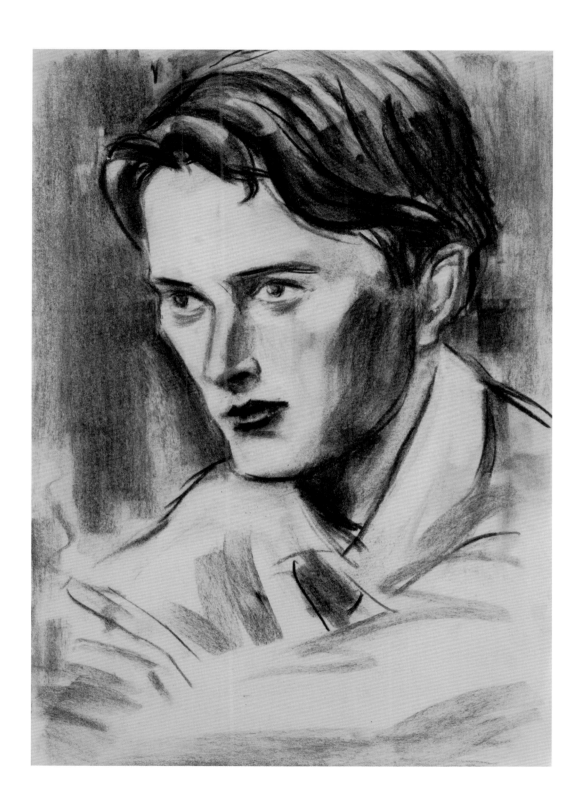

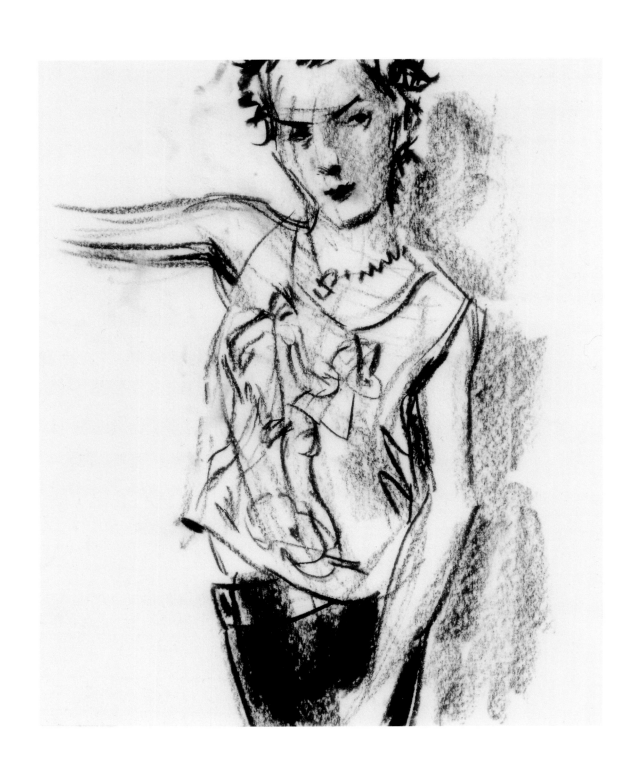

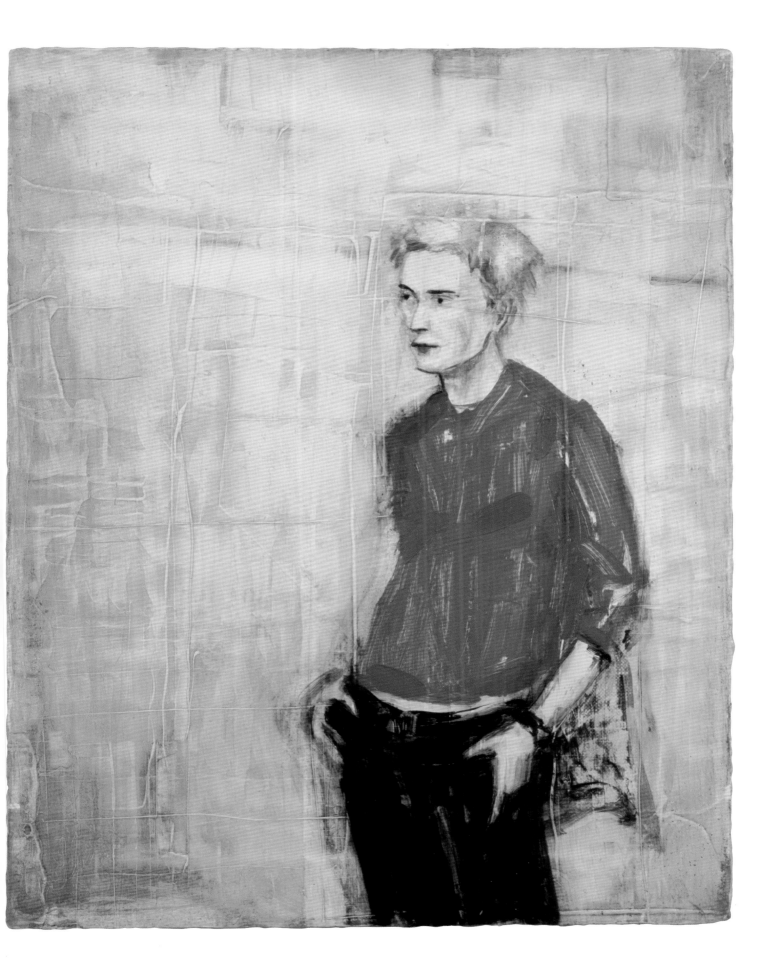

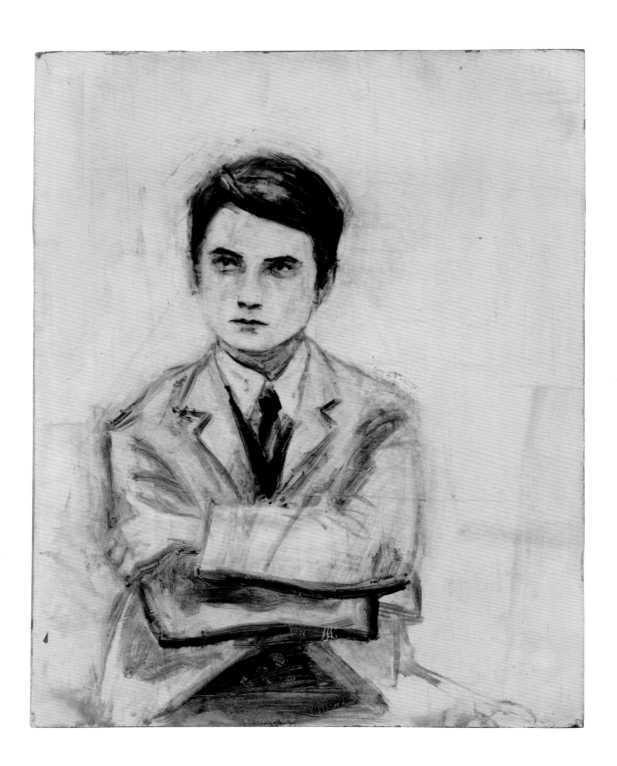

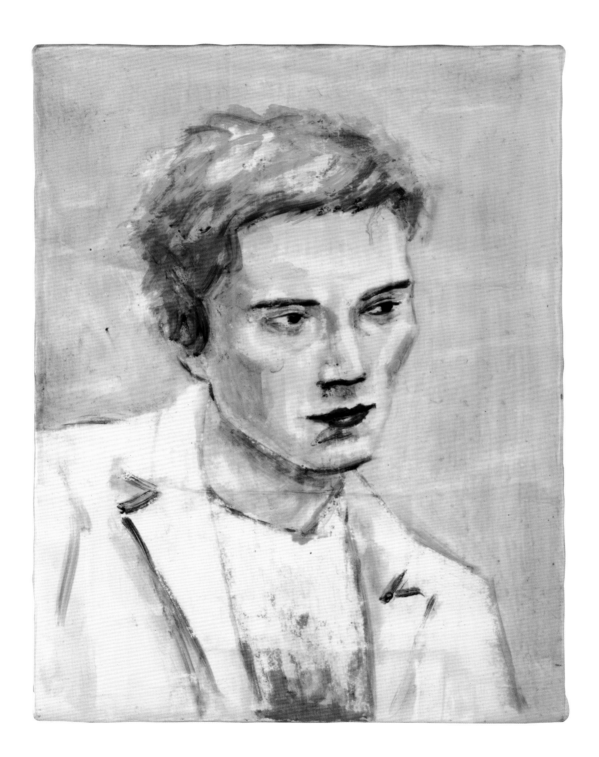

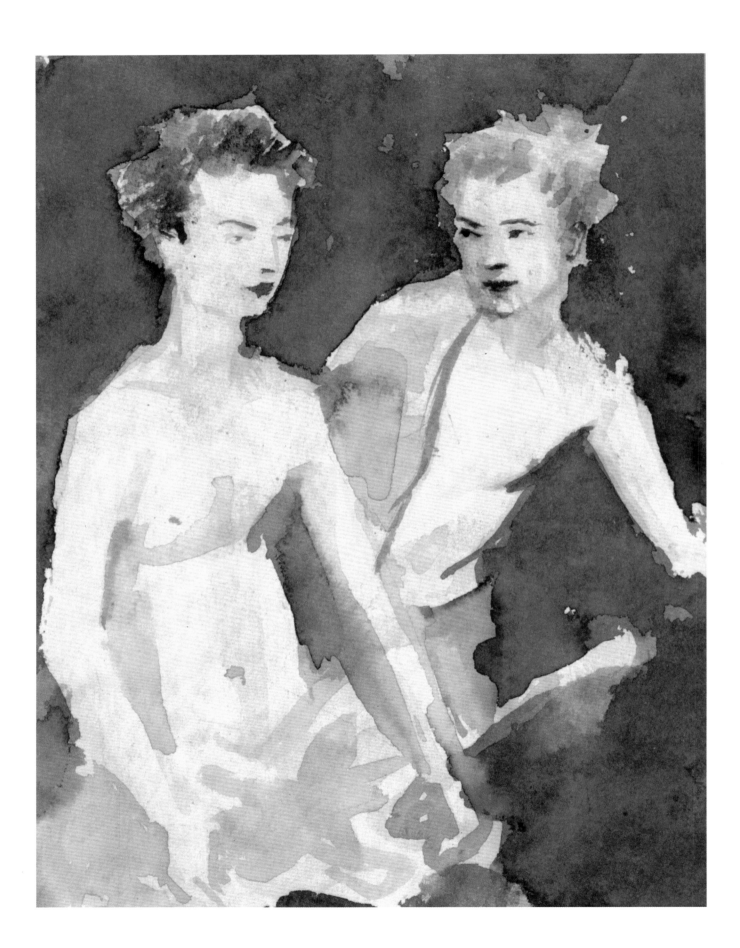

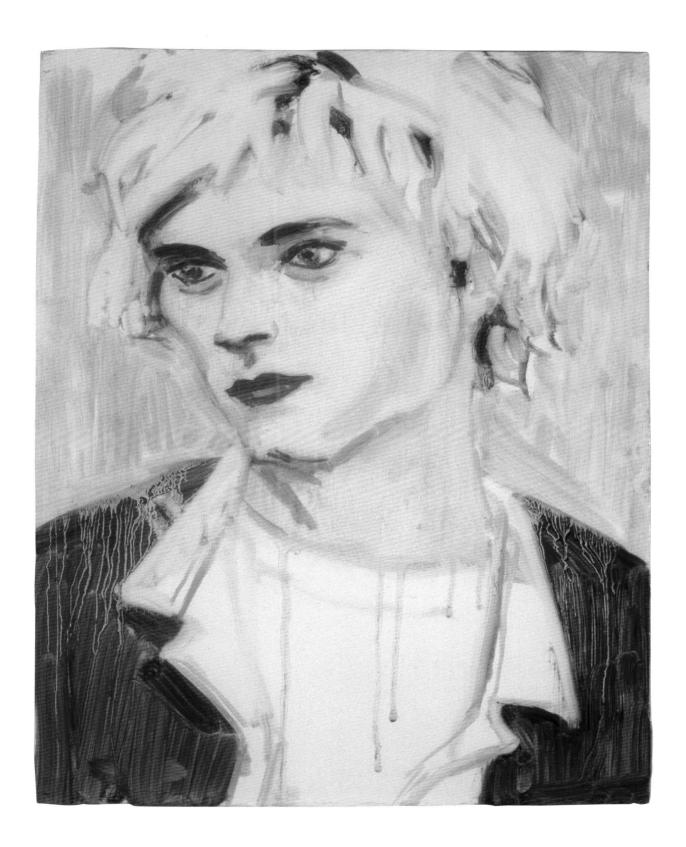

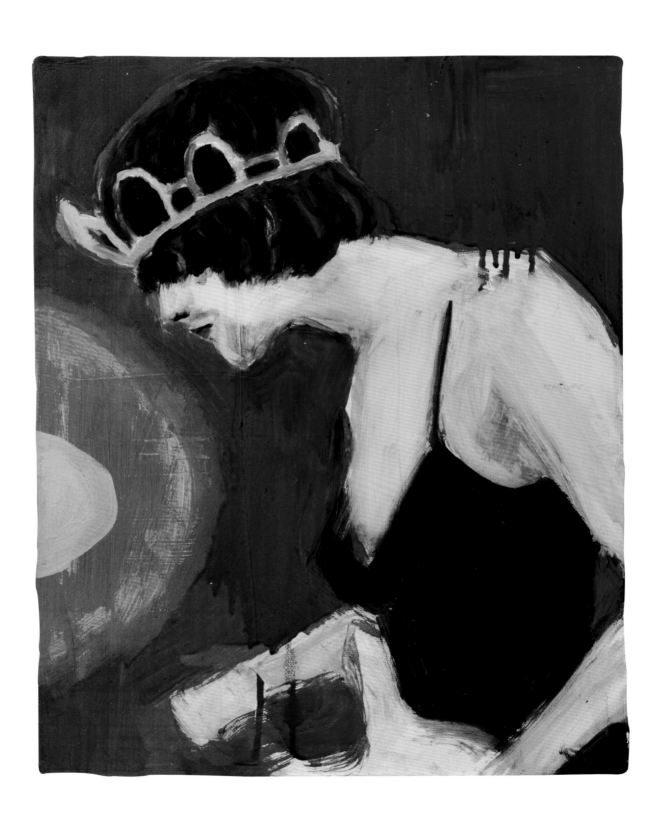

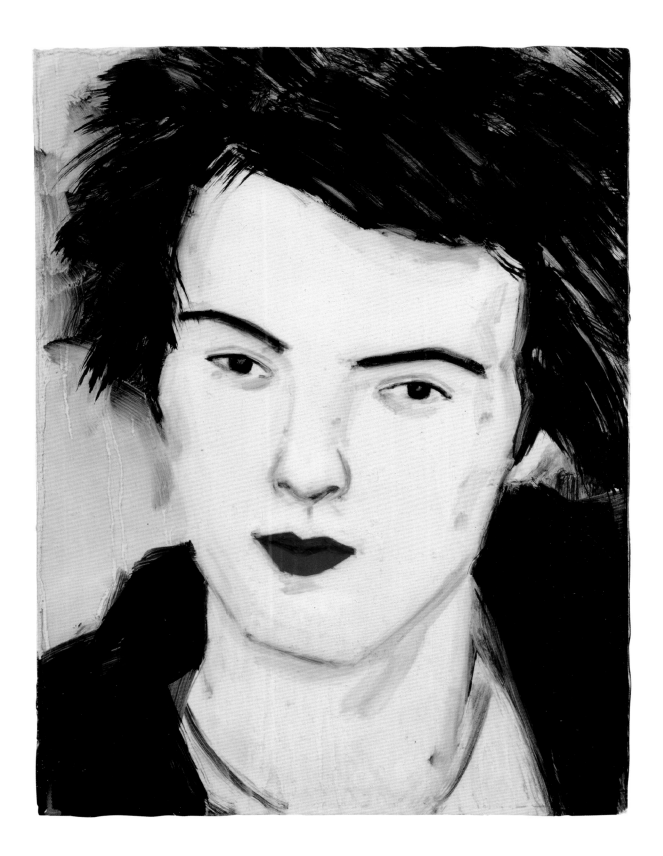

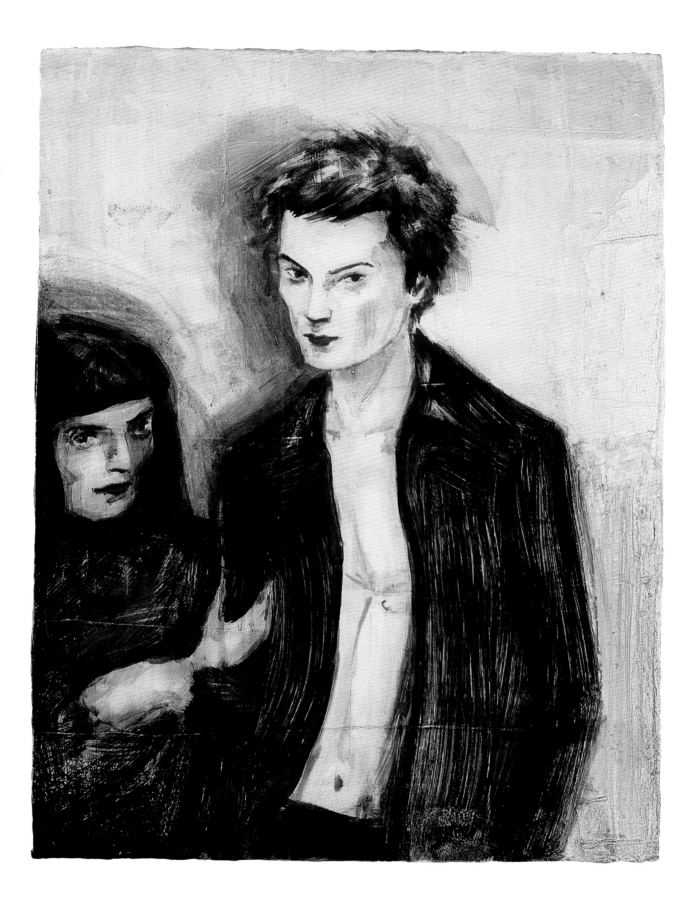

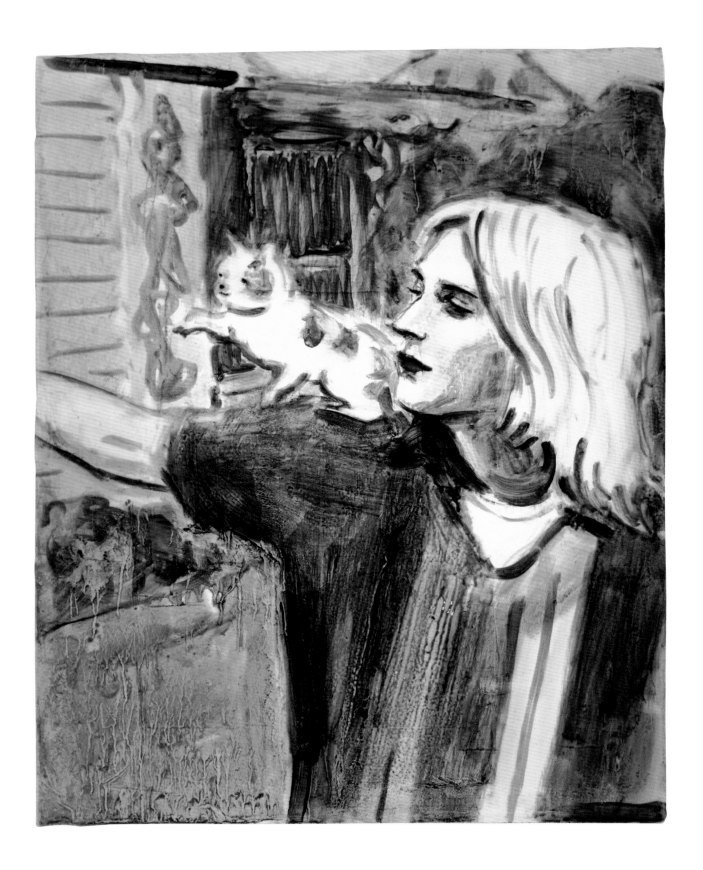

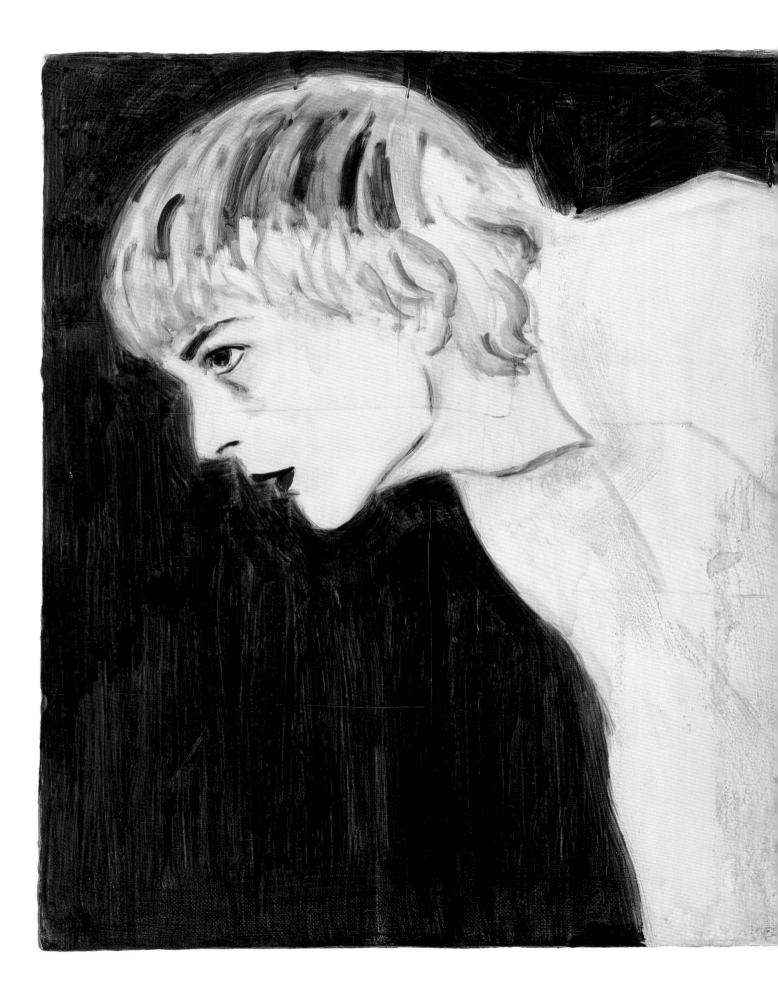

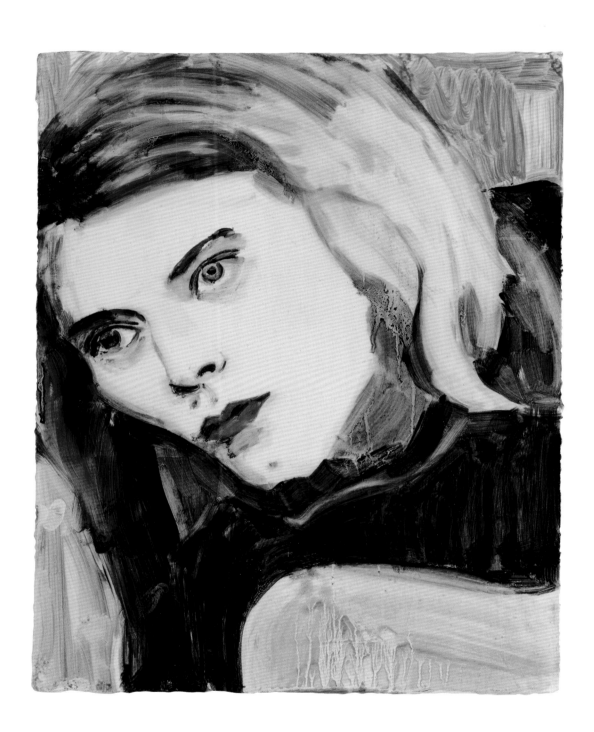

PIOTR.

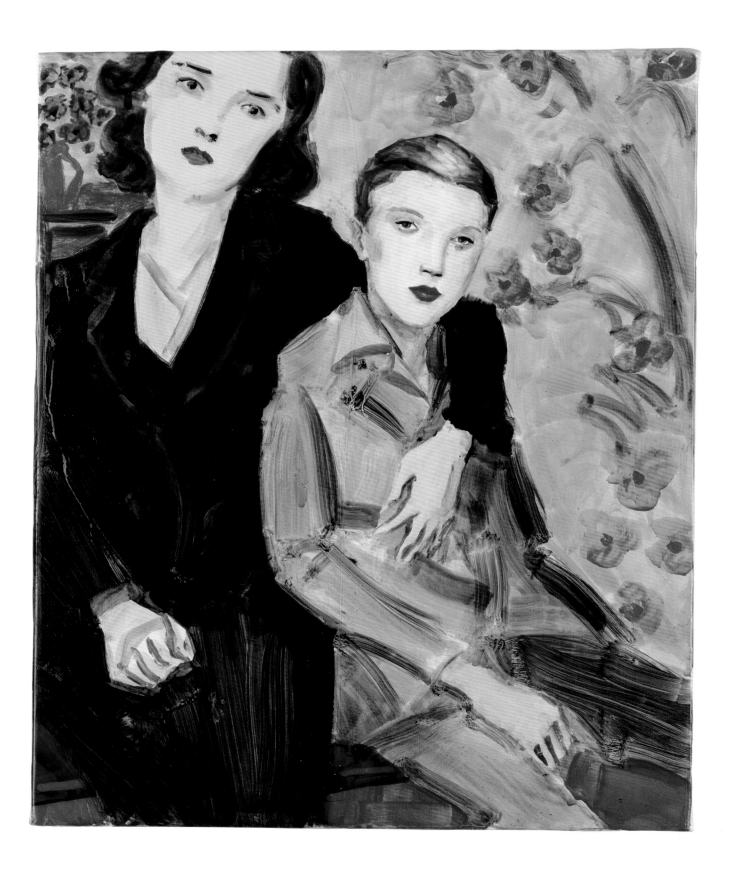

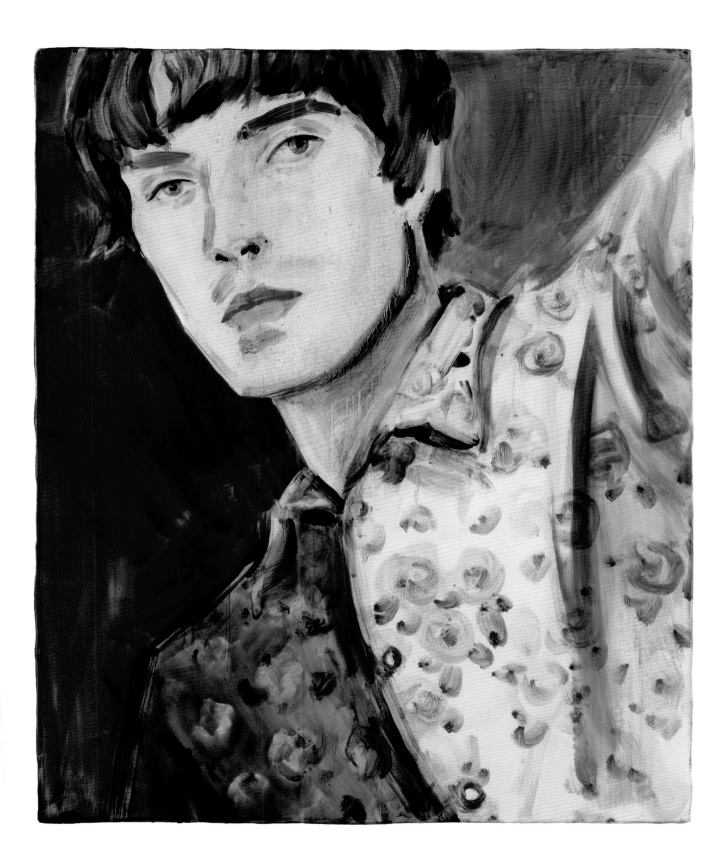

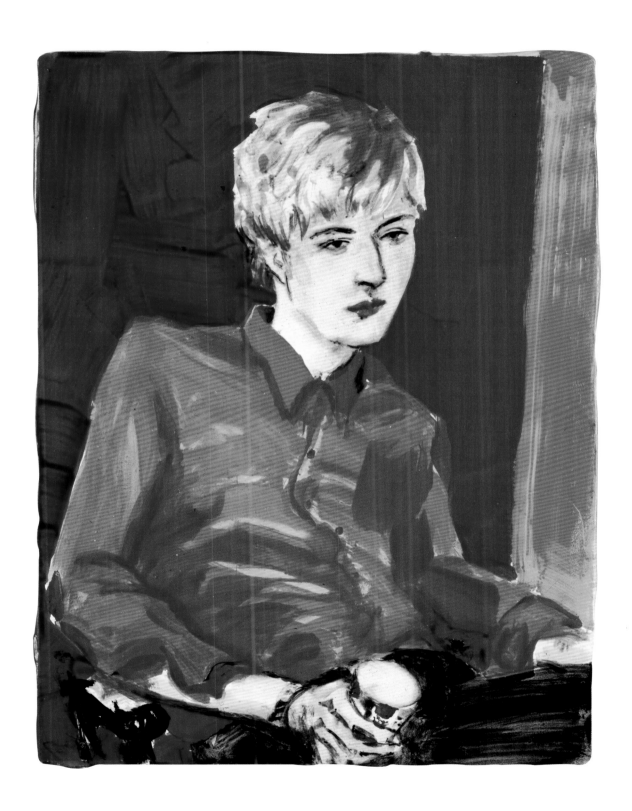

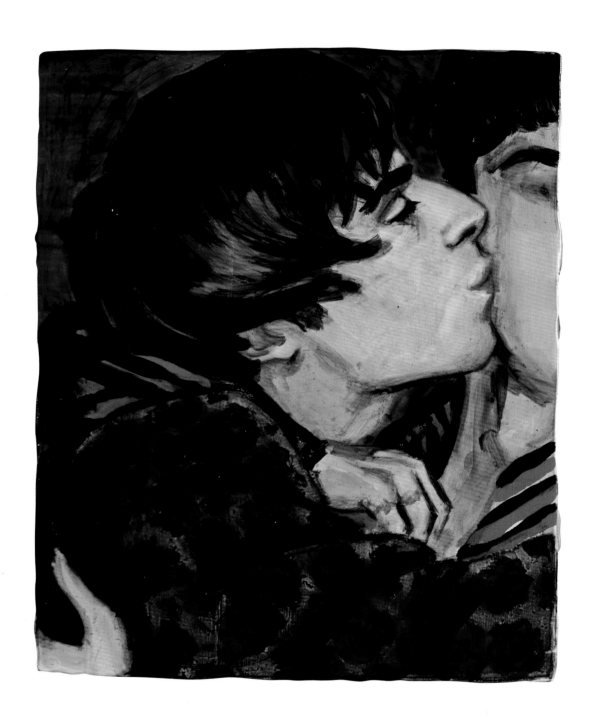

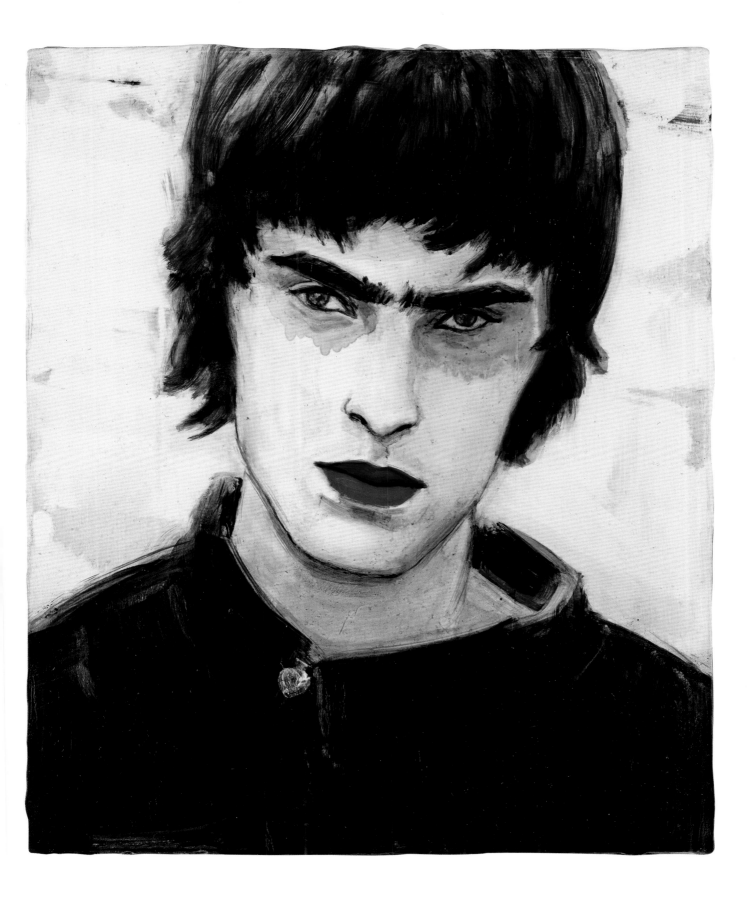

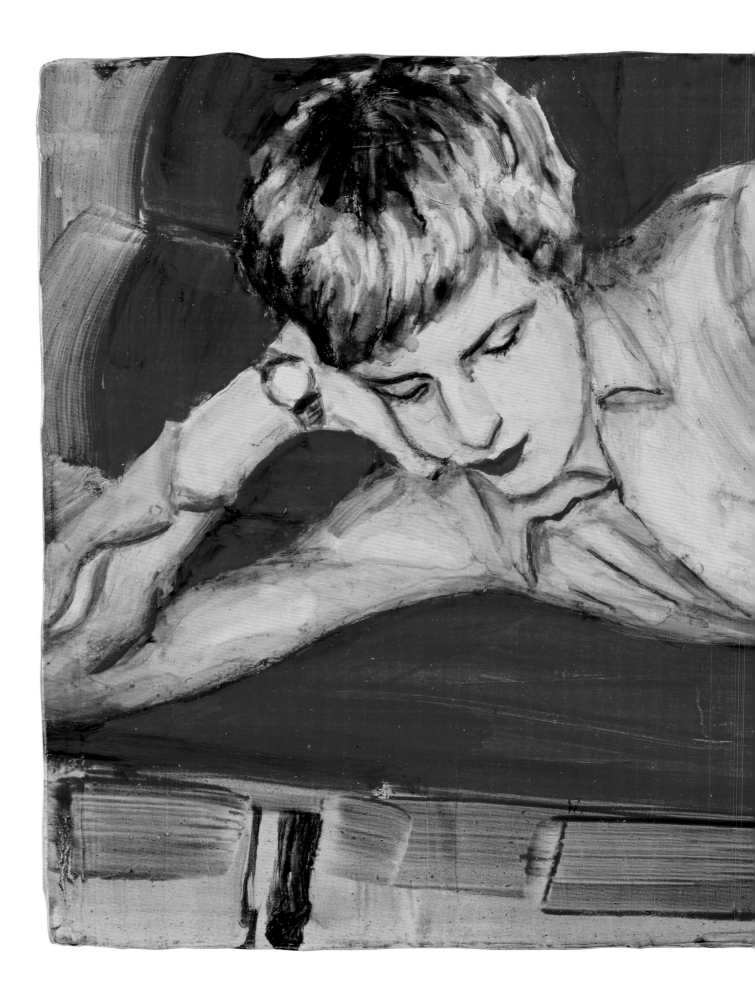

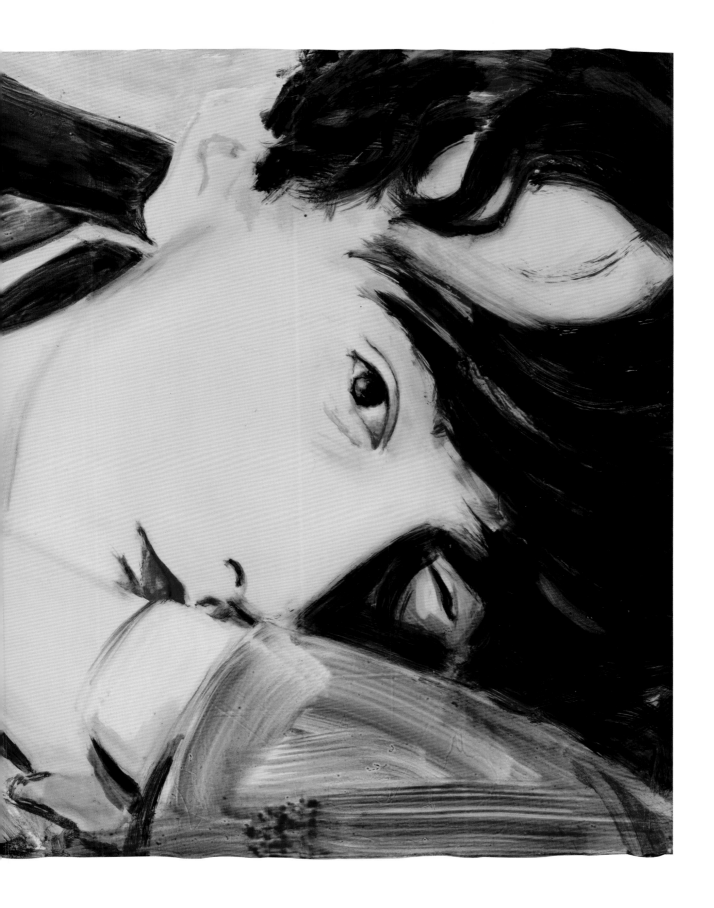

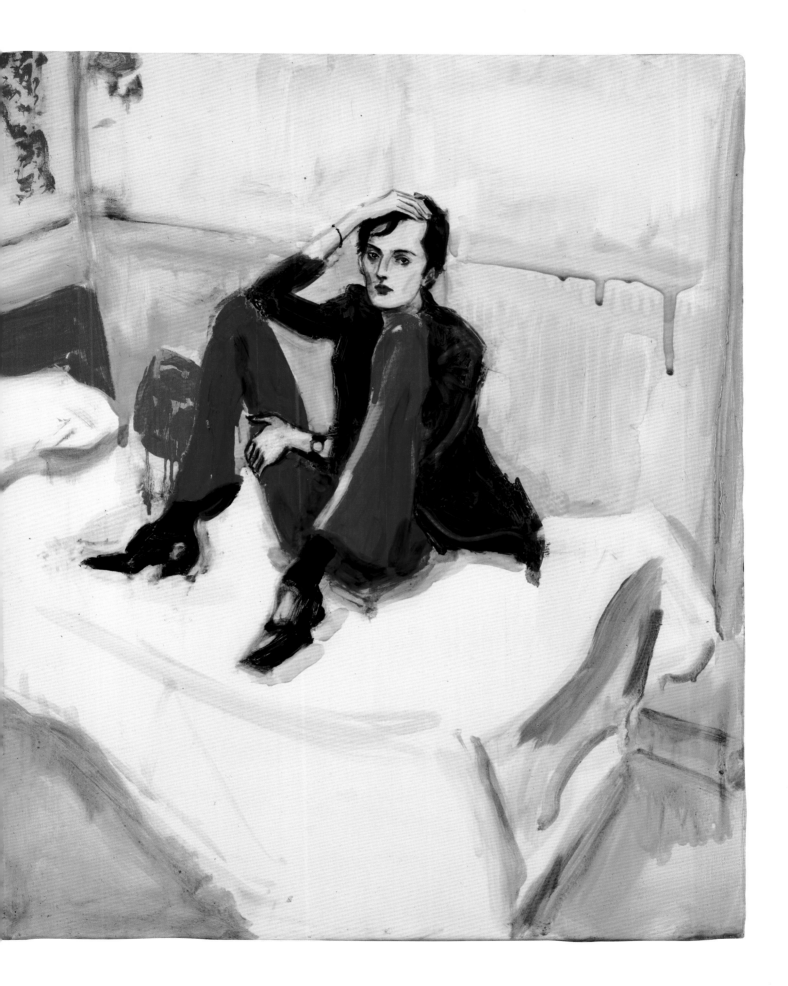

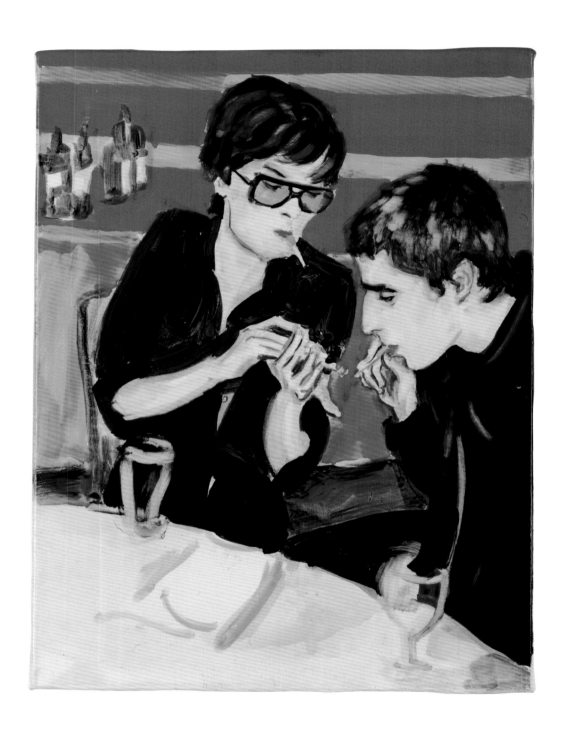

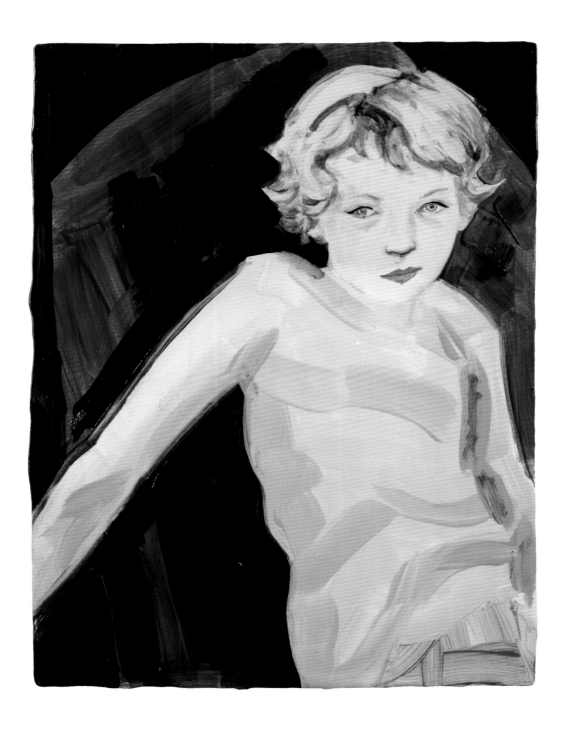

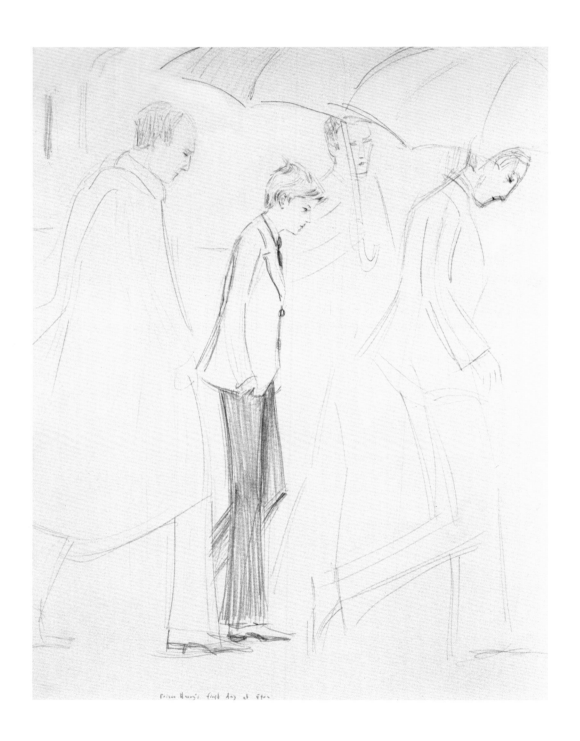

Prince Henry's first day at Eton

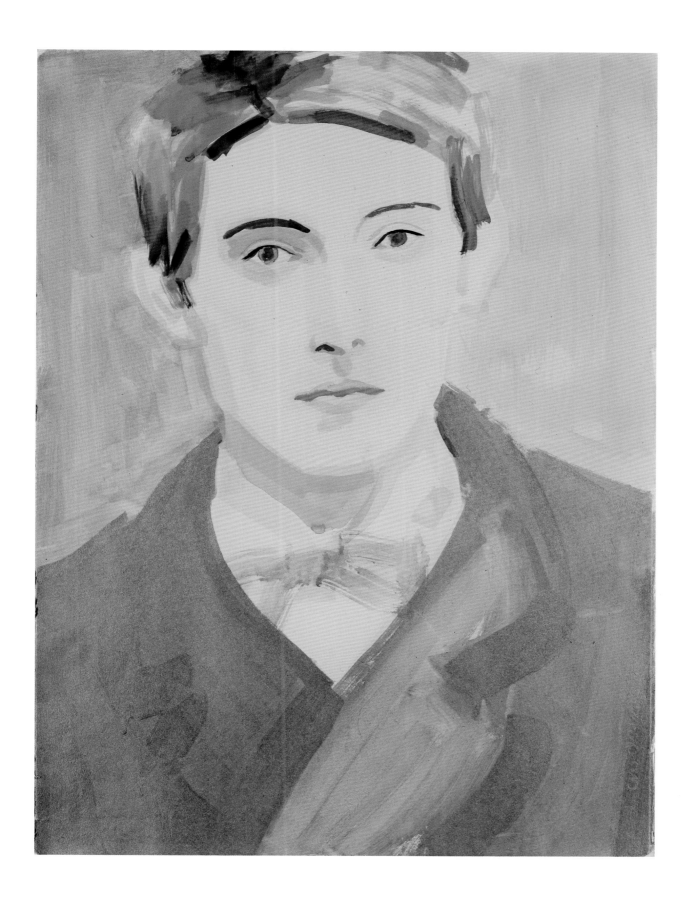

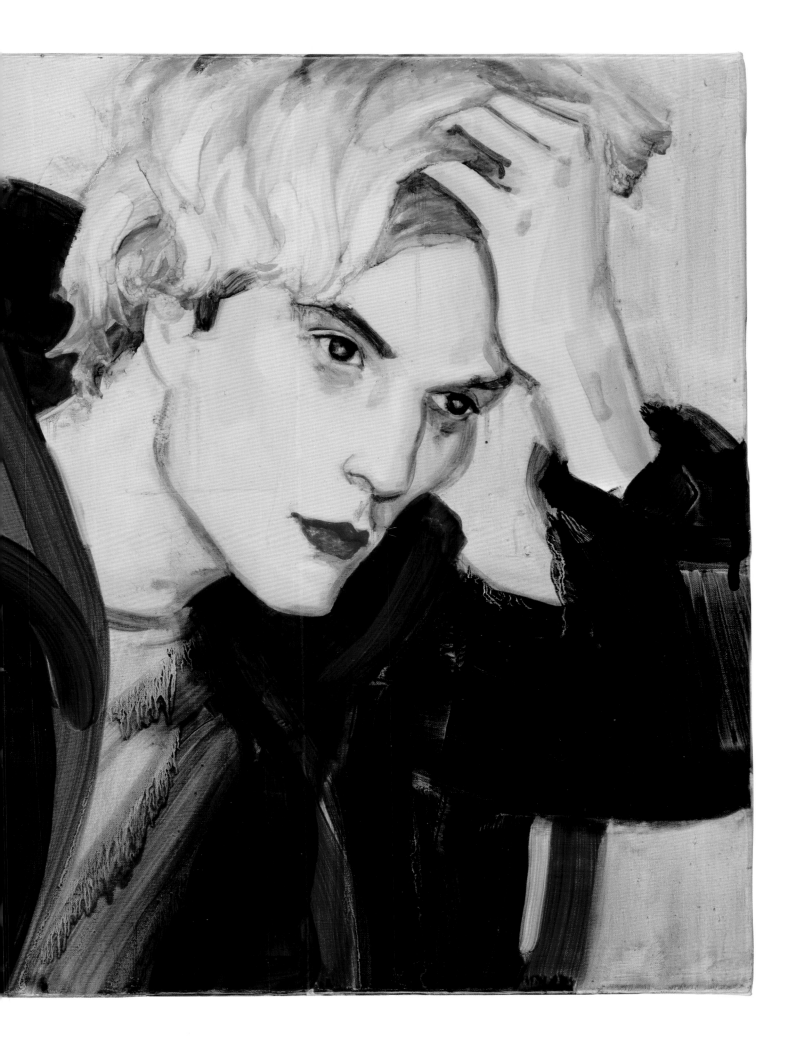

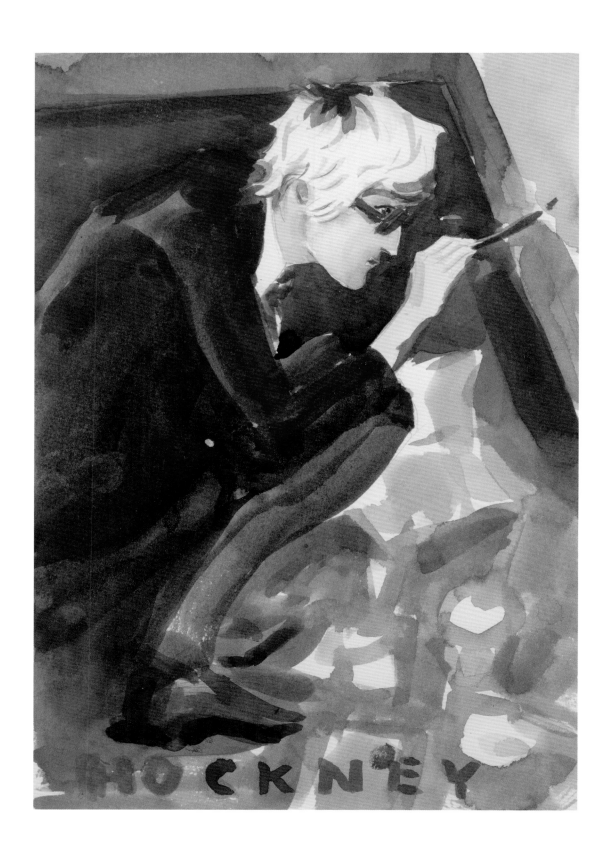

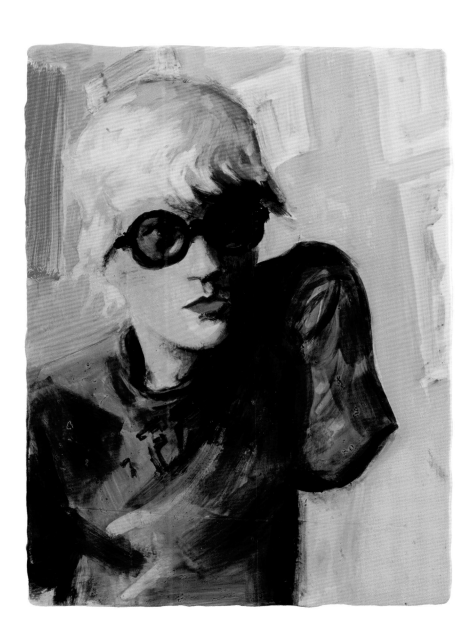

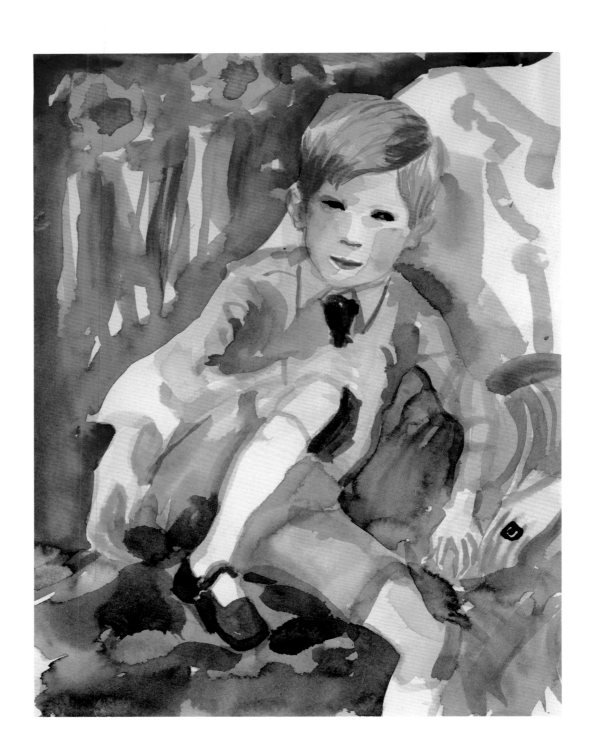

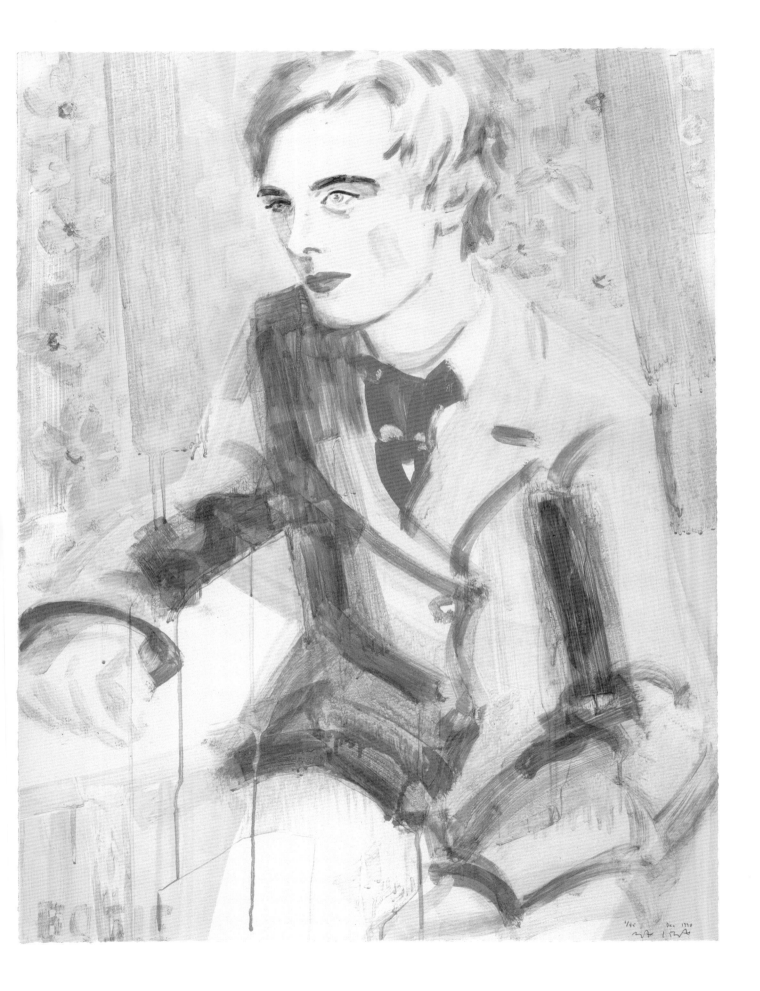

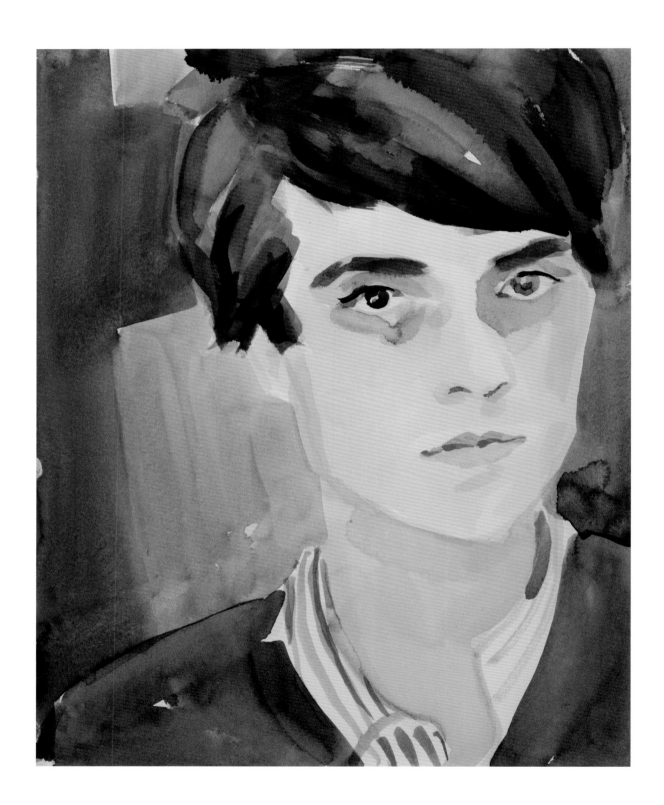

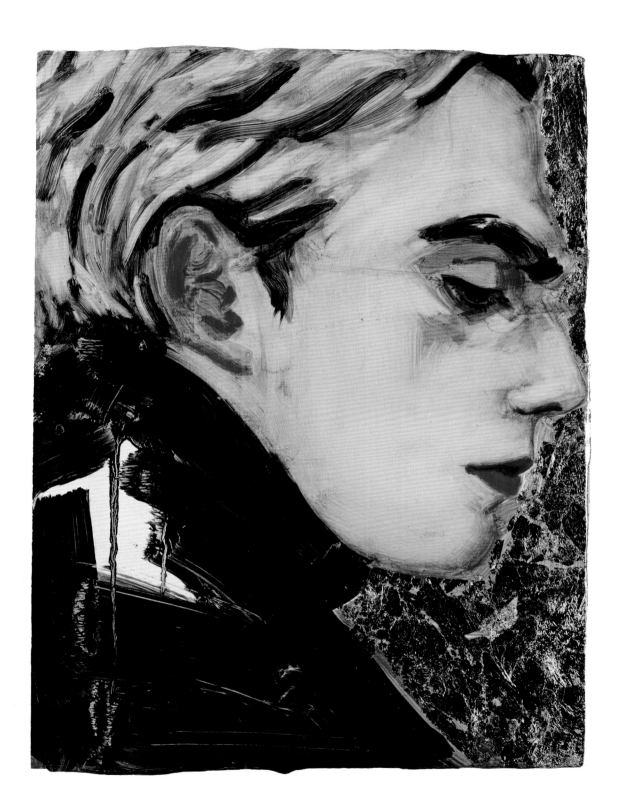

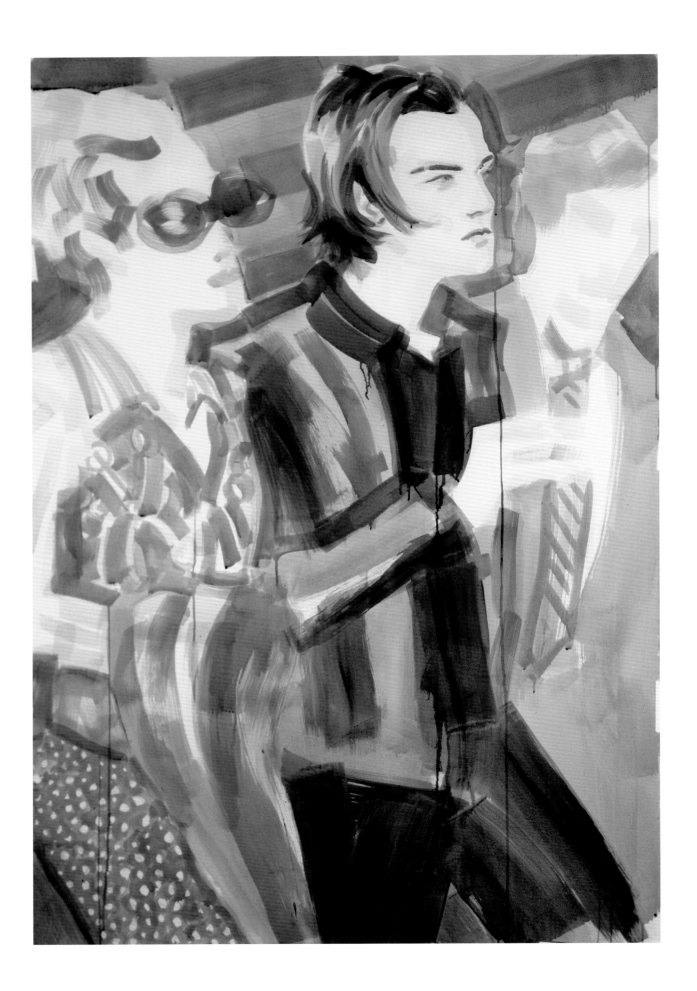

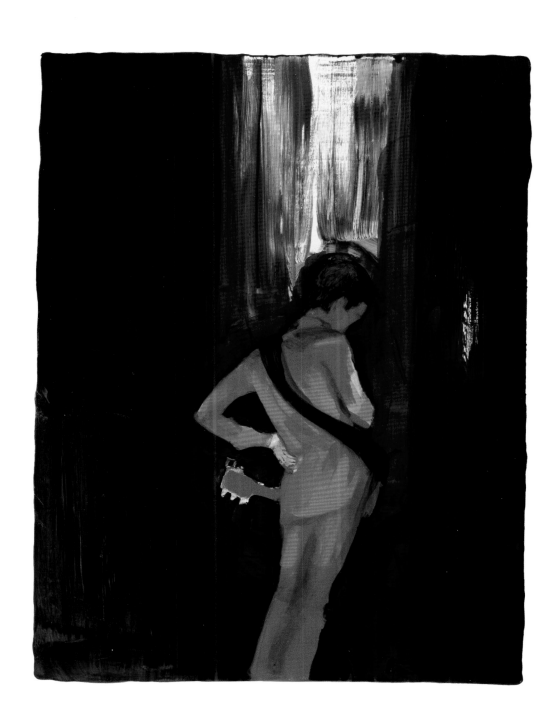

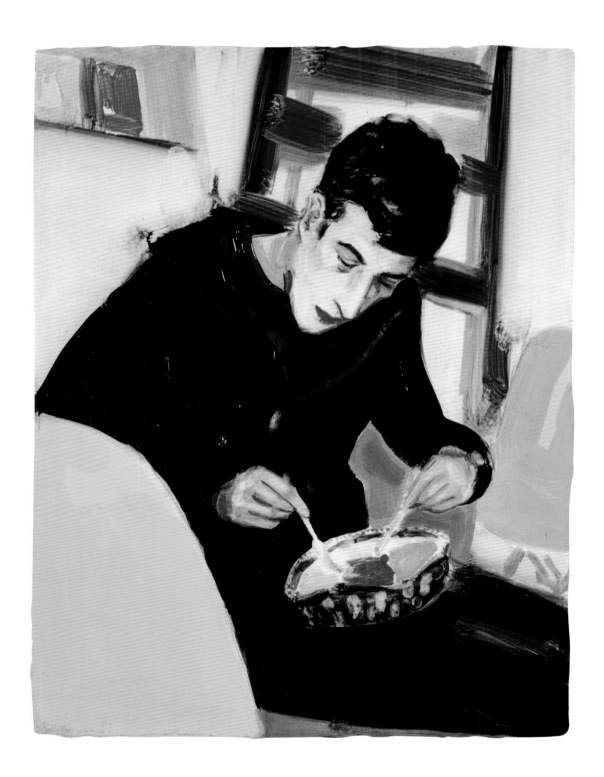

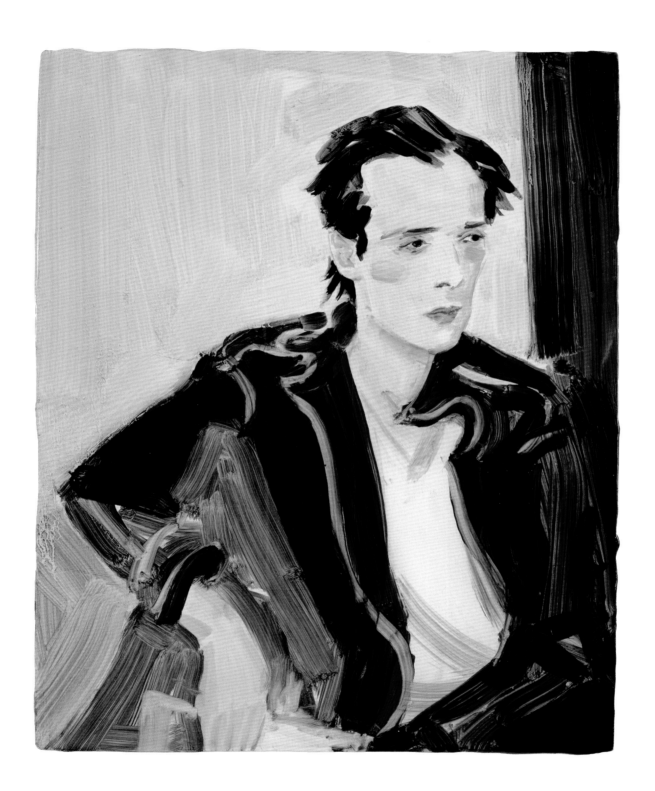

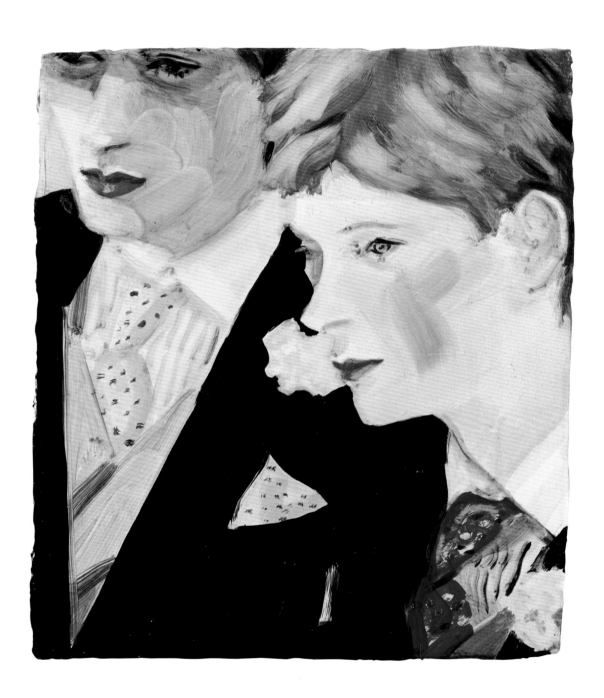

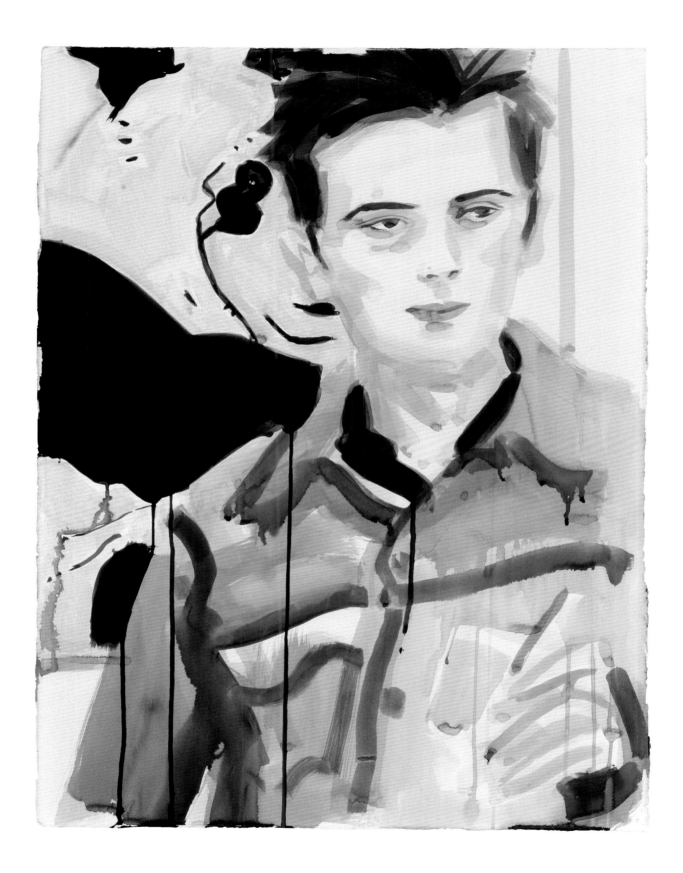

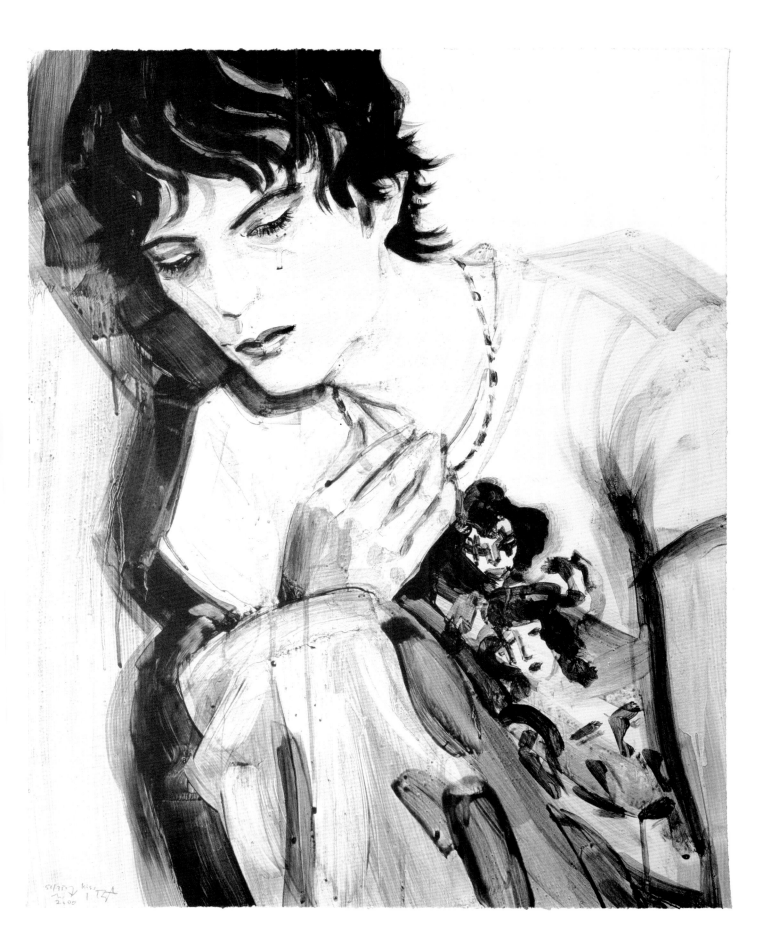

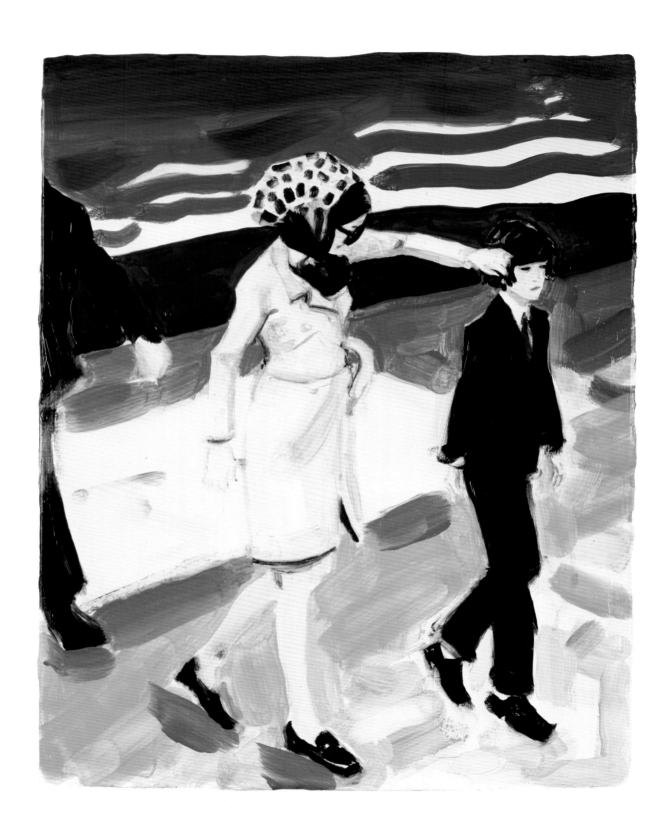

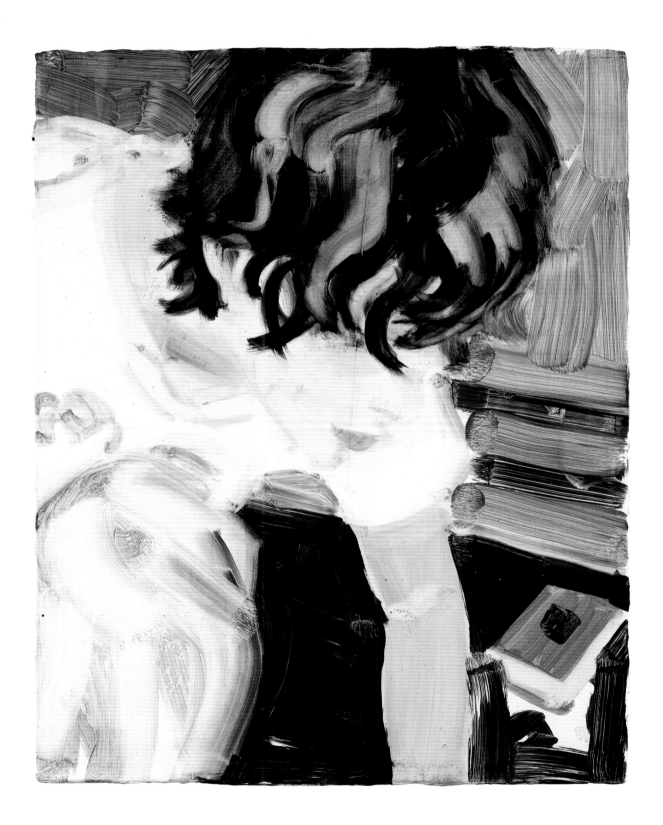

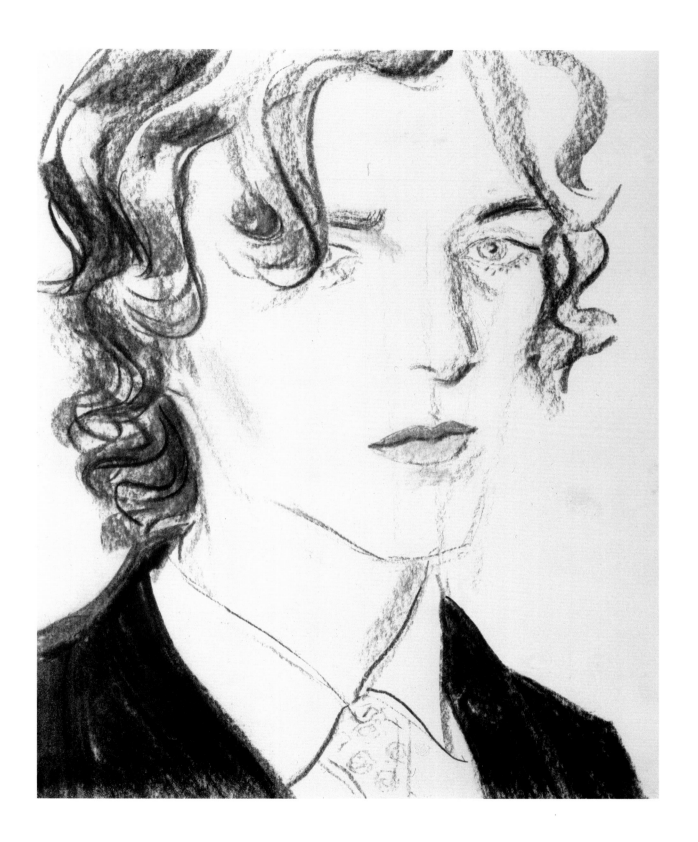

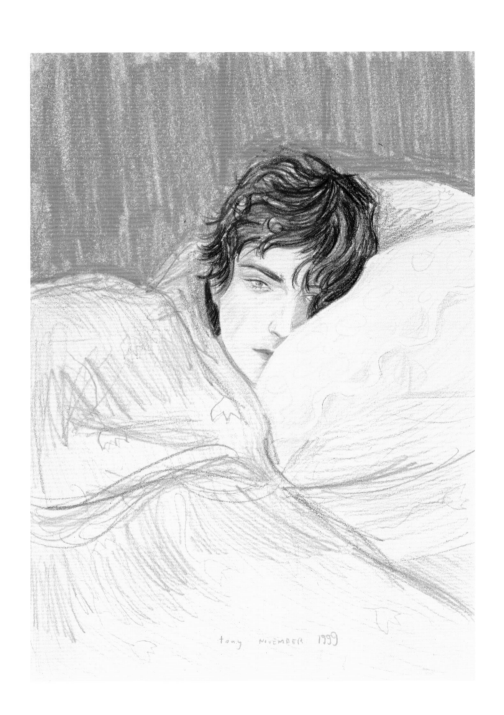

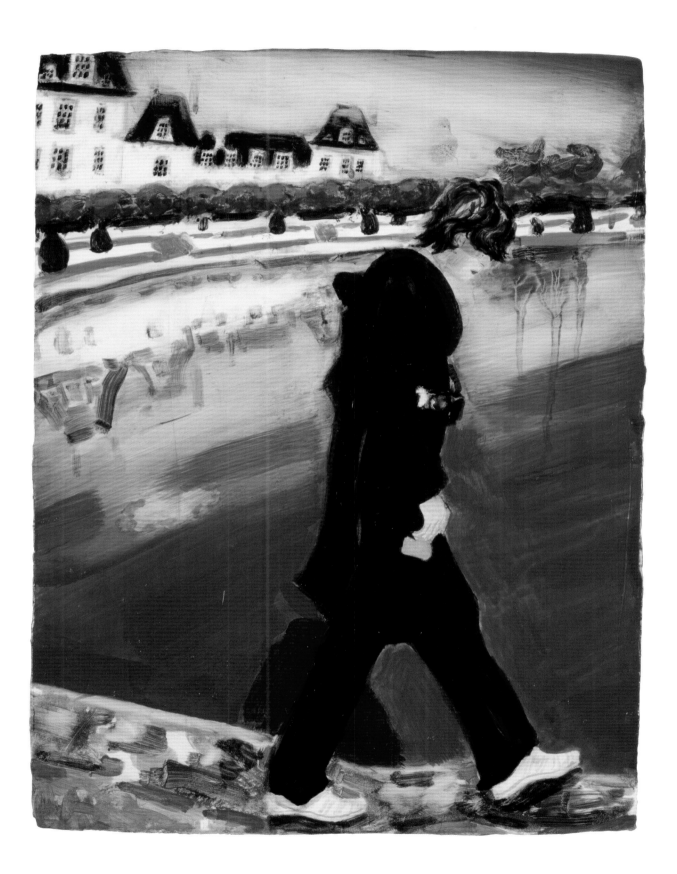

SAVOY
LONDON

The Savoy, Strand, London WC2R 0EU
Tel 0171 836 4343, Fax 0171 240 6040

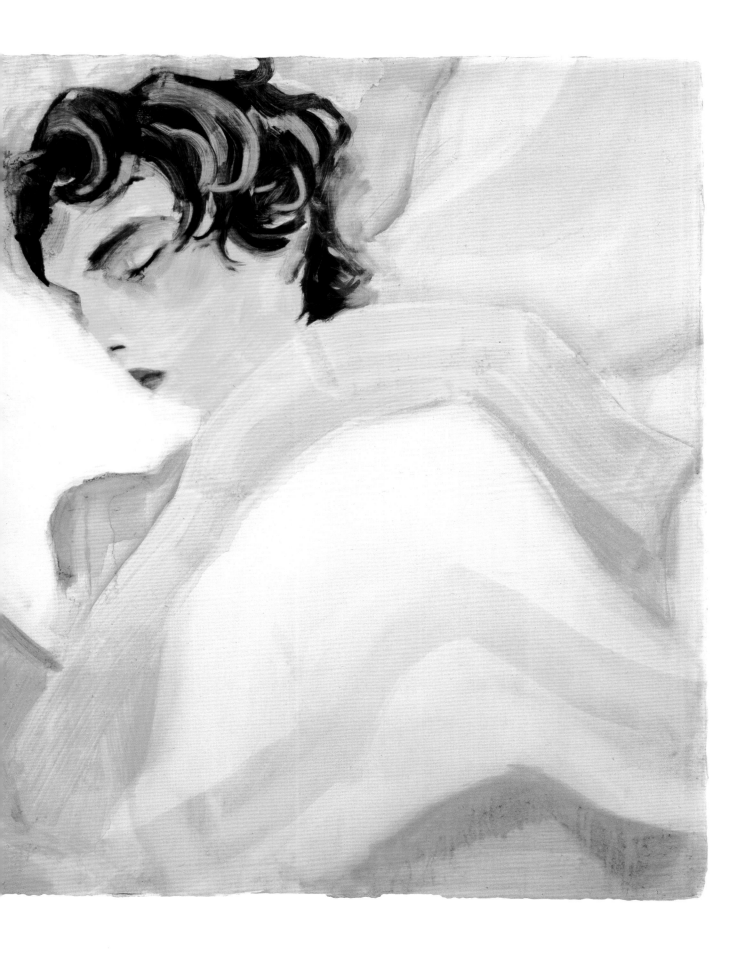

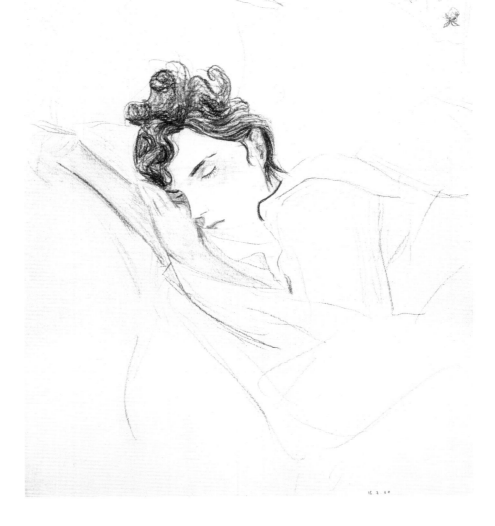

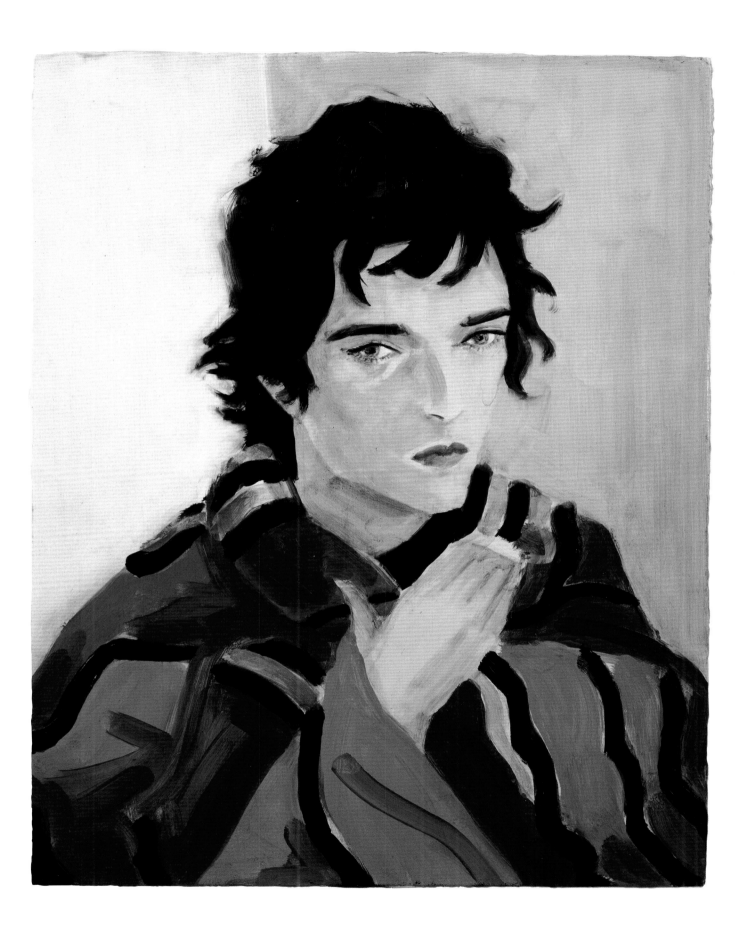

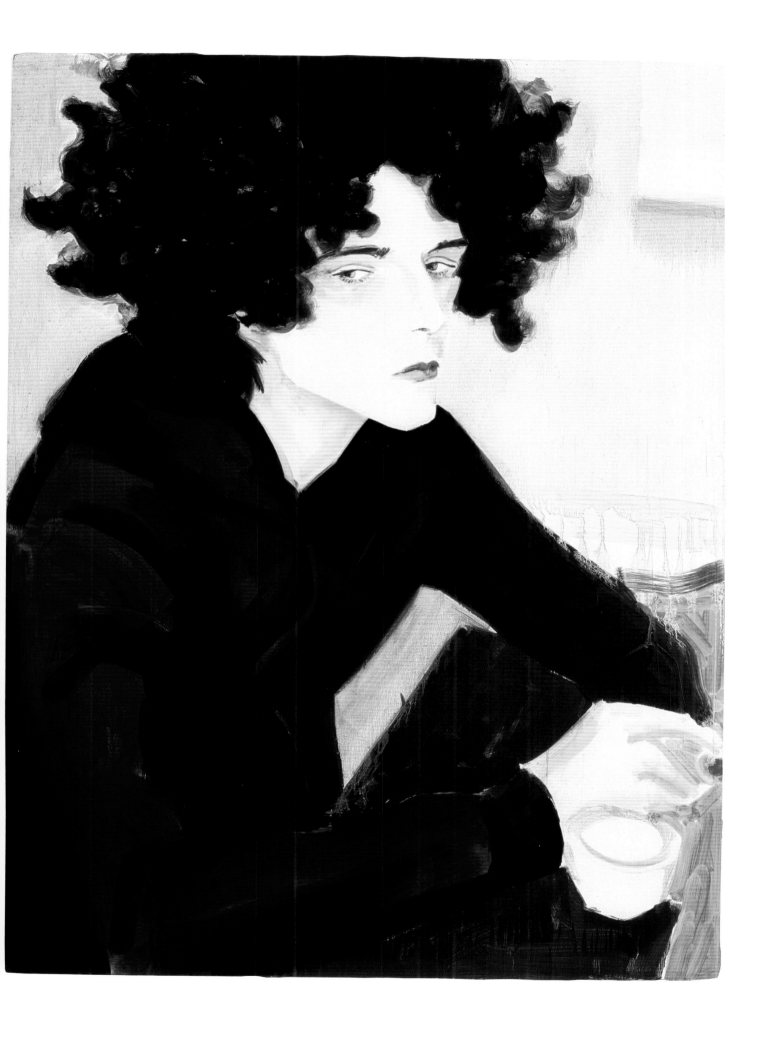

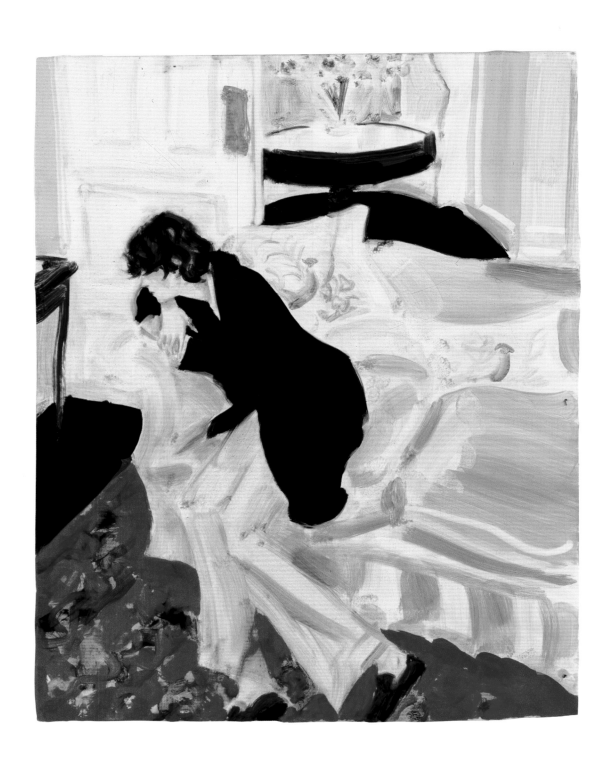

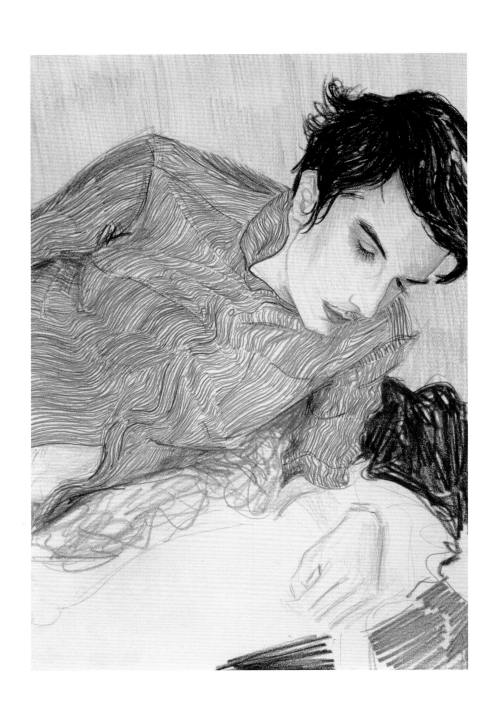

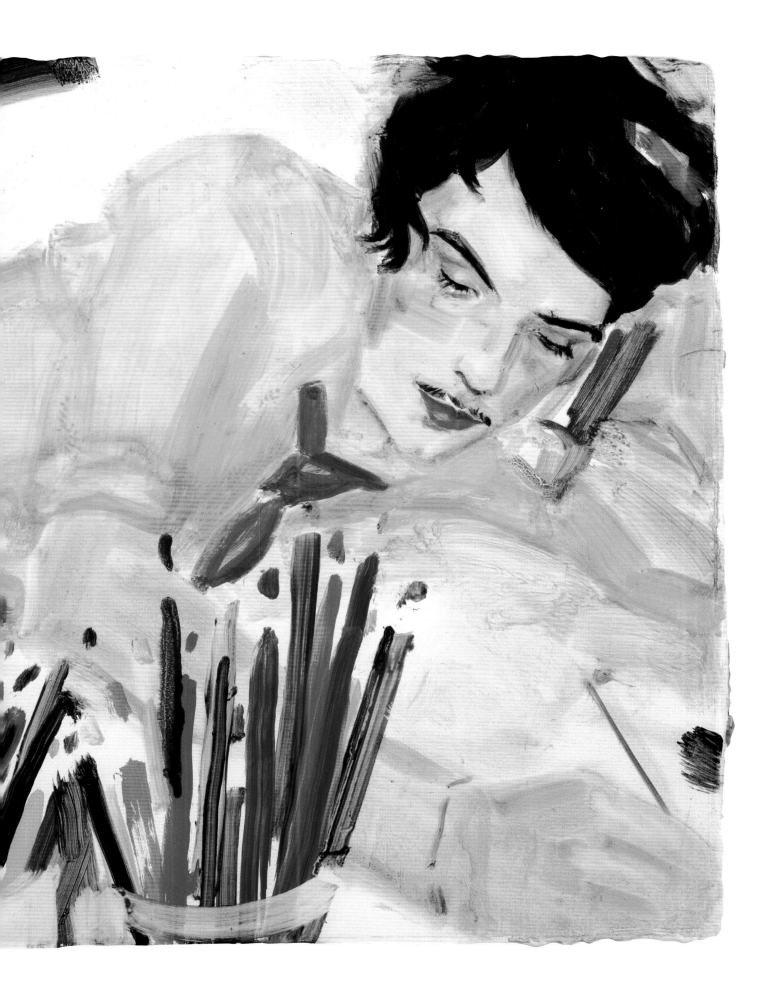

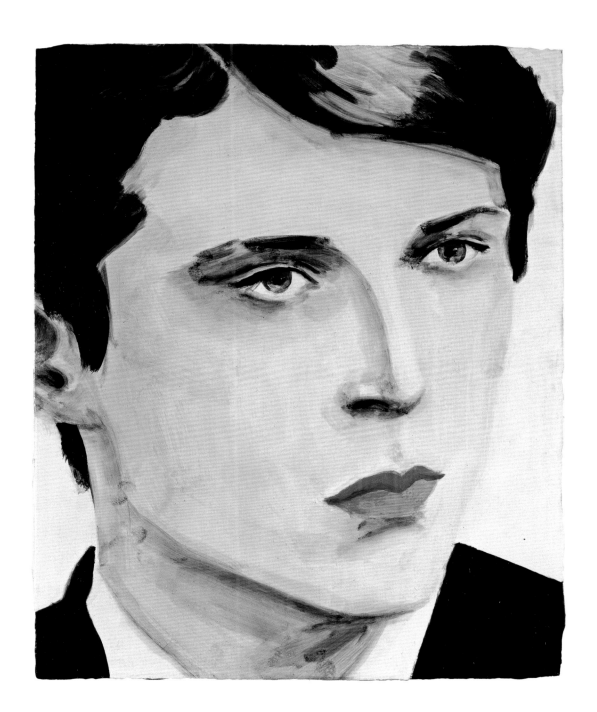

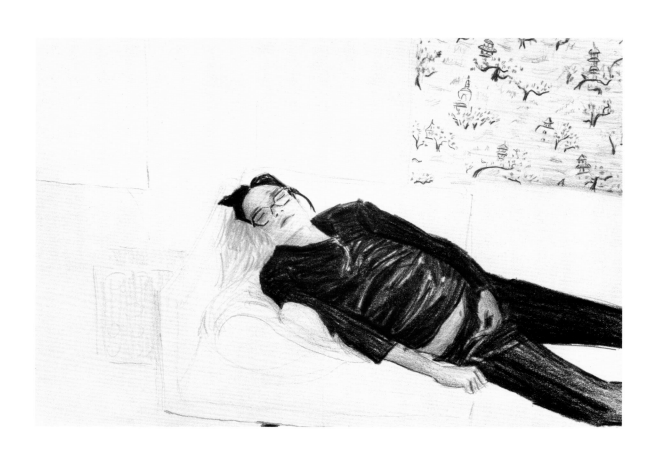

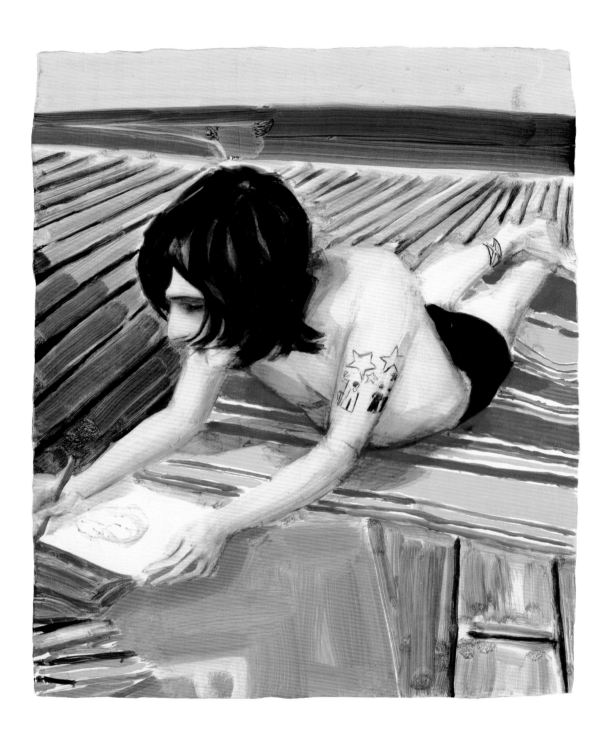

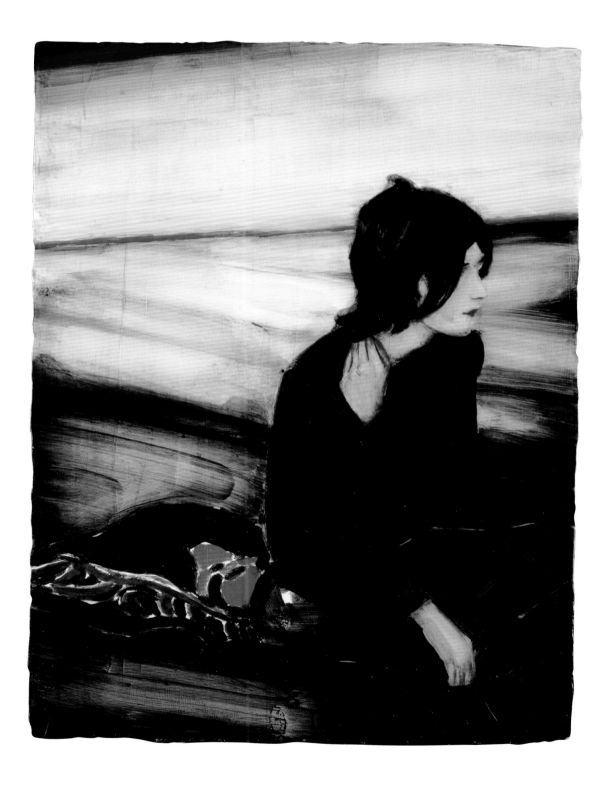

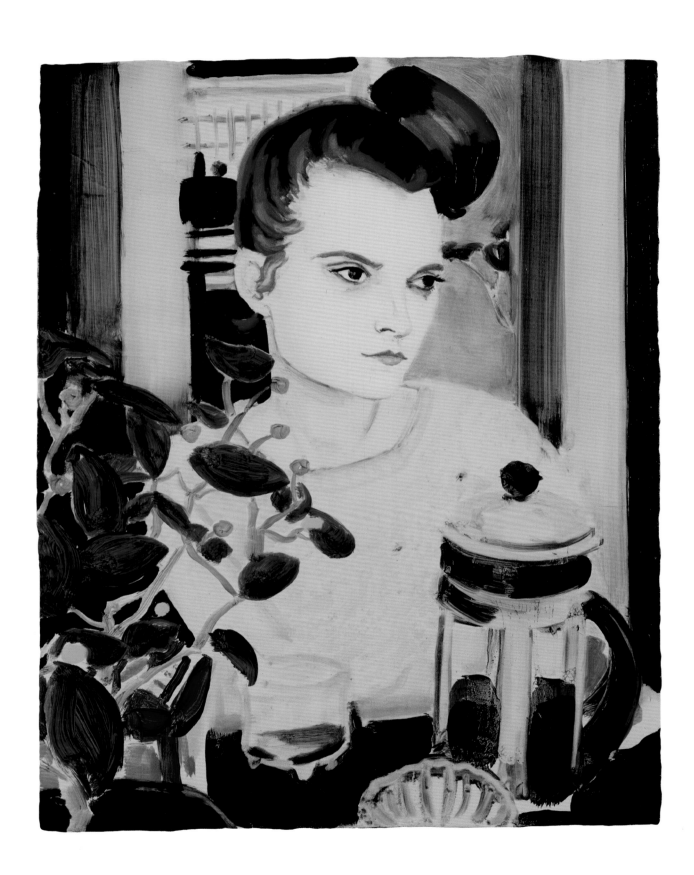

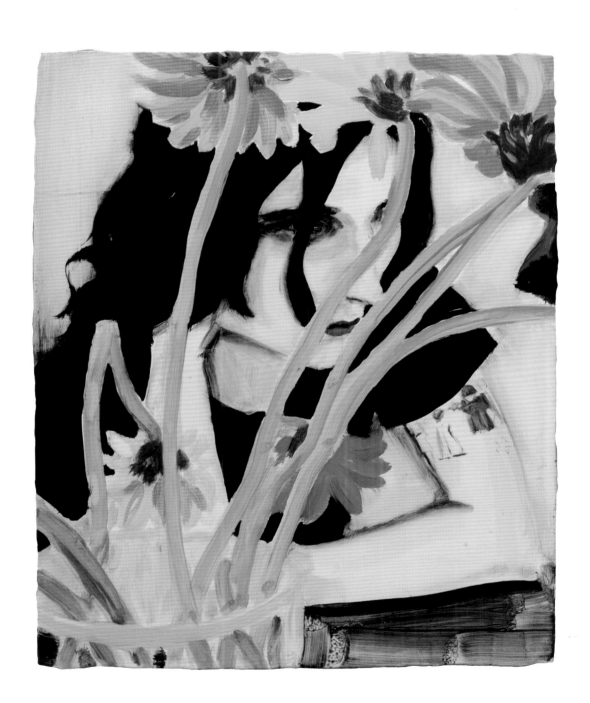

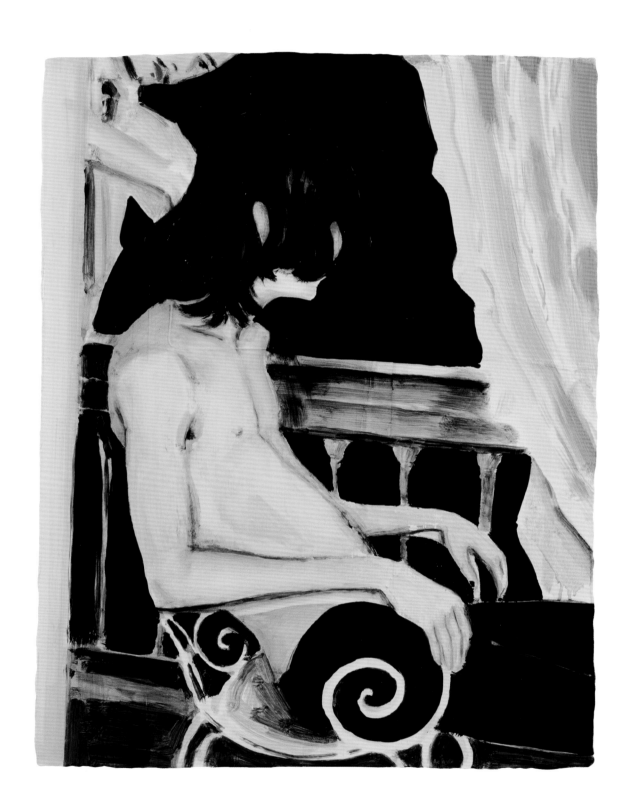

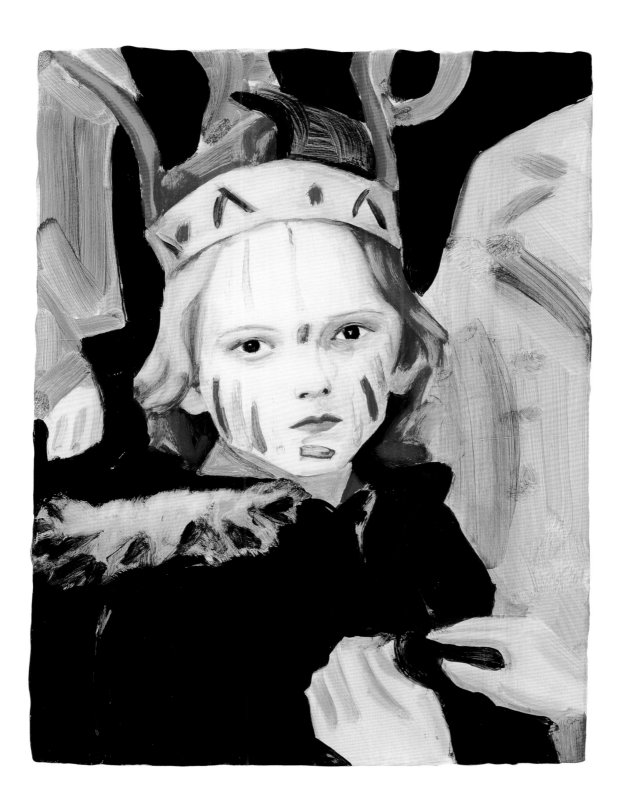

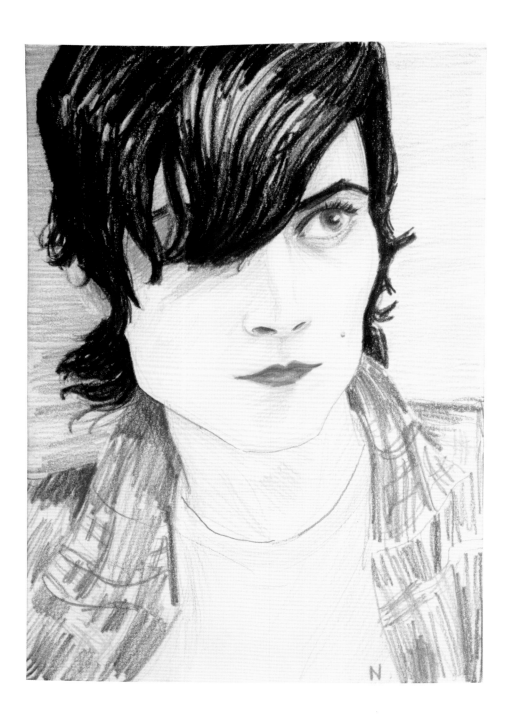

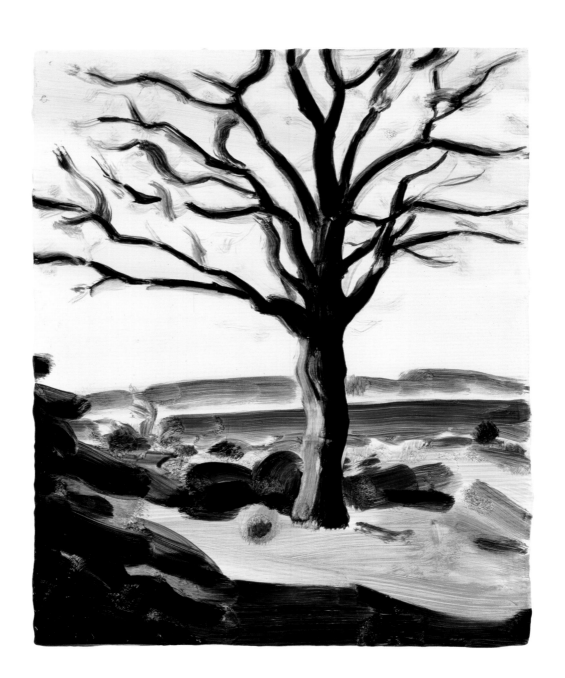

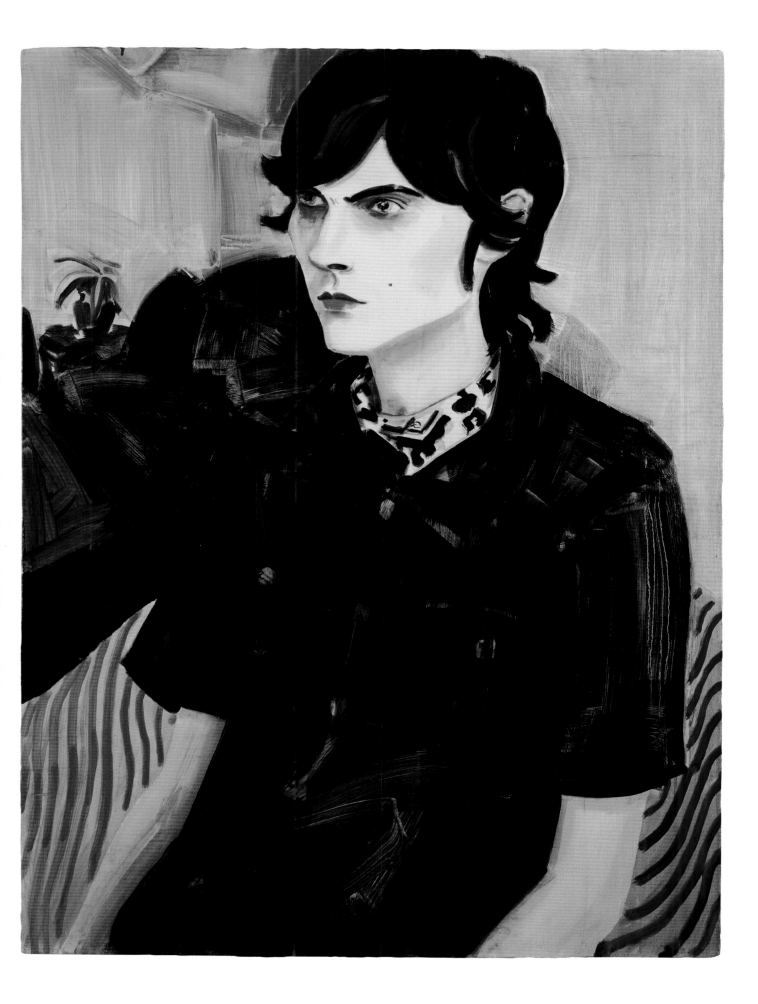

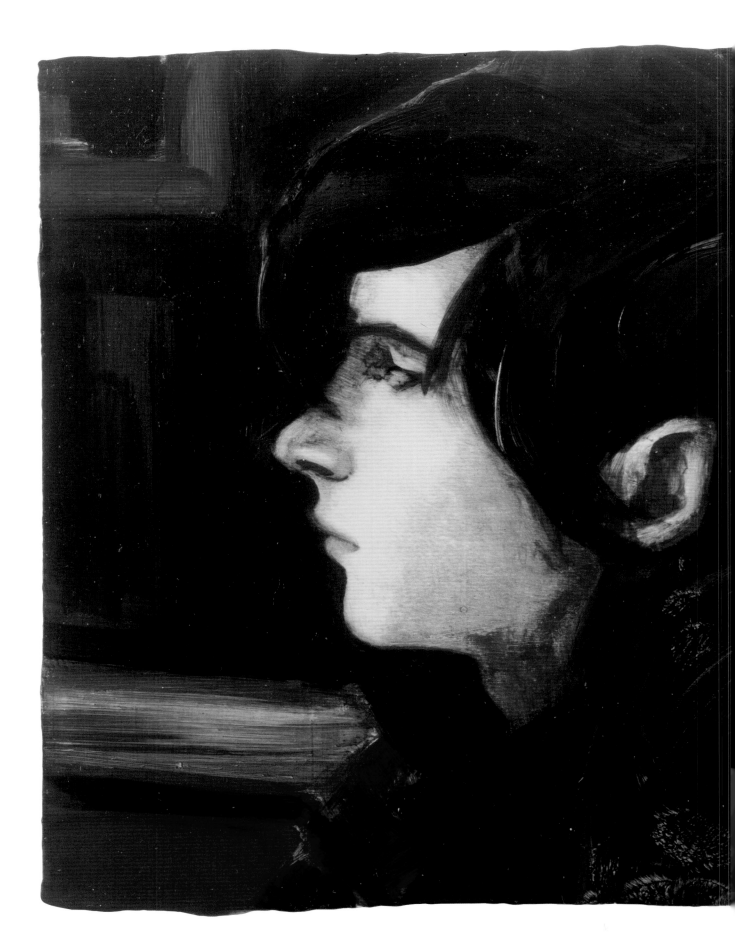

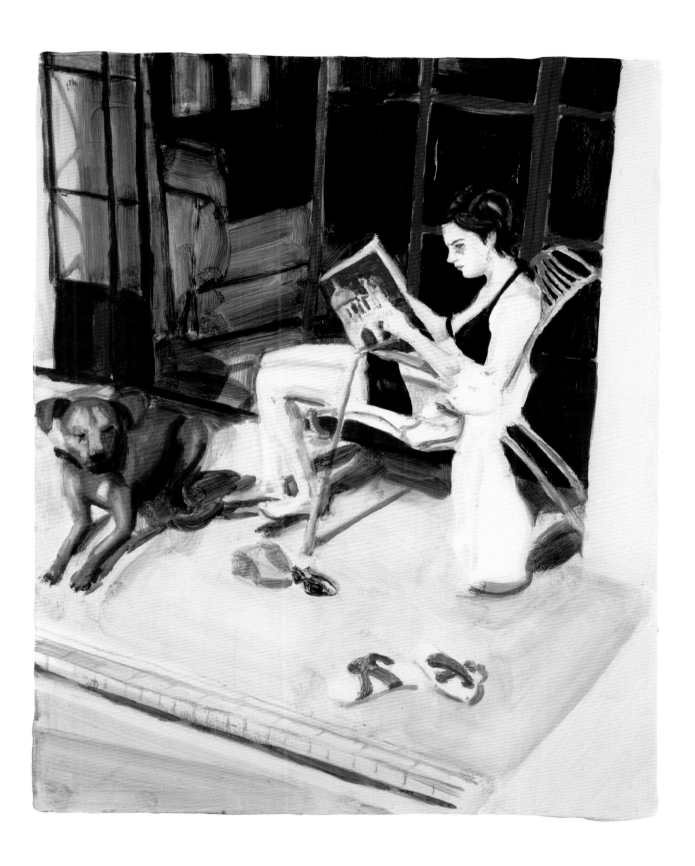

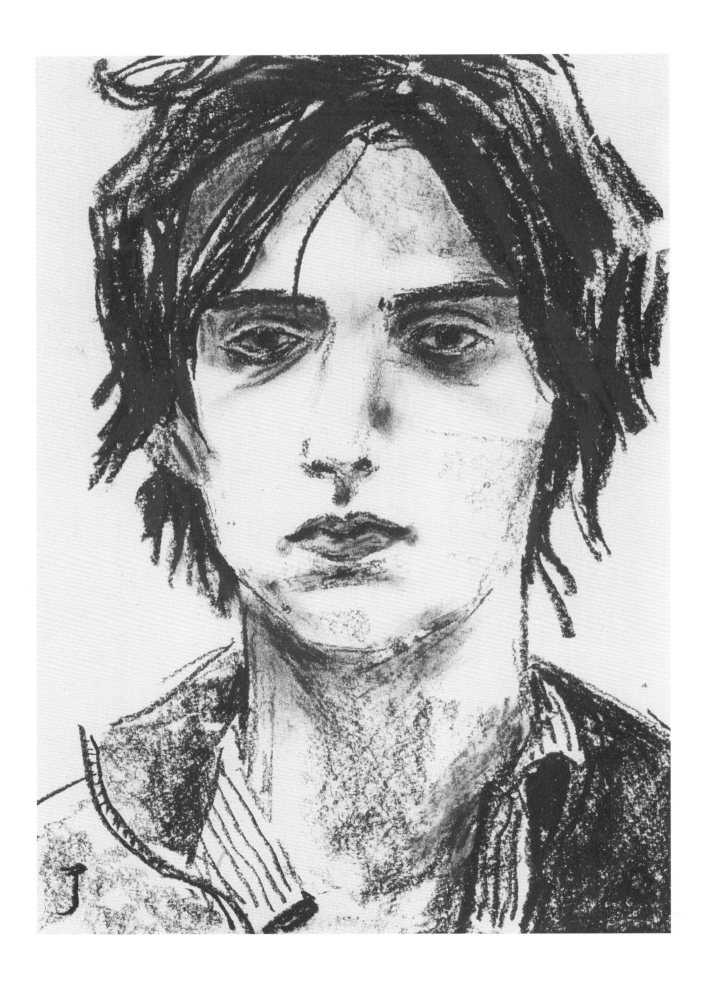

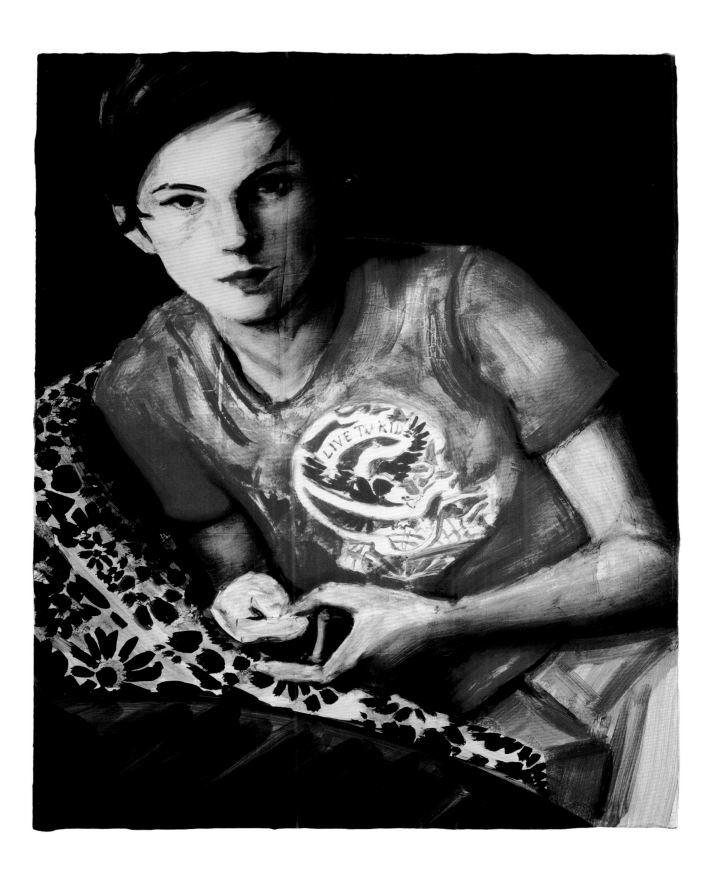

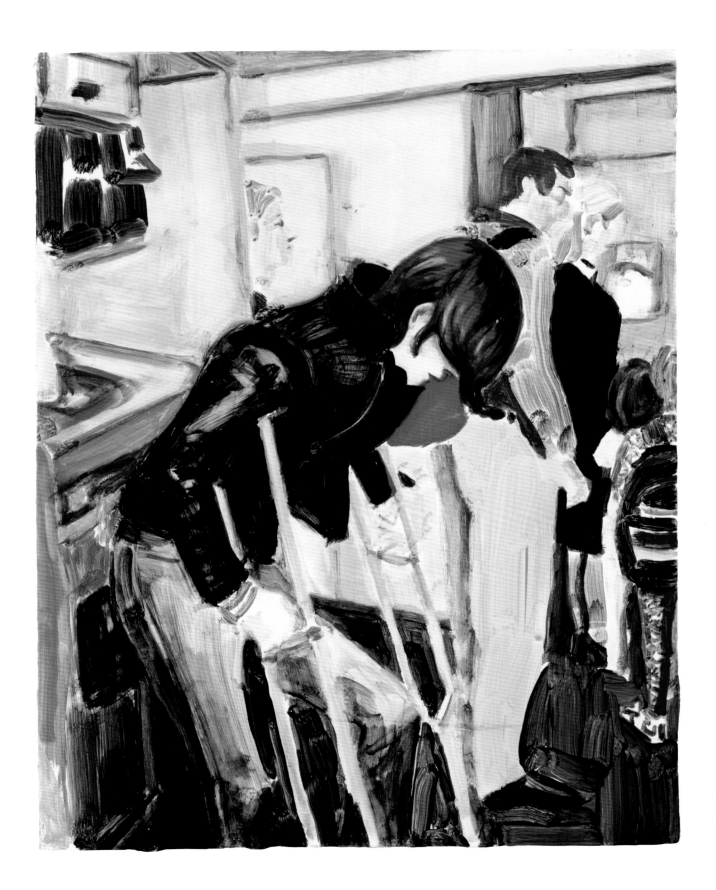

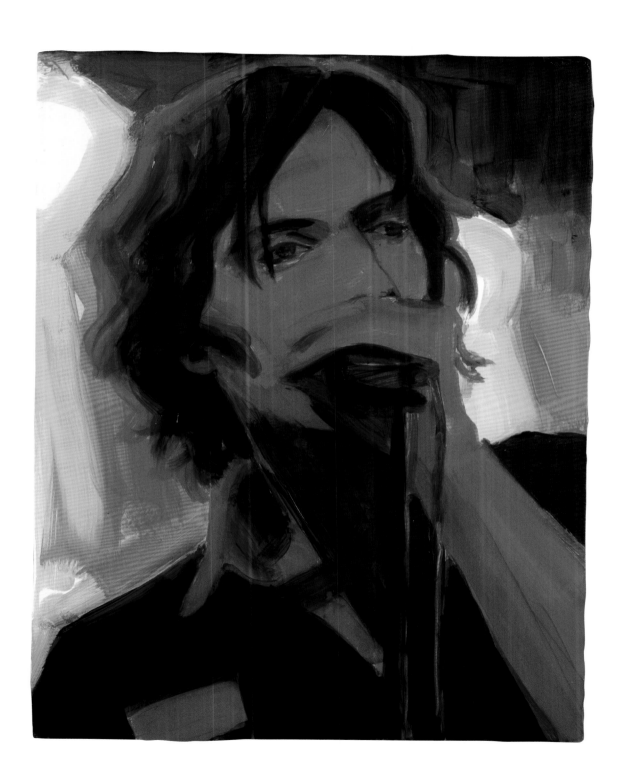

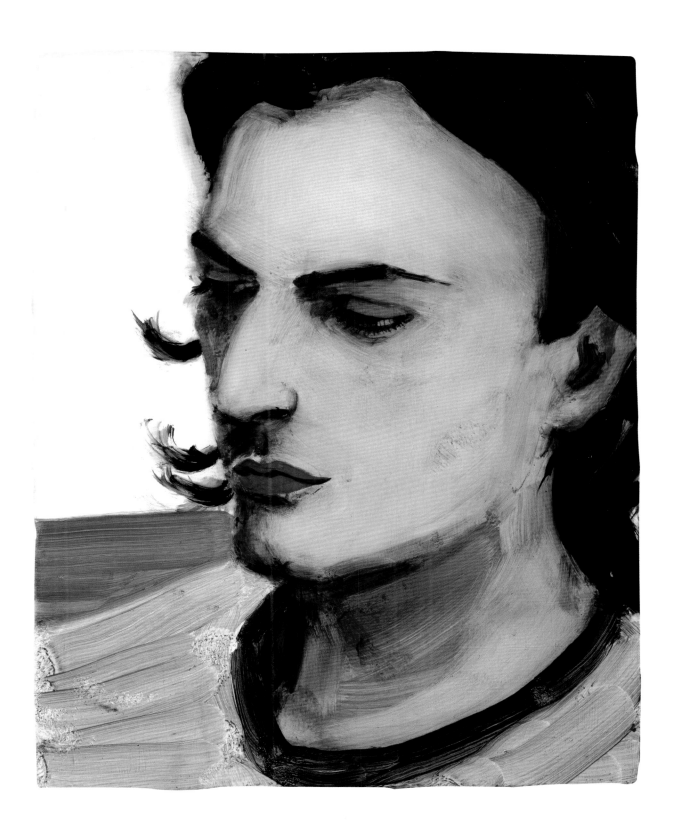

WALT

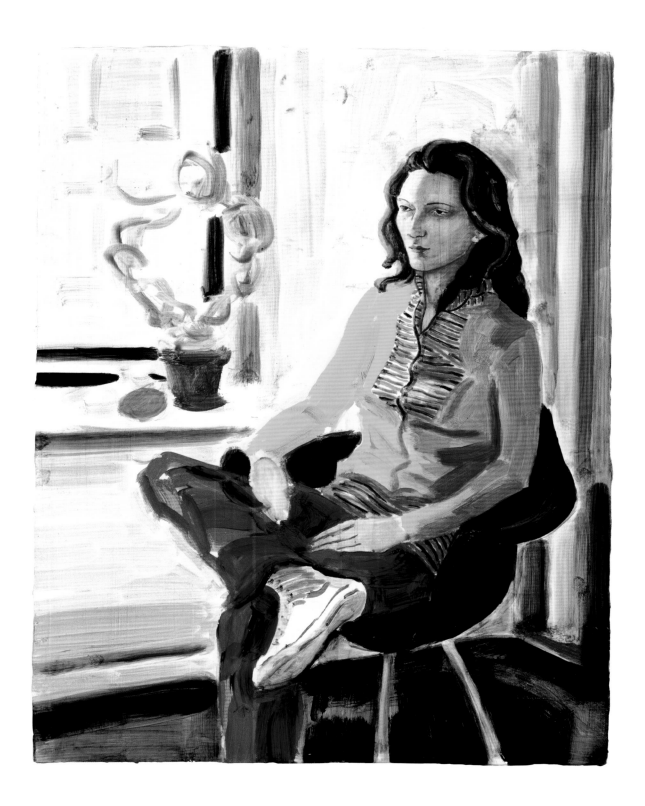

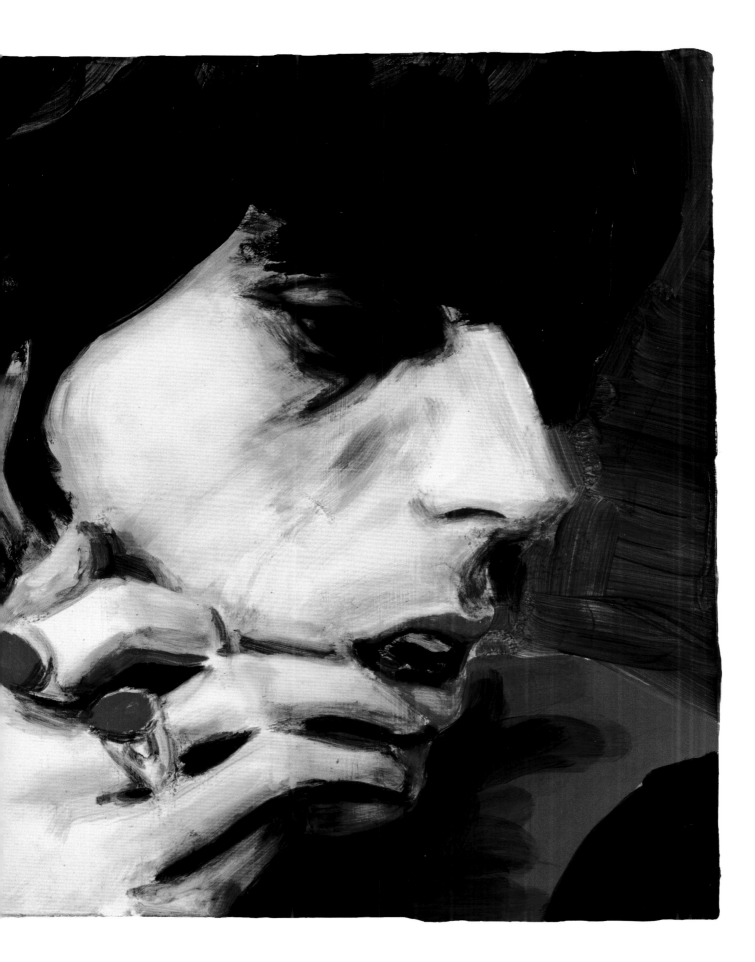

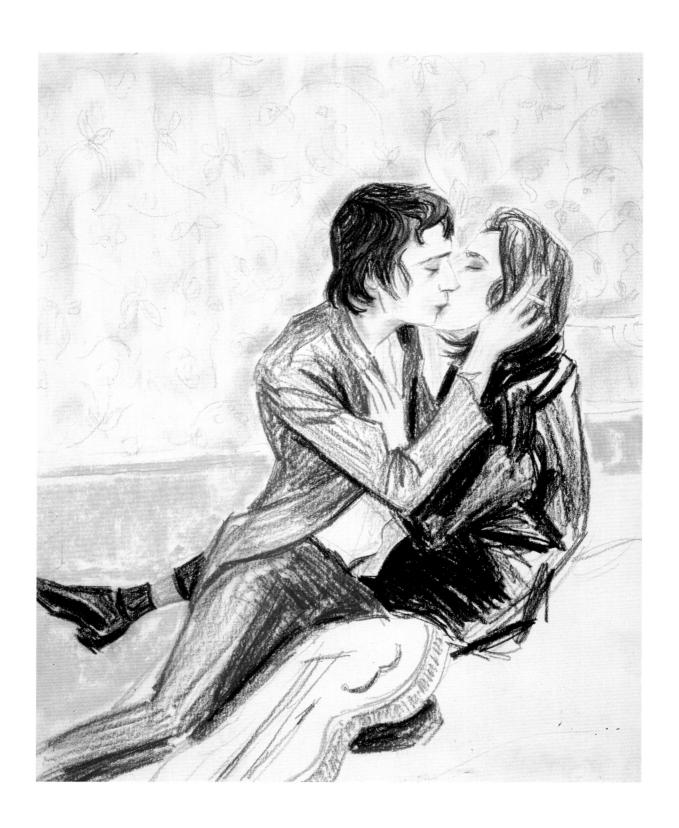

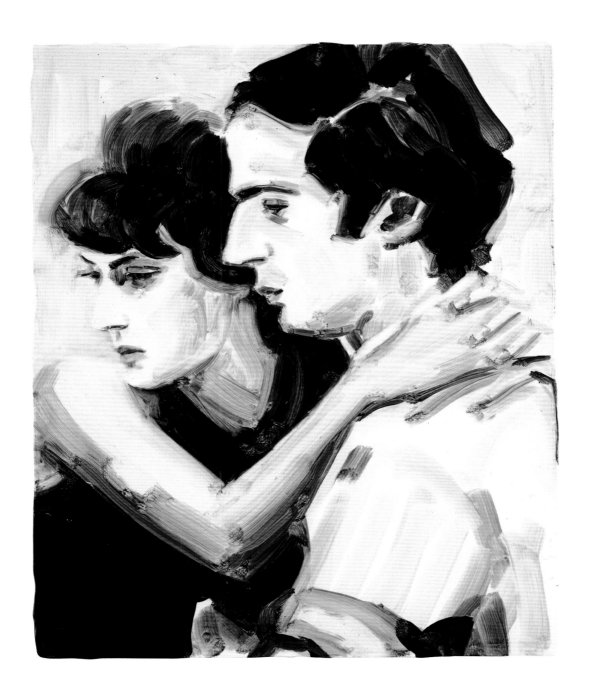

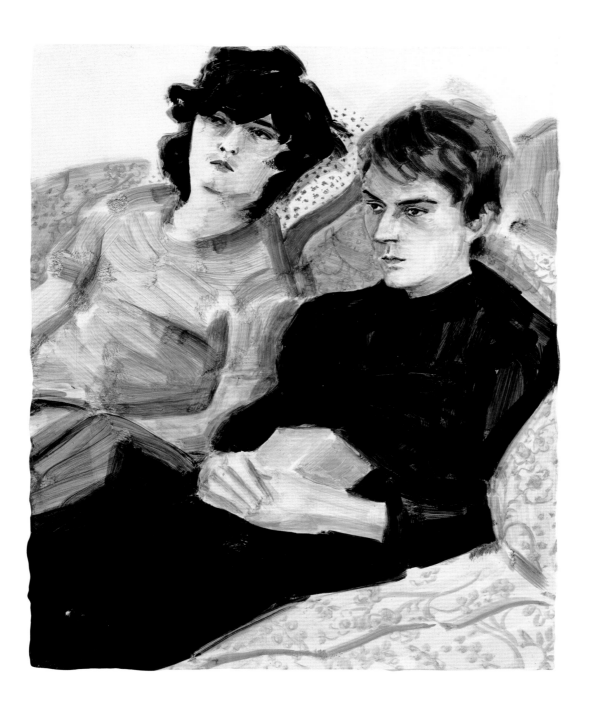

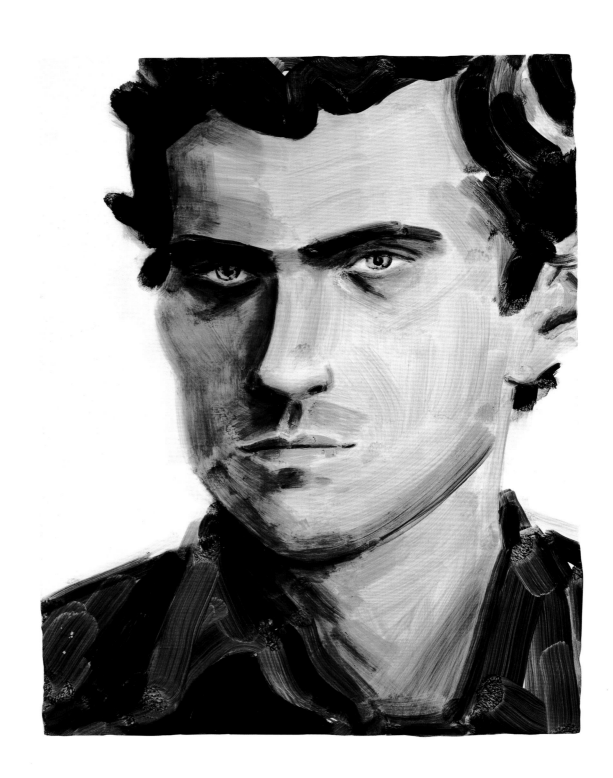

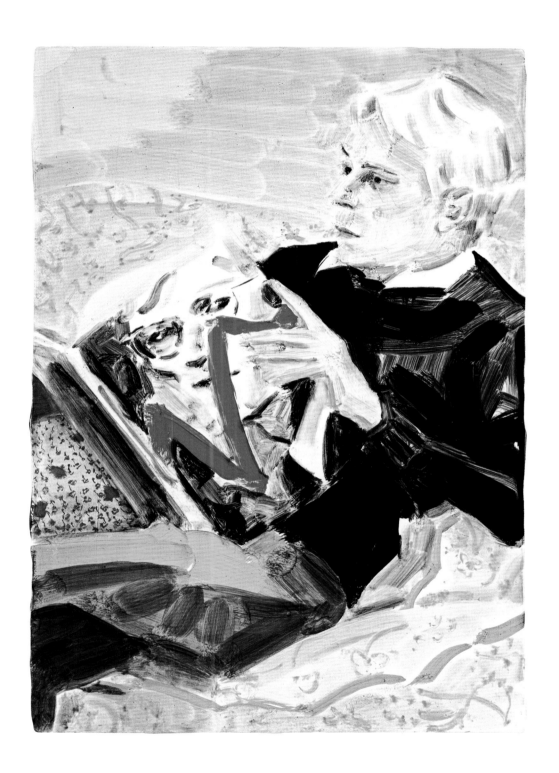

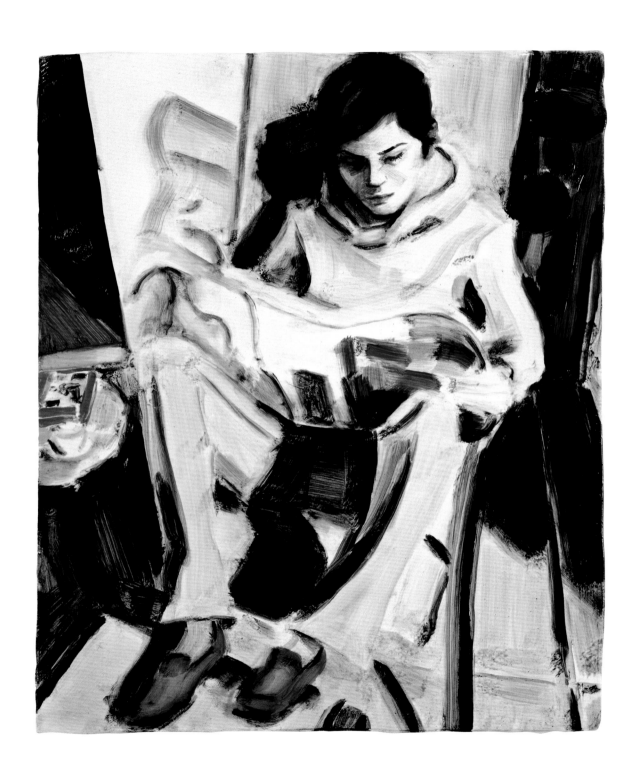

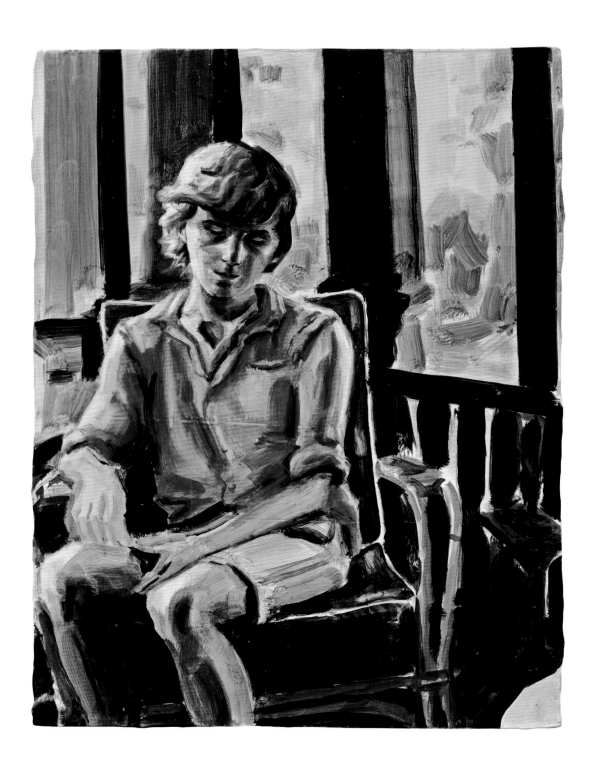

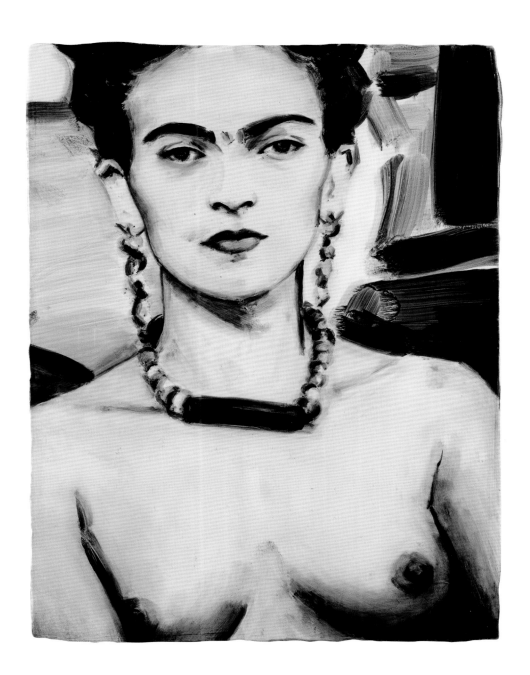

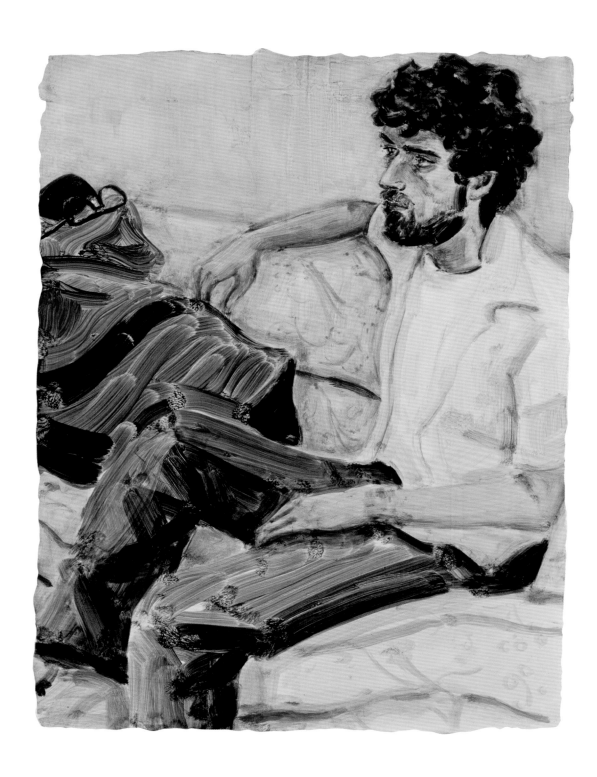

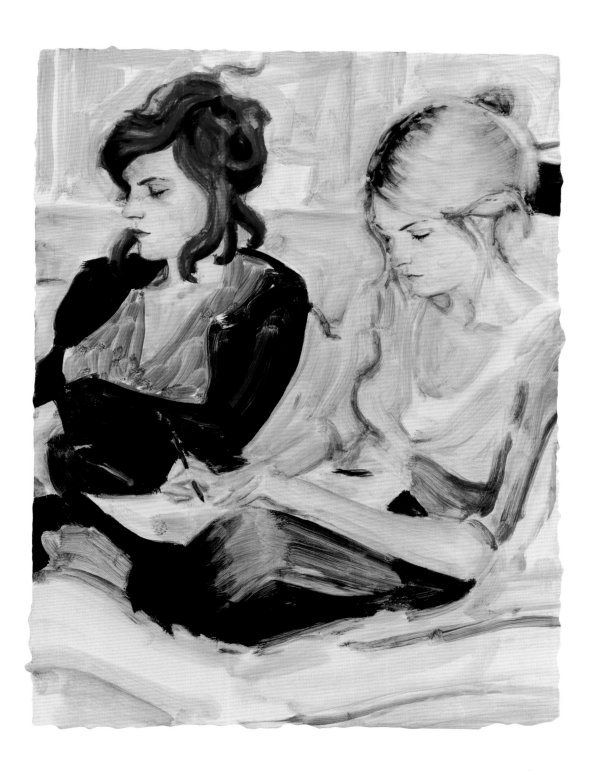

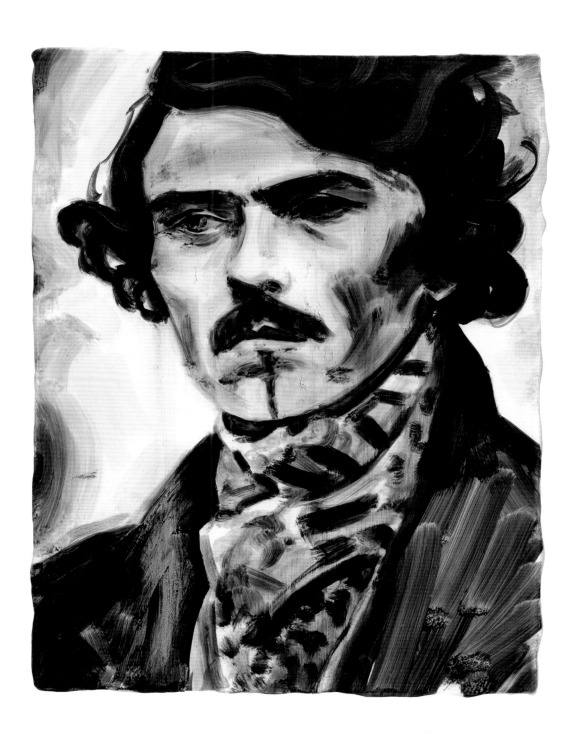

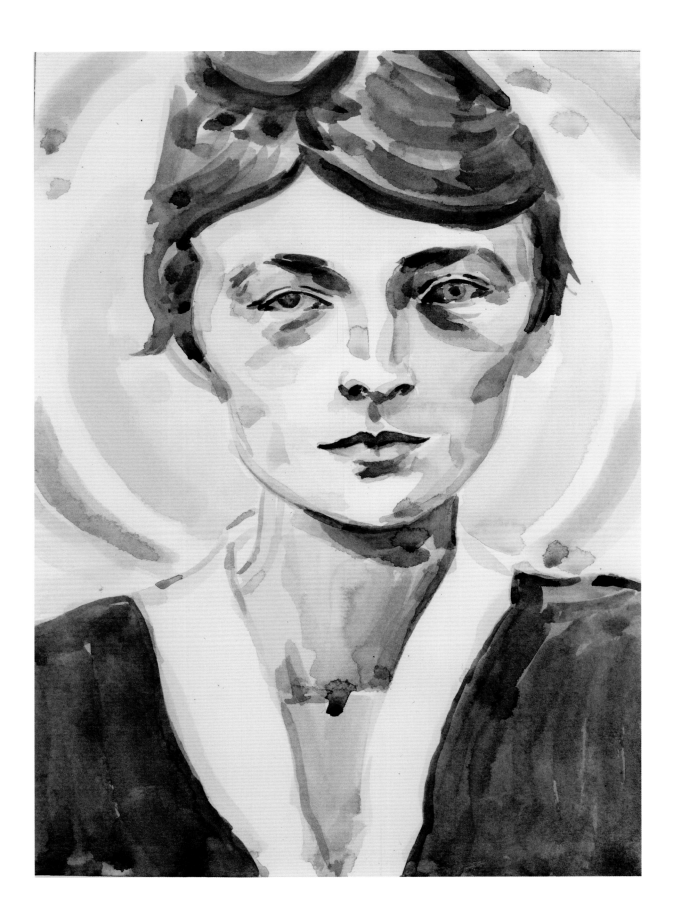

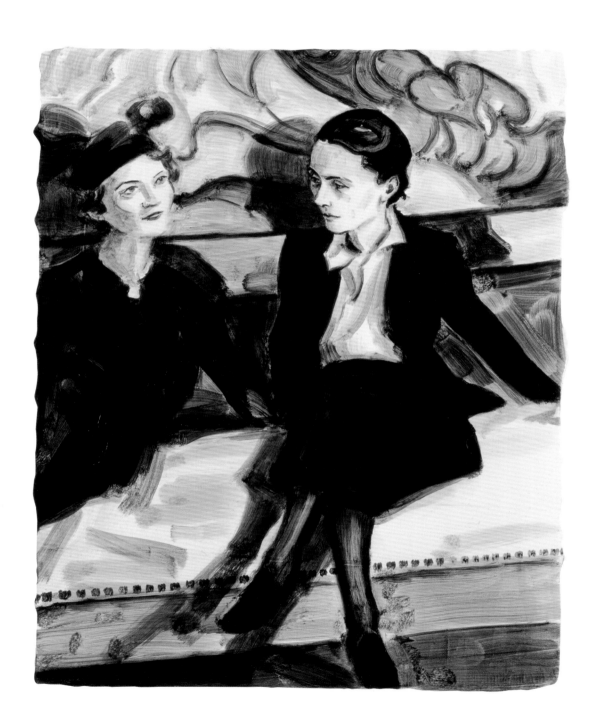

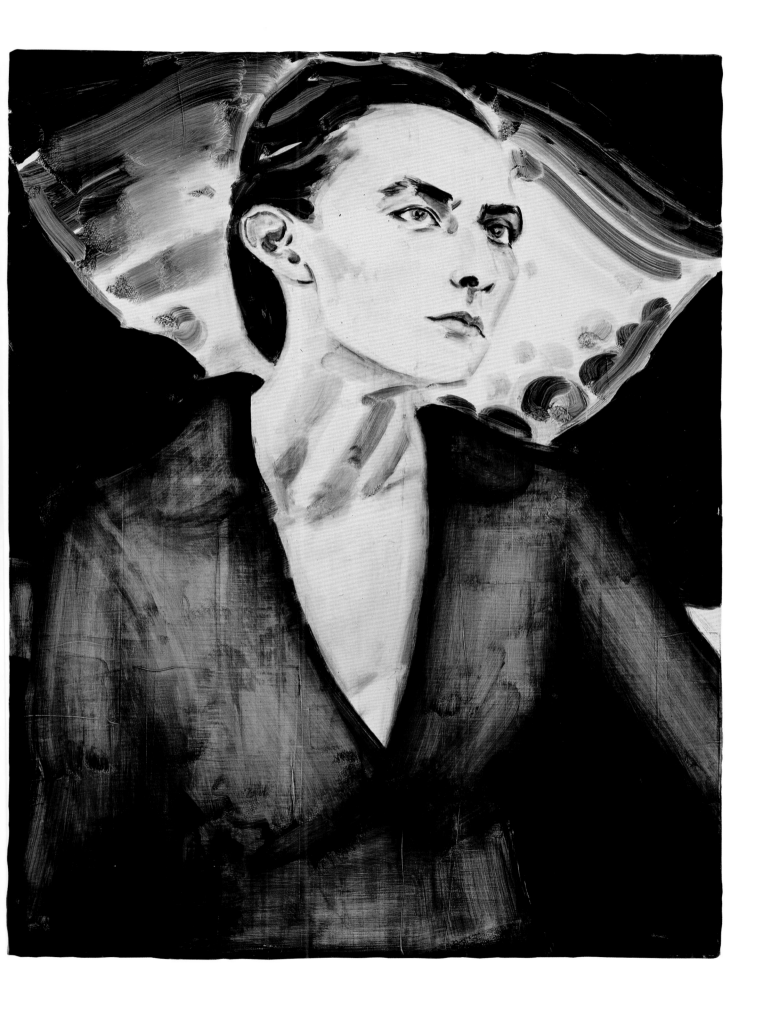

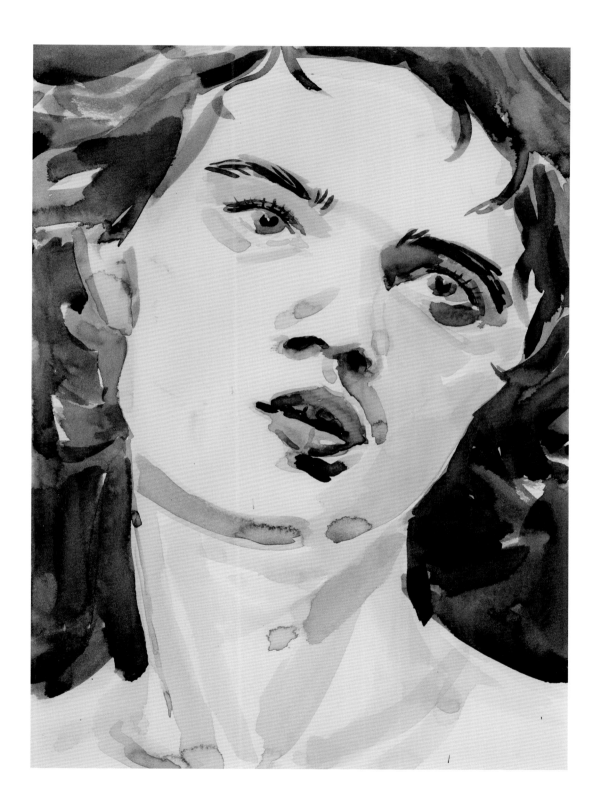

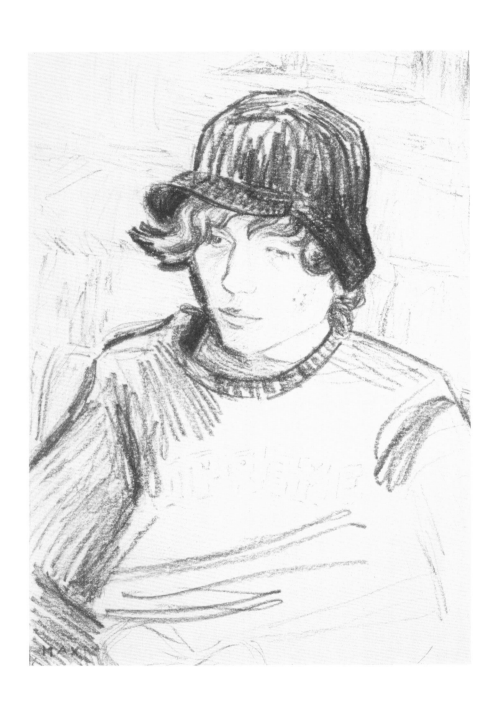

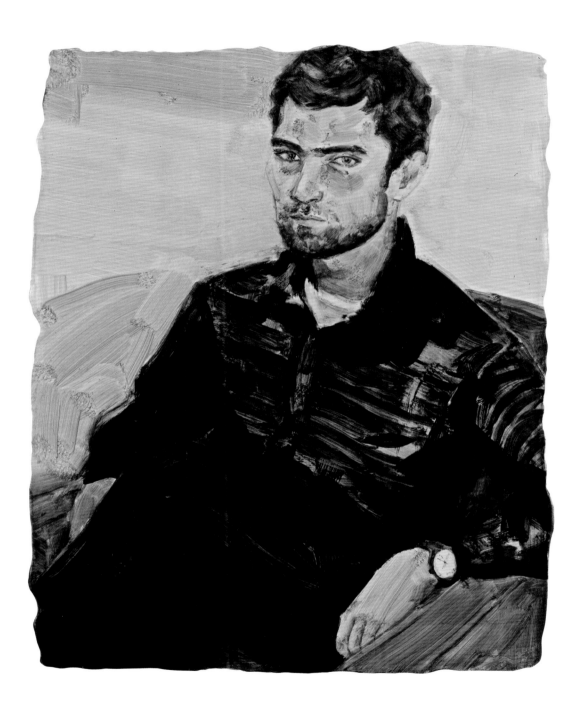

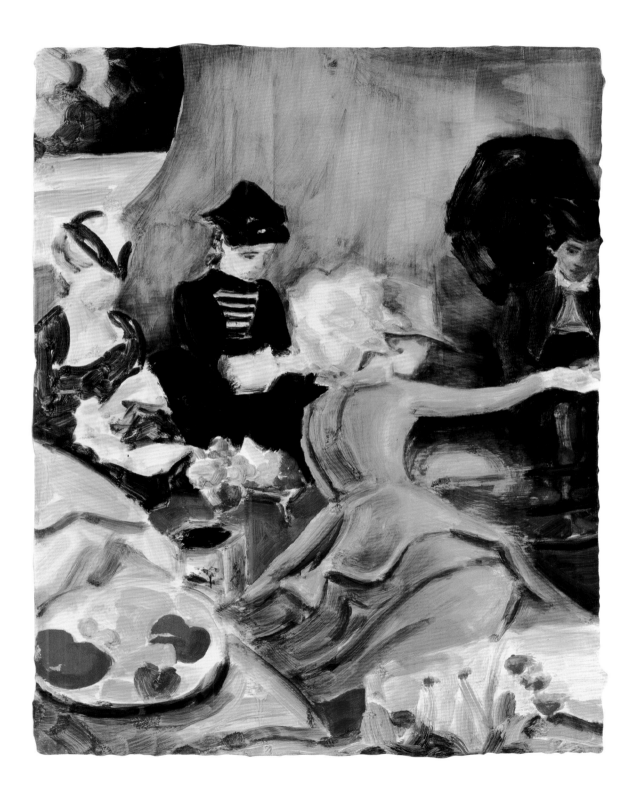

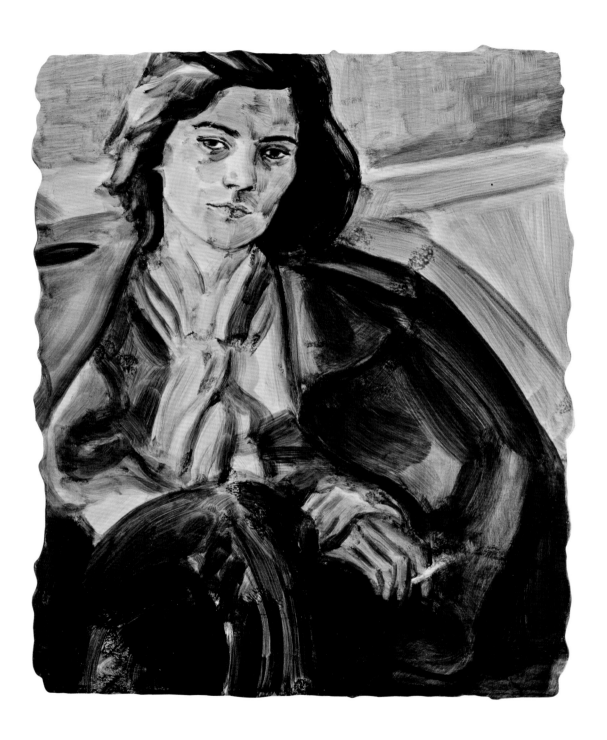

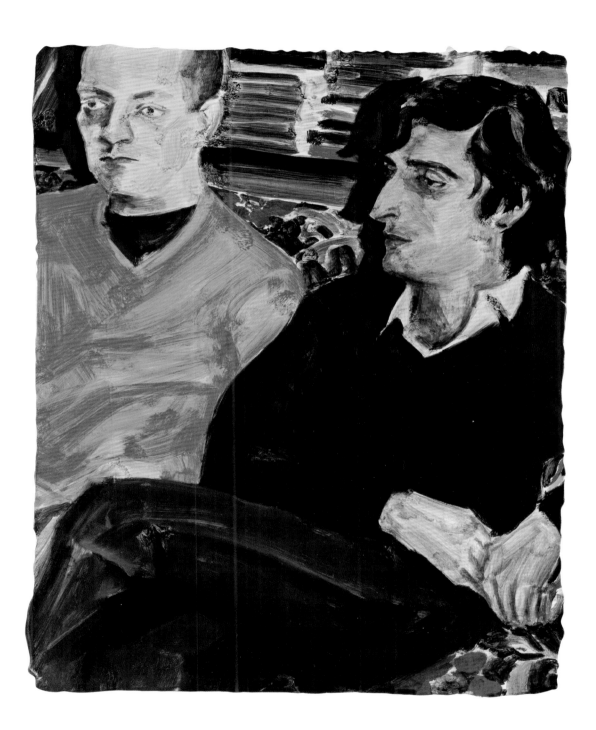

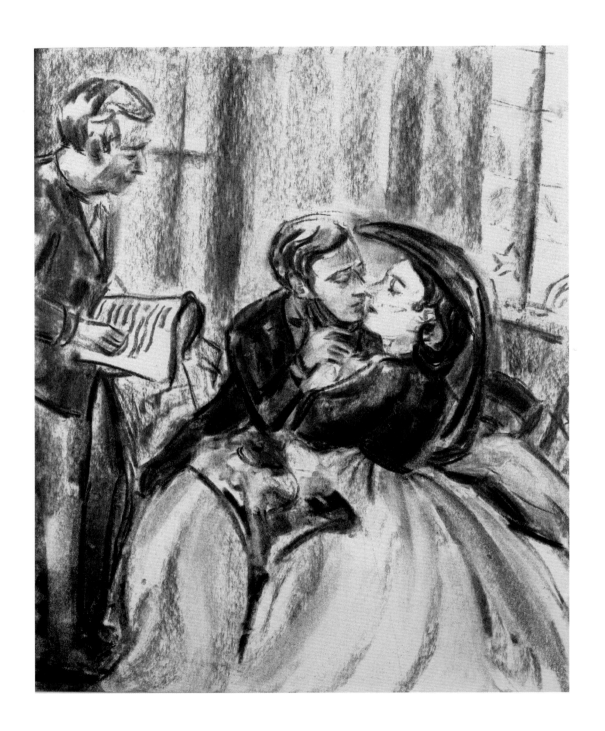

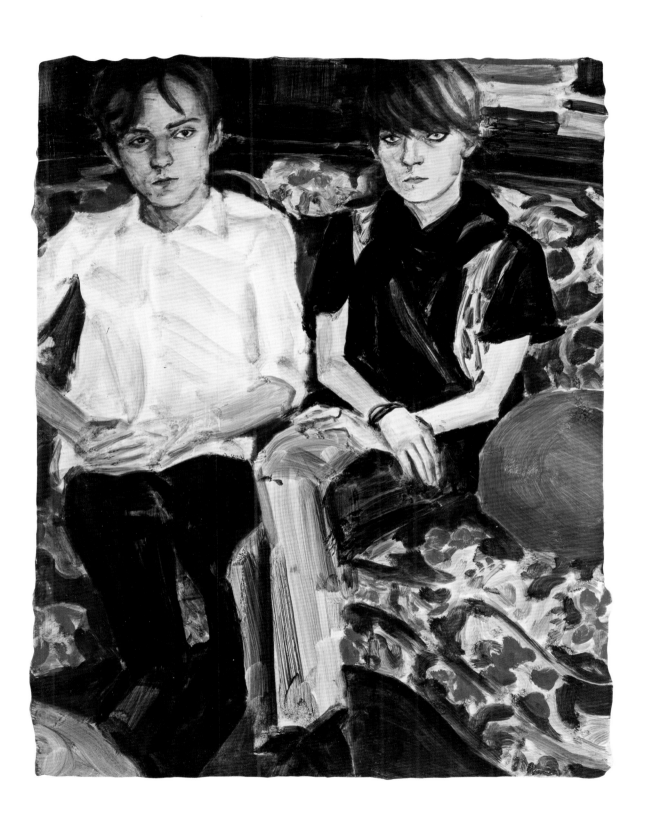

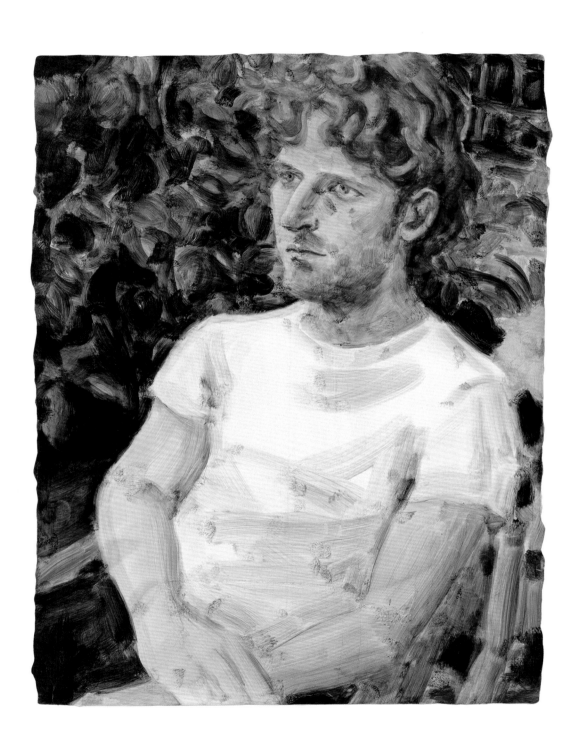

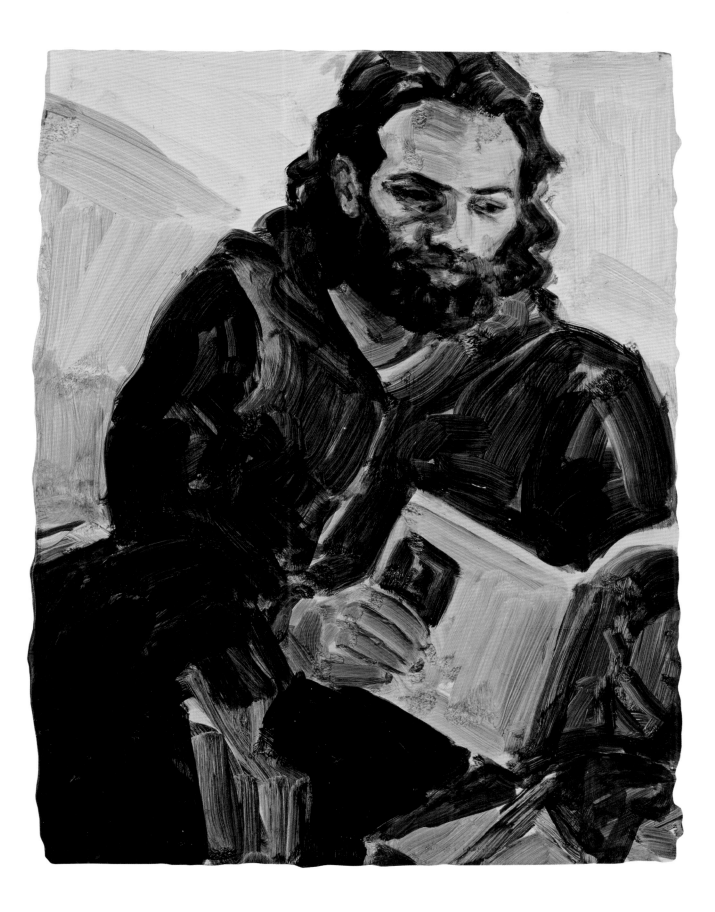

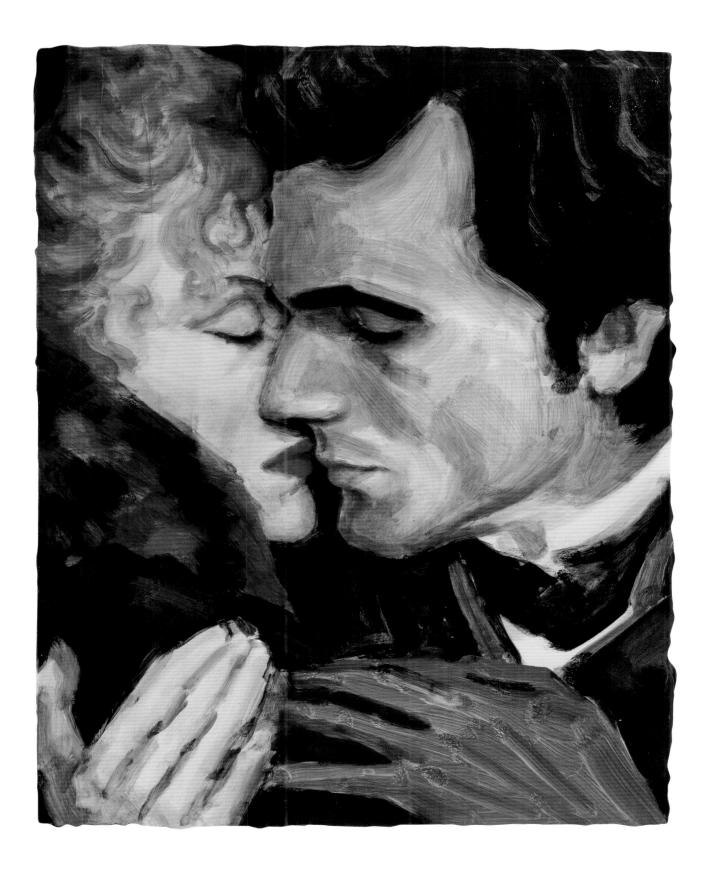

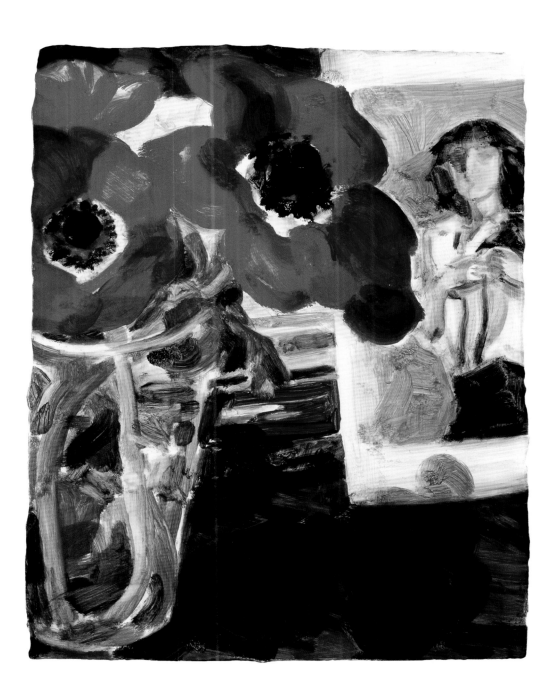

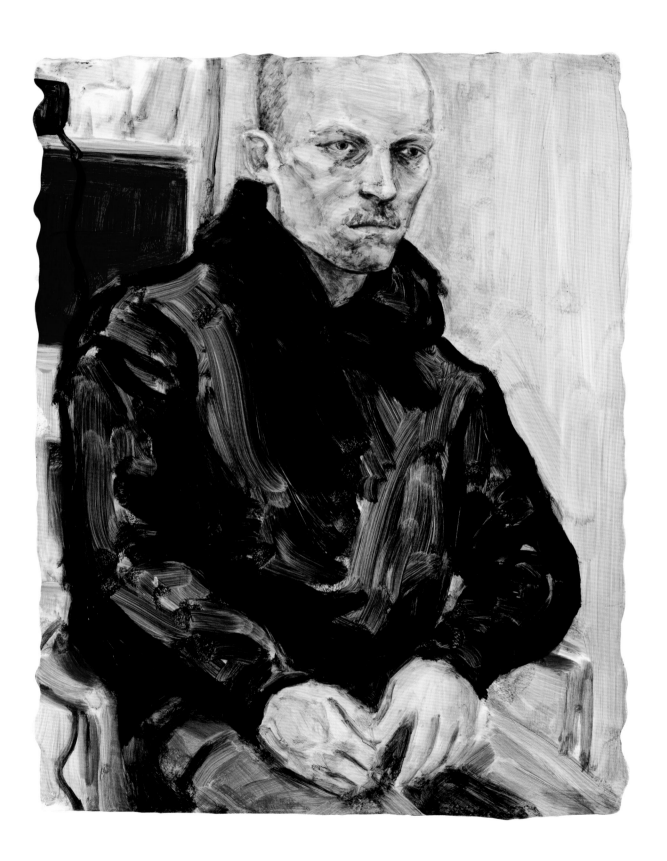

Fin
de
Siècle

Laura Hoptman

This exhibition and the publication that accompanies it are as much about an artist, Elizabeth Peyton, as they are about an era. Although it began in the early to mid-1990s, it is difficult to pinpoint when this era ended; all that can be conclusively said is that it is definitely over. Peyton's work, though, endures, and to this day it continues to speak to us in the present tense.

One of the extraordinary things about Peyton's oeuvre is that it can serve as a chronicle of a particular period — at a certain moment in the history of culture in certain places among a few people who were enthusiastically making it. Sometimes they knew each other; sometimes they were just mutual fans. In retrospect, her paintings have become a kind of essence of a fifteen-year period in popular culture, something like a complicated perfume that retains the sensory grace notes of a hundred different exquisite elements, but on its own is distinct.

If that period in a certain slice of culture in the United States, as well as in cities like London and Berlin, is gone on the streets and in the galleries, it remains forever fresh in her paintings. Despite their myriad references to art history, they have never coaxed us into nostalgia, and even now, looking at a 1995 portrait of Kurt Cobain, we can feel a mix of rue, admiration, and sentiment, not as a memory, but again as if the picture were painted yesterday. This feeling is similar to listening to a great song recorded decades ago; it still does what it set out to do, even if it is so familiar as to be emblematic.

Peyton's paintings were seen by a relatively small but influential audience in 1995, the year of her first substantial exhibition in a commercial gallery in New York; since that time, her paintings, drawings, watercolors, and prints have been exhibited annually in either New York, Los Angeles, London, Berlin, or other major capitals across Europe, the U.S., and Asia. The regularity of her exhibition record has allowed interested viewers to follow her work closely and comprehensively. What is revealed when the work is seen in toto is an astonishing consistency of technique, of subject, and of purpose. From her first exhibition, this artist seems to have emerged in full possession of her faculties, with a project to capture in portraiture individuals in whom she discerns a magical quality — an indescribable mixture of romanticism, beauty, grace, creativity, innocence, sexuality, "zazz." She found her preferred medium early — oil on board mounted on a frame of about a quarter of an inch thick — and she has rarely deviated from these materials, or from her paintings' small size (most are around eleven by fourteen inches). From the beginning, her source materials were photographs that she found or snapped herself, as well as film, video, and stills.

By the mid-1990s she began to sketch from life, but the difference it made in the look of her paintings is subtle, almost negligible; all the work retains a mixture of intimacy and stylization whether it was painted from photographs or from life.

In the very contemporary art world, fifteen years is a long time to be at the center of a discourse. Peyton was not the only figurative painter to attract attention and controversy during this time, but her work arguably attracted more attention and more controversy than most others, at least during the first ten years of her career. It did this because it was and is the most radical example of a particular kind of popular realism that emerged in the 1990s and reached its apex during the first few years of the new millennium. Her paintings are also the most appealing, a characteristic that made them all the more problematic, emerging as they did in a period when many critics and institutions were suspicious enough of visual pleasure to have written it out of the aesthetic conversation.

Elizabeth Peyton
Gavin Brown February 2007
2007
Oil on board
11 3/4 × 9 in (29.8 × 22.9 cm)

Looking back, there is no doubt that the creation and reception of Peyton's paintings in the 1990s utterly changed the contemporary art landscape in New York, and perhaps in London and Berlin as well. Mapping out how much has changed since that time and considering the repercussions of that change are crucial not only to begin the task of making a history of our last fin de siècle, but to begin the work of forging an understanding of the start of our new century. Considering her paintings in the light of their origins offers us the possibility to do both of these things.

It is a truism that figurative painting has never left the contemporary art discourse, but it is also fair to say that at the beginning of the 1990s it was not central to the art conversation at the cutting edge, in criticism, in galleries, and especially in museums of

contemporary art, except in a highly ironized form. Critical and institutional taste in the early 1990s was built upon premises of anti-visuality, even though contemporary artists — not necessarily painters — were trying to find their way out of the deserts of cynical, endgame Conceptualism. Benjamin Buchloh's "Refuse and Refuge" (1993), an essay on the work of Gabriel Orozco, laid out the strategy that anti-object types would use to pump new life into the tired hard-line of doctrinaire Conceptualism. As made clear by Orozco's photographs and arrangements of tweaked found objects, Conceptualism at that moment had quietly been replaced by an adamantly material kind of sculptural work that hid under a veneer of Conceptualism, a bloody, beating heart of ecstatic visuality that included super-sophisticated graphic composition, gorgeous materials, and the irresistibility of serial repetition. Artists like Orozco, Mona Hatoum, and Felix Gonzalez-Torres were in the business of making lovely objects that metaphorically referred to highly politicized concepts. The elliptical narrative, formal elegance, and politically charged back story accompanying their works acknowledged the post-Minimalism of artists whose goal was to dematerialize the art object, with objects that could be produced in editions of five. Thus, anti-commodity cake was had, and eaten too.

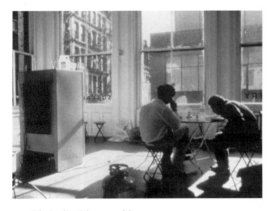

Rirkrit Tiravanija
Untitled (Free) 1992
1992
Installation, 303 Gallery, New York

Although New York has been developing (or devolving) into an elite playground for the wealthy shopper for more than twenty-five years, lower Manhattan, and many parts of north Brooklyn, definitively kissed their own bohemian asses goodbye in the 1990s. After slumping in the early 1990s, from 1995 to 2007 real-estate prices rose a stunning 245 percent and rents a "mere" eighty-seven percent. Tuition at NYU's Tisch School of the Arts hit $32,000 per year (a hundred percent increase over a twelve year period), while at the same time NYU became the most popular school in the nation for graduating seniors. After a precipitous decline beginning in 1989, the contemporary art market began its

swift ascent around 1996, creating a bubble that, at this writing, is at its most swollen, with European and American figurative painters riding its crest.

At the very beginning of the 1990s though, New York was in a recession, real-estate prices were at a pause after the go-go 1980s, and the art market was definitely in the deep doldrums. This is where Peyton comes in, as do her then-husband Rirkrit Tiravanija, her friend the art dealer Gavin Brown, and, peripherally, me. Because I lived through the 1990s as a participant in the artistic discourse, this narrative can only be somewhat of a personal take on a small portion of the activities that took place at the time. I offer it, though, as history, with its biases and parameters made as apparent as possible.

By 1991, Tiravanija's truly conceptual notion of staging social events in cultural spaces like not-for-profits and galleries had begun to receive serious attention in magazines, galleries, and also in museums outside New York. The work has superficial connections to the narrative-Conceptualist crowd, but with his emphasis on the participatory, he created something new that would come to be called "relational aesthetics," a term coined by the French critic Nicolas Bourriaud in his 1998 book of the same title. In that book, Bourriaud defined a kind of Conceptualism that was audience-oriented to the point of being audience-inclusive and, most importantly, militated against the distrust and cynicism that surrounded the act of making and viewing art. A hallmark of Tiravanija's work has been its collaborative nature, not only with fellow relational aestheticians like Philippe Parreno, Liam Gillick, and Pierre Huyghe, but with those with whom he shared time and ideas. These artists included Gabriel Orozco, Maurizio Cattelan, and Elizabeth Peyton. There is a deep connection between Tiravanija's work and Peyton's that has heretofore remained unexamined. Although not immediately apparent, Tiravanija's work relates to her paintings, albeit in an oblique way, through its emphasis on audience reception as an integral part of a contemporary work of art.

Beginning with his earliest activities Tiravanija was reenacting a fundamentally Duchampian struggle with the readymade as channeled through a better-man-than-Warhol desire to engage art with a much broader community that included artists, spectators, and passers-by. During 1991 and 1992, in situations like the *Water Bar*, a series of one-night-only exhibitions held in various commercial galleries including 303, Randy Alexander, and Jack Tilton, as well as not-for-profit venues, Tiravanija organized social interactions such as meals, drinks parties, and a dance, for a growing coterie

of friends, friends of friends, and even strangers. Inspired by Gordon Matta-Clar Food cafeteria, by Andy Warhol's Factory by humanism, Buddhism, and the plain ol desire to connect, Tiravanija's mediums a well as his grand themes were one and the same: love and community. Although her medium could not be more different, these are Peyton's grand themes as well. Community, for both Tiravanija and Peyto is a rich and complicated notion. On the one hand, it signifies the stuff of the work itself, a very Warholian notion, as, in both Tiravanija's and Peyton's cases, the comm nity in question is largely an orchestrated one filled with carefully chosen participan Tiravanija, describing the medium of his installations, goes so far as to list "lots of people" along with wood, clothes, and foo and although there is often a large elemen of chance involved in the makeup of the participants, they are most often members of the artistic community, whether artists, spectators, or students. Community for Peyton is comprised of the subjects of her portraits. Although many are people she h never met, by painting them she brings the into her orbit, even consummates a dialog — imaginary or not — with them. Thus, in fifteen years of pictures, Peyton can count as members of her closest coterie Napolec and Gavin Brown, Kurt Cobain and Piotr Uklanski, Maurizio Cattelan and Jarvis Cocker, Sharon Lockhart and Queen Elizabeth II, Tony Just and John Kerry, David Hockney and Oscar Wilde, Marc Jacobs and Georgia O'Keeffe, among many others.

On the other hand, both Tiravanija's activities and Peyton's paintings are also made to be experienced by a much larger community, one composed, in his case, of curious or hungry passers-by, and in hers any of us who recognize and/or relate to h young, beautiful, and luminous subjects. For both, their desire for community can b linked to a very contemporary notion of popularity. For Tiravanija this might mean an ever-growing circle of acquaintances emanating from an international nexus of art-world friends. For Peyton, though, it means the kind of mass recognition that c create an emperor or a superstar. Whethe not she dreams, like Warhol, of the transfo mation of her style into a logo (which I beli she does not), since her first exhibition sh has endeavored to position her work in su a way that it remains accessible to a large a not necessarily art-oriented constituency

I met Tiravanija in the late 1980s when I saw, and memorably participated in, a wor by him staged at a non-profit gallery in Lov Manhattan. Peyton I met in 1991 through t painter Verne Dawson,[1] and it was then th I began to follow her work, over the years writing about it, including it in exhibitions

d acquiring it for museum collections.
that time, Tiravanija and Peyton had
eady befriended Gavin Brown, an artist
d budding art dealer who was working at
Gallery, which Tiravanija joined around
t time. By 1994 Brown had opened his first
w York gallery in a small storefront about
far west on Broome Street as you could
. Peyton was among the founding artists
resented; Tiravanija left 303 to join Brown
years later. This choice of a marginally
ripheral location, just far enough from the
er important contemporary galleries to
inconvenient, would become a pattern;
m Broome, Brown would move to the
-quite-Chelsea address of West 15th
eet. Presently, his gallery is in the far
st Village, an outpost in an area that has
w attracted five or six galleries that,
urally, arrived some time after he did.

Elizabeth Peyton
Exhibition view, Room 828, Hotel Chelsea
(Chelsea Hotel), New York, 1993

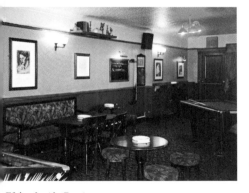

Elizabeth Peyton
Exhibition view, Prince Albert pub,
London, 1995

In addition to Peyton and the sculptural
o Jake and Dinos Chapman, Brown's
ble at the outset included a large number
ble figurative painters: Peter Doig, Chris Ofili
oth of whom he knew from his days in
ndon), Verne Dawson, and (within a year
opening) Laura Owens. What all these
inters seem to have in common is an exu-
rance, if not outright joy in their medium;
ermeates their palettes, and their una-
shed embrace of painterly cuisine. You
n see it in the gusto with which Owens and
li seize the decorative, and the way Doig
periments with five different techniques

of paint application in a single motif. You can
see it in their love of the sinuous serpentine
line and their fascination with the shocking
clarity of primitive draftsmanship, from cave
painting to Shaker design. The generosity,
vigor, lack of cynicism, and, okay, *love* that
emanated from the work of these painters
was palpable to anyone who managed to see
those early exhibitions of Doig (1994), Ofili
(1995), Dawson (1995), Owens (1997), and
of course Peyton (1995).[2]

By 1991 she had already hit on the seeds
of what would be her mature style; her first exhi-
bitions, as part of group shows in galleries
or, more interestingly, in alternative spaces
like the ladies room of a SoHo restaurant,
a rented room at the Hotel Chelsea, an
apartment in Cologne, and a pub in London,
featured images of historical figures like
Marie Antoinette and Napoleon Bonaparte,
and fictional ones like the actor Jean-Pierre
Léaud in the role of Antoine Doinel, as
well as intensely intimate portraits of those
closest to her. Some of the historical works
were clearly inspired by art-historical
precedents. As a freshly minted art-history
graduate student who had studied under the
great scholar of academic French painting
Robert Rosenblum, I recognized many of her
allusions and seized upon them with glee.
I remember one instance, early on, when I
excitedly talked at her about depictions of the
young Napoleon of 1799, the Baron Gros,
Jacques-Louis David, Arcole, and the Egyp-
tian campaign for some minutes before I
realized she was staring at me silently with a
quizzical look on her face. After concluding
my lecture with an offer to lend her the best
biography of Napoleon that had ever been
written, she politely declined, explaining that
she wasn't at all interested in Napoleon the
hero because her subject was Napoleon
the *human being*. Later, I found out from an
interview that Peyton was quite the scholar
of nineteenth-century painting, literature
(she professed a preference for Balzac),
and Napoleonic history. It was then that I
understood her interest in and knowledge of
history was a parallel but ultimately different
project than her depictions of historical
figures. It was her way of getting to know
her subjects better, not her way of selecting
them. Above and beyond the more obvious
patterns in her choice of subject matter —
that is, the overwhelming choice to depict
men over women, youth over age, as well as
royalty and those involved in the arts—other
thematic paths introduced early on continue
throughout her oeuvre. Mothers, fathers, and
sons, for example, appear with regularity,
from Sid Vicious and his mother (1995) to
Constance Wilde (wife of Oscar) and her
child (1996), to Elvis and his mother Gladys
(1997), to Jacqueline Kennedy and John John
(1999) to Max, son of Gavin Brown (1996, 2007),
and Prince Harry, son of Diana, Princess of

Wales (1997). Subjects, famous as well as
obscure, are often depicted during the first
flowering of their genius: Napoleon (1992) not
as Emperor of the French, but as a victorious
general of 1799; Princess Elizabeth (1993)
at the age of eighteen, nine years before she
acceded to the throne but just at the moment
when she took on the weight of her royal
responsibilities during World War II; Kurt
Cobain (1995) before worldwide fame, drugs,
and Courtney Love; Al Gore (2000) as an
idealistic young man of the post-Vietnam
era. Finally, these subjects are most often
depicted in contemplative, private moments
rather than active ones. Reading, sleeping, at
leisure on a sofa, a towel, or a deck chair, her
subjects have a self-contained absorption
that is mutually reinforced by the composi-
tional seamlessness, and indeed the almost
vacuum-like quiet of pictures that depict
their subjects as if they were details in the
larger fabric of the world outside the frame.

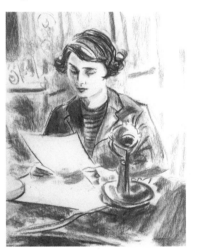

Elizabeth Peyton
Princess Elizabeth's First Radio Address
1993
Charcoal on paper
14 × 11 in (35.6 × 27.9 cm)

I fell incontrovertibly in love with Peyton's
paintings from the moment I first saw them,
not because of my background in nineteenth-
century French painting but because they
were, and are, ravishing, in style, in execution,
and in sentiment. They moved and continue
to move me in a way that forces me into
French; I am *boulversée* in the face of such
a gorgeous use of color and, later, pattern,
such languid, almost erotic brushstrokes
that slide the slick and shiny paint across the
hard Masonite surface, such winsome faces
masking wild romanticism, creative genius,
and utter decadence. As I wrote at the time,
it wasn't hard to self-diagnose; her paintings
triggered in me, and probably in many others,
classic Stendhal Syndrome: utter derange-
ment as a result of an excess of beauty.
Thankfully, in 1992 there were no emperors
to follow blindly in to a Russian Winter, and
much, much too little sensory enjoyment on
the walls of contemporary art venues in

New York, so I decided to take a page from psychiatrist-cum-social-philosopher Slavoj Žižek and "enjoy my symptom!"[3]

Although it might have been difficult to tell from the 1993 Whitney Biennial, which infamously contained a large amount of socially aware installation work, some cracks in the aesthetic of anti-visuality were beginning to appear, and not just in art studios. A second seminal text of the early 1990s was Dave Hickey's *The Invisible Dragon: Four Essays on Beauty* (1993), which contained a series of essays that pretty much outed beauty as the shared desideratum of artists and viewers alike. For Hickey, visual pleasure was a meeting point for art and life, and thus could do what narrative Conceptualism could, but in a more honest fashion.

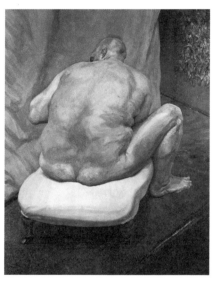

Lucian Freud
Naked Man, Back View
1991–92
Oil on canvas
72 1/4 × 54 1/8 in (183.5 × 137.5 cm)

Hickey gave political correctness a pass, and although he never prescribed narrative painting — or even painting itself — his eloquent writing gave people like me leave to revel in what seemed like revanchism. If you accepted Hickey's arguments, it was heady to believe in visuality again, to unashamedly embrace narrativity, to wallow in figuration, in oil paint. The book that followed, *Air Guitar* (1997), eloquently continued the fight for the triumph of precept over concept, and gave Hickey international cult status in art history programs everywhere — and to an extent, a position within the mainstream contemporary art discourse.

In retrospect, clues that sensibilities were ripe for change were apparent in the excitement caused by inspirational exhibitions of great figurative painters that appeared in New York museums when Peyton was at the School of Visual Arts at the end of the 1980s and in the first few years of the 1990s. At the end of 1986 the Whitney Museum of American Art mounted a

massively popular retrospective of the works of John Singer Sargent, and in 1988 Gustave Courbet had his first American retrospective at the Brooklyn Museum. 1993, the year of Peyton's first important solo show, was also the year of the Lucian Freud retrospective at the Metropolitan Museum of Art. Rather than annealing the great painter into the annals of the historical canon, this show seemed to propel Freud into the company of the youngest artists in the discourse. Scented by the still-wet paint on the newest pictures in the show (an unexpected effect in a venue like the Metropolitan), Freud's exhibition seemed decidedly more contemporary than the sublime but staid monochromes hanging in the Robert Ryman retrospective forty blocks down Fifth Avenue at the Museum of Modern Art. A similar zeitgeist test would occur in 1994 with the match-up of a Willem de Kooning retrospective at the Metropolitan and a Cy Twombly survey at the Modern. While it seemed that there wasn't a painter in town who wasn't talking about the raw, emotional muscle of de Kooning, few seemed to be dilating on Twombly's delicacies. With no critique implied of the organization of either exhibition, nor, in fact, of the genius of either artist, it seemed clear that at that moment we needed de Kooning's all-out painterliness over Twombly's cerebral restraint.

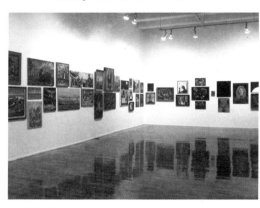

Jim Shaw
Exhibition view "Thrift Store Paintings," Metro Pictures, New York, 1991

Exhibitions in commercial galleries, too, pointed to a new sensibility. Karen Kilimnik had her first solo exhibition at 303 Gallery in 1991, and Nicole Eisenman began exhibiting her raw, Mexican-muralist/WPA-inspired paintings and drawings in group exhibitions in New York of this time. In late 1991, the Los Angeles artist Jim Shaw exhibited his extensive collection of paintings by amateur artists at the SoHo commercial gallery Metro Pictures. "Thrift Store Paintings" featured more than 100 works of self-taught art of all genres, from portraits to landscapes to fantasy pictures bought by the artist and arranged quasi-salon-style in the elegant white box of the gallery space. Vulnerable as

these anonymous works were to derision, en masse they came off as naïve but fresh, even at times wondrous affirmations of belief in the power of representational art t communicate simply, directly, viscerally.

Shaw's exhibition offered us a way to understand paintings like those of John Currin, who had already shown his portrait of yearbook girls to fanfare and controvers at White Columns in 1992 and subsequent at Andrea Rosen that same year. Currin's friends and classmates from the painting program at Yale — Sean Landers, Lisa Yuskavage, and Richard Phillips — were all painting figuratively in one form or another, and all had begun to exhibit in Ne York. Like Currin's paintings, the work of t group of artists had been received with the assumption that they were painting ironically. Currin's depictions of women in part cular were decried as misogynistic jokes; h couldn't be serious about the subject matt let alone the reactionary technique, which conjured Vargas girls and Norman Rockw in equal measure. What the "Thrift Store" paintings allowed us to see was that what might easily be read as an ironic appropria tion of kitsch aesthetics can just as easily b read as a sincere — if awkward — attempt a unmediated expression. What stylistically could be condemned as reactionary, could also be seen as strategically arrière-garde.

The return of figuration at the beginnin of the 1990s was a proof that diachronic notions of the "progress" of contemporary art since the advent of modernism were tru dead and buried, giving way to a more synchronic picture of artistic development Just as historical figures, outsiders, and non-Westerners could be rediscovered, reassessed, and reinserted in to an everricher artistic canon, styles, strategies and attitudes could reemerge and be relevant again but in an entirely different manner tha they had been heretofore. Contemporary figuration embraced illusionism, historicism, narrativity, and visual pleasure with unironic gusto. All complaints surroundin the medium of oil painting — its status as a commodity, or as a practice inherently anti progressive in both political and formal senses of the term — its pandering to popular, or worse, mass culture — were cast aside for the tired, outdated argument that they were. Willed or not, a certain inge nuousness marked contemporary figurativ painting of the period. And if it caused it to look a little stupid in comparison to some o the more theoretically hip Conceptual work that dominated institutional spaces at the time, then it was a refreshing, youthful, and optimistic stupidity that seemed to open th discourse to wider possibilities. To paraphrase Marcel Duchamp, at the time we all wanted to be stupid in precisely the way our new painters were.

Peyton's solo exhibition in room 828 at
ᵉ Hotel Chelsea in 1993 was a quiet but
soundingly successful debut. Included
ʳe seventeen drawings and watercolors of
bjects ranging from Princess Elizabeth II
ⁿ Napoleon to King Ludwig of Bavaria.
though she had made paintings of similar
bjects, Peyton chose to show only works
paper, which served to emphasize both
ᵉ modesty and the intimate nature of her
ʳctice. Some sketches were included —
pies of a detail from a van Dyck painting,
ʳ example — but most of the show con-
ᵗed of highly finished drawings, many of
ⁱch canted towards the illustrational.
retrospect, this exhibition can be seen as
ⁱnd of inauguration of a notable transition
ᵗhe field of contemporary drawing:
ᵉcting the previous emphasis on drawing
ᵃ process, contemporary artists began to
ᵒpt drawing as a primary means for public
ᵖression. Beginning in the late 1990s,
ᵃ narrative, figurative, illustrational kind of
ⁿtemporary drawing underwent a renais-
ⁿce in the studios, galleries, and muse-
ᵘs. Beginning, arguably, with Peyton's
ᵒtel Chelsea exhibition, figurative drawing
gan to be considered as central to the
ⁿtemporary art discourse, a position that
ᵃd not enjoyed for 100 years.

Elizabeth Peyton
Ludwig II of Bavaria
1994
Oil on board
17 × 12 in (35.6 × 27.9 cm)

Organized by Gavin Brown, who paid
ᵉ artist/critic Douglas Blau to write an
ᵉssay for the pamphlet that accompanied the
ᵒw, the Hotel Chelsea exhibition was not
ᵛiewed widely. Thanks to word of mouth,
ᵒugh, and probably the unconventional
ⁿue, enough artists and critics saw it to
courage genuine interest (as opposed
curiosity) in what seemed at the time to be
ᵗremely peculiar work. ⁴ If a context had
gun to be built for contemporary figura-
ⁿ, there was little precedent for contempo-
ʳy and sympathetic (!) renderings of

European royalty, past and present. Peyton's
works could be interpreted as reactionary on
the level of style as well as subject matter,
and yet it was undeniable that they seemed to
indicate a way, if not *up*, then *forward* in the
discourse, away from ironic appropriation,
sly conceptual pictorialism, and un-nuanced
identity politics. Interestingly, in the decade
after the definitive disintegration of conven-
tional notions of left and right in 1989 and
the ascendance in the U.S. and Britain of
smack-in-the-middle centrist politicians like
Bill Clinton and Tony Blair, the aesthetics
that had accrued to those positions had
begun to die as well. It seemed at the time
that gradually, then all of a sudden, artists
like Peyton stopped paying attention to
critical theory, if they ever had in the first
place; they threw away the suspicion of
images and seized — with alacrity — the
tools to make illusions again. This is not to
say that politics were ignored by Peyton and
the other young artists who were working
figuratively. The decision to exhibit works in
a hotel room — and several months later,
in a pub — clearly indicated a desire to reach
an audience outside of the art world. In
some cases her direct translation of popular-
culture images into oil paint pointed to a
more ambitious desire to breach a much
more sacred divide. As T. J. Clark observed
about the critical outrage ignited by the
exhibition of Gustave Courbet's *Burial at
Ornans* (1849–50), "the critics did not object
to the exploitation of popular art; on the
contrary, it was already accepted as a source
of imagery and inspiration, as one way to
revive the exhausted forms of high art. But
to adopt the procedures and even the values
of popular art — that was subversive."⁵
Like Courbet's "history" painting, which
featured the good and recognizable bourge-
oisies of the provinces posed in a composi-
tion snitched from a mass-marketed print,
Peyton's drawings and paintings proudly
and unironically lent the dignity of fine art
to her cast of mass-market heroes, however
discredited (Napoleon, Sid Vicious),
mocked (Marie Antoinette, Mad King
Ludwig, Lady Di), or excoriated (John
McEnroe, Lord Alfred Douglas).

These early drawings prickled and
sparked because they were figurative,
because they were heartfelt to the point of
ingenuousness, because they were politi-
cally incorrect in medium and in subject,
and because, in a Warholian, Tiravanijian
way, they reached out to a broader popular
public beyond the specificity of the New
York art world.

Peyton's work did have a proper art world
debut a little over a year later at Gavin Brown's
enterprise (GBE) on Broome Street in the
spring of 1995. That exhibition included only
paintings, most of which were of the rock star
Kurt Cobain, who had committed suicide the

year before. If the Hotel Chelsea exhibition
had been restrained in terms of color, the
Kurt paintings glowed with yellows (hair),
reds (jacket, lips), and blues (shirt, back-
ground) feelingly slathered on to the
Masonite surfaces that would become
Peyton's signature support. The Kurt of this
first series was recognizable as Kurt Cobain,
but he was not the same Kurt we knew
from MTV, the tabloids, or his recordings.
Peyton's Kurt was sleek, not scruffy, elegant,
gentle, and almost feminine. When the show
was reviewed, critics like Roberta Smith of
the *New York Times* saw allusions to a heady
mixture of precedents from banner periods
of narrative realism in the history of art: the
Pre-Raphaelites, Andy Warhol, and paint-
ings of pinups made by Walter Robinson and
shown at Metro Pictures in the early 1980s.
Mention was also made of Karen Kilimnik,
whose drawing of the celebrity model Kate
Moss was on the cover of the February 1994
Artforum. Contemporary references were
helpful in explaining Peyton's work in the
same way that art historical references were;
they gave precedents for some of Peyton's
subject matter, for her composition, for her
"crypto-reactionary" style, for her brush-
work, but not for the way all of these elements
coalesced to speak truth to power for the
cultural moment. Smith did identify Peyton's
work as an avatar for a new sensibility, one
that was "inherent in a lot of current work,"
but one which lacked a name. Smith called
it "realism" but then offered "emotionalism,"
a tag that was more accurate but ended up
not sticking. ⁶

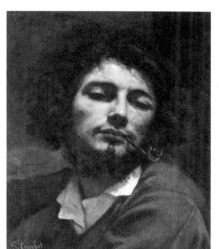

Gustave Courbet
Self-portrait, "Man with Pipe"
ca. 1849
Oil on canvas
17 × 14 1/2 in (45 × 37 cm)

Smith's encomium in the *Times* helped
establish Peyton as, at the very least, a
regional phenomenon. But the GBE exhibi-
tion was followed in short order by several
exhibitions abroad. Her first important
forays in Europe took place in Cologne and
London; both shows, notably, in spaces

that were not galleries. In Cologne, the art historian Burkhard Riemschneider organized an exhibition in his apartment. A year later when he and his partner Tim Neuger became early pioneers of the Berlin art scene, opening a gallery first in Charlottenberg and then in 1998 moving to the now-thriving gallery district in Mitte, Peyton was their only painter among a stable of artists associated with relational aesthetics, including Tiravanija, Jorge Pardo, and Tobias Rehberger.

Shortly after Cologne, Cabinet, an adventurous, experimental, and adamantly marginal gallery in London established by Martin McGeown and Andrew Wheatley in 1991, organized an exhibition of Peyton's work in the Prince Albert pub, not far from their small gallery space in the Brixton neighborhood in South London. By electing to exhibit works on paper and paintings of Marie Antoinette, John McEnroe, Sid Vicious, and Kurt Cobain in a bar in Brixton, a place dubbed by one British art magazine as the "least glamorous part of London," Peyton might have accidentally engineered a soft critical landing in a city notorious for its vicious critics, because the exhibition venue was considered so off the beaten track that even the events magazine *Time Out* refused to list it. The exhibition did receive a substantial review, however, in *Frieze*, then a new but increasingly influential art magazine. The reviewer, curator Gregor Muir, posed the question "Are these drawings for real?" and answered it with a moving argument for their relevance to the cultural moment in mid-1990s London. Through the grease and cigarette smoke of the Prince Albert, Muir observes, patrons "beautifully performing activities that are not worth doing" perfectly mimic what is going on in a picture like *Kurt Smoking* in 1992. Peyton's images of the charmed and the damned of yesterday and today, from Muir's point of view, stood for the "collective state of mind that we so desperately seek." The drinkers at the Prince Albert, like the critic, like all of us, were able to identify with the ability to invent "their reputations and the world around them," shared by all of Peyton's subjects, as well as by the artist herself. Hard as it was to believe at first, her drawings and paintings *were* for real, and she meant them as Muir recognized, as an offer of "escape from the reality of the Prince Albert" and a chance to "enter Peyton's near perfect world."[7] What Muir recognized in her work so early on was that it embodied the hopes and dreams of those who saw them, and those who saw them were not connoisseurs or movie stars, but regular people in a pub. The appeal of the paintings was straightforward, giving viewers a picture of our time, but also a picture of ourselves as reflected in the faces of our shared heroes.

Amidst a crop of paintings and drawings of Kurt Cobain, John Lydon, Ludwig II, and Queen Elizabeth, for her first show at GBE, Peyton exhibited a portrait of her fellow GBE artist Jake Chapman. Although she had produced paintings and drawings of Tiravanija and other friends and relatives, this was the first instance in which she exhibited a painting of someone who was not immediately recognizable to a general audience and, most significantly, who was not (yet) famous. With the addition of an artist from her immediate circle, at this early date she made a giant step towards redefining the aesthetics of her portraiture. As the critic Jerry Saltz pointed out some time later, her choice to use her contemporaries as subject matter removed the fantasy aspect from the entire project, and brought her work closer to realism. It also made her subjects more empathetic, and easier to relate to, whether they were the beloved Cobain or the testy McEnroe. Saltz was an exception, because most critics either ignored the inclusion of regular people in to Peyton's lexicon or acknowledged them, with a nod to Warhol, as proto-superstars in the artist's firmament. Either way, her work was (and is) still most often incorrectly described as a high-art form of extreme fandom.

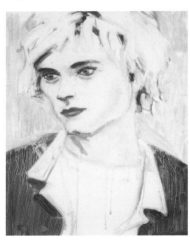

Elizabeth Peyton
Zoe's Kurt
1995
Oil on board
14 × 11 in (35.6 × 28 cm)

This might explain why until recently — perhaps the beginning of this new millennium — institutions like museums and biennials had an equivocal relationship with Peyton's work. It would be inaccurate to state that her work was shunned by major museums in the U.S., but it remains a fact that they did not avidly collect it until early in the next century, and with the exception of a few supportive curators it was not included in biennials or major institutional group exhibitions.[8] When a group of her paintings was included along with those of John Currin and Luc Tuymans in a small exhibition I curated at the Museum of Modern Art in

1997 as part of its "Projects" series, it creat a certain level of discussion. As the critic a curator Bill Arning pointed out at the open ing of that show, it was not that Peyton's or Currin's or Tuymans' work was unknown, it was just that it was completely unexpecte in the context of MoMA. More than out-of-place, it was interpreted within the museur as frankly hostile to the Modern's narrative progressive modern art that had no room for a return of figurative painting. Not a few the museum's curators were deeply unhap with the show; nonetheless, it established an institutional beachhead for Peyton's works (as well as Currin's and Tuymans'). And by the early 2000s all three artists wou have entered the MoMA collection.[9]

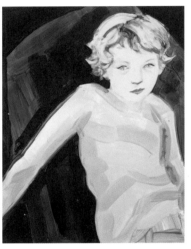

Elizabeth Peyton
Max
1996
Oil on board
12 × 9 in (30.5 × 22.9 cm)

In a review of an exhibition at GBE that same year, Saltz, writing for *Time Out New York*, commented that Peyton's work had "captured some kind of cultural shift," whi he went on to describe as the relocation of the contemporary sublime in culture rathe than nature.[10] This extreme timeliness, reflected in her choices of subjects — whic in 1997 included Lady Diana, Prince Harry, Jarvis Cocker, as well as Gavin Brown, his small son Max, and the painter Udomsak Krisanamis, a new member of the GBE stak — was thrilling, but it also was unsettling, particularly for institutions that prided themselves in taking a long view of art and its significance in history. Works so utterly contemporary would seem, in their specifi city, to promise a short shelf life; what would Liam and Noel Gallagher signify after everyone had forgotten the music of Oasis?[11] Once again, it is illuminating to return to the precedent set by the history of art that is filled with great paintings and sculptures whose original narratives have been lost; in the final analysis, it is the painting itself — its composition, its color, its visuality — that enables it to hold its ow

ng after its subject recedes into obscurity.
ltz might have qualified the notion of the
blime by locating it in timely culture rather
an timeless nature, but the thrill, the
stabilization, the joy caused by extreme
auty is the same whether looking at the
racle of Niagara Falls or the boy, *Max*
96), with his yellow hair and blue pullover
t against a midnight blue and purple
ckground.

In the years 1996 through 2000 Peyton
oduced a number of pictures that, like *Max*,
n be considered both iconic and sublime:
rvis (1996), with his head in his arms, taking
the entire picture surface save for a tiny
angle of sun-yellow background that
verberates perfectly with his plum-colored
veater; *Blue Liam* (1996), who is all white
ce, blue eyes, and red, red lips; *Harry* (1998),
ortrait of the carrot-haired prince in his
onian jacket; and *Palladium Martin* (1999),
ilver-leaf rendering of one of the owners
Cabinet. In 1999 she found a new subject in
r partner, the artist Tony Just. Like Kurt,
ony would become one of her grand sub-
cts, with images of him sleeping, walking,
d posing dominating her production
two years.

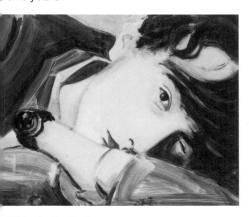

Elizabeth Peyton
Jarvis
1996
Oil on board
11 × 14 in (28 × 35.6 cm)

From 1998 to the turn of the millennium
eyton had thirteen one-artist exhibitions
d participated in twenty-three group exhi-
tions, in galleries and museums throughout
e world. Her paintings were written about
d reproduced in art and general-interest
agazines from *Artforum* to *Bazaar*, in news-
pers like the *Los Angeles Times*, *The Daily*
elegraph, and the *Frankfurter Algemeine*
eitung. More than a phenomenon, her work
d attained popularity, in the sense that it
d penetrated the precincts of the same
opular culture that she was using as a
imary inspiration for her subject matter.

Around 2000 I began organizing a group
hibition that would attempt to sum up the
assive changes that had occurred in the
ntemporary art discourse in the past
ecade, and for which Peyton's work was

emblematic. When "Drawing Now" opened
at the Museum of Modern Art in January
of 2002, figuration was dominating contem-
porary mainstream artistic practice in
capitals like New York, London, and Berlin.
Whether or not an exhibition at the Museum
of Modern Art marks an ending to a parti-
cular kind of contemporary art-making is
open to question, but "Drawing Now" can
serve as a chronological endpoint for this
narrative of the beginning of Peyton's career
as well as the beginning of the end of
the century.

"Drawing Now" was an examination of
the range of figurative drawing strategies,
focusing on eight distinct types of drawing
with roots in popular culture, beginning
with those that had relationships to scientific
drawing, architectural drafting, visionary
architectural drawing, ornament, cartoon-
ing, vernacular drawing traditions, and
finally illustration. By this time, less than a
decade after its debut, Peyton's paintings
and works on paper had spawned legions of
followers among artists working in painting
and, particularly, drawing. Some modified
or outright adopted her youth-oriented
subject matter; others emulated her small
format, single-figure compositions, fresh
brushwork, or insouciant line. "Drawing
Now" was a popular success, as were
subsequent exhibitions like "Chèr peintre:
Peintures figuratives depuis l'ultime
Picabia" (Dear Painter: Painting the Figure
since Late Picabia) (2003) at the Centre
Pompidou in Paris, which also presented
Peyton's work in the context of her own
generation and that of younger emulators.

I began this narrative by stating that the
sensibility that took form in the 1990s in New
York and in certain European capitals was
over, but only in the sense that it is no longer
transformative. The profound revolution in
thinking about and in seeing contemporary
art that was sparked by the advent of Peyton's
paintings has come to pass. So-called
"reactionary" style has been reborn as
radical; painting is no longer an automati-
cally ironic gesture; and most importantly,
popular cultural forms and subjects ranging
from comics to pinups to illustrations have
taken their rightful place in the contemporary
art discourse. They have done so not as
source material, not masked, subsumed,
or transformed by high-art practices (see
Pablo Picasso or Roy Lichtenstein) but as
they are. T. J. Clark on Courbet in 1851 could
just as easily have been writing about Peyton
in 1991: "Instead of exploiting popular art to
revive official culture and titillate its special,
isolated audience, Courbet did the exact
opposite. He exploited high art — its techni-
ques, its size and something of its sophisti-
cation — in order to revive popular art. His
painting was addressed not to the connois-
seur, but to a different, hidden public;

it stayed close to the pictorial forms which
were basic to popular tradition; it trans-
formed its sources, but only in order to
enforce their supremacy; not, certainly,
to excuse their shortcomings."[12]

Peyton's work, then, introduced a new
chapter in contemporary art, but it also
introduced a new audience. We swooned,
collectively, and, as the critic Lisa Liebmann
pointed out at the time, in an arid, suspicious
contemporary art atmosphere it was a
release we sorely needed.[13] There is no
doubt that things are completely different
now, with so many ideological and economic
changes occurring inside the art world and,
more profoundly, in this country and the
world at large. It is a source of wonder and of
joy that looking at Elizabeth Peyton's work
now does not make us nostalgic for the time
that created them, but affects us in a way that
can still make us lose our breath and perhaps
lose ourselves, propelling us into a death-
less, but utterly pleasurable, state.

1 Although he was an acquaintance at the
time, we were married in 1999.

2 Brown kept unreliable hours; I remember
an awkward instance in which I found myself
minding the gallery for several hours
after walking in and finding it unattended.

3 Slavoj Žižek, *Enjoy Your Symptom!:
Jacques Lacan in Hollywood and Out*, Routledge,
Oxford, 2001.

4 Shaun Caley Regen remembers that her
husband Stuart Regen attended the show,
and Sadie Coles, who had yet to open her
gallery, bought a drawing from it.

5 T. J. Clark, *Image of the People: Gustave
Courbet and the 1848 Revolution*, Princeton
University Press, New Jersey, 1982, p. 140.

6 Roberta Smith, "Blood and Punk Royalty
to Grunge Royalty," *The New York Times*,
March 24, 1995, p. C32.

7 Gregor Muir, "Elizabeth Peyton: The
Prince Albert Pub," *Frieze*, September 8,
1995, pp. 70–1.

8 Francesco Bonami, who included
Elizabeth's works in important group
exhibitions at the Venice Biennale (1995)
and at Site Sante Fe (1997), is a notable
exception.

9 Interestingly, it would take until 2004
for Elizabeth's paintings to be included
in a Whitney Biennial exhibition.

10 Jerry Saltz, "Review," *Time Out
New York*, March 27–April 3, 1997, p. 43.

11 In fact, a portrait of Al Gore, the
2000 democratic candidate for president,
was identified in a review published
not two years after the election as a
"portrait of a boy." Giorgio Verzotti,
"Elizabeth Peyton: Deichtorhallen,"
Artforum, February 2002, pp. 139–40.

12 T. J. Clark, op. cit. p. 140.

13 Lisa Liebmann, "A Tender Trap,"
Parkett, No. 53, 1998, pp. 85–7.

Excessive Life

Iwona Blazwick

Beauty is made up of an eternal, invariable element and of a relative, circumstantial element, which will be, if you like, whether severally or all at once, the age, its fashions, its words, its emotions. [1]
Charles Baudelaire, 1863

Elizabeth Peyton's rhythmic lines, crayon-box colors, and tightly cropped close-ups deliver a retinal punch that make her portraits always about and of the moment. Her paintings are utterly contemporary in subject and treatment. Yet they are also part of a historical continuity. They take their place in the epic story of portraiture in which artists have struggled since antiquity to use the artifice of stone, paint, or film to translate the lived reality of a face. But we might also see them within the genre of *nature morte*, in which the young lives she captures are given all the mutable beauty of cut flowers.

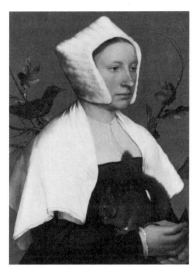

Hans Holbein
A Lady with a Squirrel and a Starling
ca. 1526–28
Oil on board
22 × 15 in (56 × 38.8 cm)

What gives Peyton's small paintings their remarkable intensity? Their scale ranges from being one-to-one with an actual head or even smaller, telescoping down to as little as nine by seven inches. This format recalls the panel paintings of Northern Renaissance masters such as Lucas Cranach or Hans Holbein, a period when "Portrait painting witnessed the confrontation between a meditation on death — the memento mori — and a glorification of the magical powers of painting." [2]
She shares with them their use of flat, non-perspectival space and enamel-like monochromes to create a backdrop for a sitter. Her precious, intimate pictures could be happily installed in the chambers of a grand old European house. At the same time her oil-on-board paintings approach the humble scale of the common snapshot, an association reinforced by the informal and intimate poses of her subjects. Like photographers such as Jack Pierson or Wolfgang Tillmans, Peyton portrays friends in domestic interiors, out in bars, or at holiday destinations — dreaming, being in love, convalescing.

The power of her paintings rests partly in the tension between a modesty of scale and subject matter, the barely containable energy of her mark-making, the flat rawness of her sumptuous colors, and the volatility of her compositions.

Although Peyton is a figurative painter, her work owes a debt to the legacies of abstraction. The internal structure of her images is geometrical. Just as early modernists were in thrall to the futuristic vitality of the diagonal — think of Rodchenko's upwardly gesturing workers or columns of marchers — so Peyton harnesses the energy of the angle. The shallow, internal spaces of her images are often divided into three sections. A work such as *Luing (Tony)* (200 positions the head of her subject at the point where three blocks of color — blue, pink, and white — meet. Our gaze is led up the thick black stripes striating the figure's sloping, blue, bathrobe-clad shoulders and along the red tip of his cigarette to become locked on his chiseled features. Against the summit of his upper body and the simple monochromatic division of the background between chalky white and plaster-of-Paris pink, Peyton unleashes the dark brown octopus of the young man's hair and the oceanic energy of a fabric pattern. Executed with the aristocratic panache of Ingres, Peyton substitutes the nineteenth century's exquisite velvets and opulent brocades for the patterns and textures of the everyday.

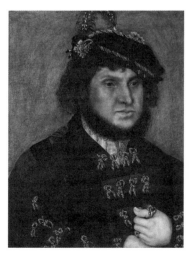

Lucas Cranach the Elder
Portrait of Johann the Steadfast
1509
Oil on board
16 1/4 × 12 in (41.3 × 31 cm)

Against the architectonic internal structure of Peyton's images, her figures lounge, lean, or sway. They are all on the diagonal. But it is not the directional diagonal of the revolutionary avant-gardes that

ints upwards to a utopian future. Rather
ese figures — their youth, their beauty, and
e moment of time they inhabit — are about
fall. This sense of something fleeting and
lnerable is intensified by the delicacy of
eyton's drawing.

Peyton uses a traditional range of
ediums, including oils, watercolors, and,
cently, etching and lithography. Through-
t, her use of the graphic is critical, as
monstrated by drawings such as *Crown
ince Ludwig* (1995) or *Julian* (2003). These
o works on paper display the full repertoire
curves, arabesques, curlicues, stripes,
d tones that Peyton deploys, to a number
ends. Almost like calligraphy, her use of
e line serves to structure space; it dances
ross the image to generate a vibrant sur-
ce dynamic; and it creates an iconography
the face.

The symmetrical zigzags of Ludwig's
els, the swooping curves of his shirt, and
e bubbly, lace-like silhouette of his coiffure
ake this deceptively simple image a small
udy in rococo ornamentation. The shape
his face is indicated by one sparse outline,
ving it a puppet-like quality that locates him
the narrative frame of the fairy tale. Unlike
e flat, silkscreened resolution of Andy
arhol's heads, where Liz Taylor or Marilyn
onroe are translated into static, mass-
ltural icons, Peyton's emblematic marks
e reminiscent of hand-drawn children's
storical book illustrations, which gives
any of her portraits, particularly the
storic ones, a fictive quality. These are
aracters from a magical fable.

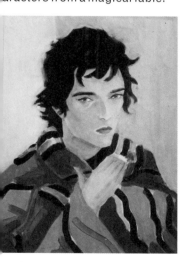

Elizabeth Peyton
Luing (Tony)
2001
Oil on board
14 × 11 in (35.6 × 27.9 cm)

By contrast the semi-naturalistic drawing
Julian emphasizes his physiognomy in a
ooding, expressionistic way. Peyton's
igular treatment of eyebrows, the slightly
uting lips, ragged hair, and darkly
udged eyes looking into the middle

distance locate this figure within the
Romantic tradition. The naturalistic and
the exquisitely graphic are combined in the
beautiful drawing *Spencer* (1999). Here the
artist uses colored pencils to transform a
shirt into an undulating river of thin red and
blue stripes. They move from the center
left of the image towards the bent head of a
pallid, dark-haired youth with the thinnest of
moustaches hovering above his succulent
lips. Propped up on his elbow, Spencer
might be in bed or lying on a couch. The
sensuality of the work is enhanced by the
pulsating fabric that ripples between his
face and the exposed triangle of his naked
stomach and — out of the frame — his groin.
Yet even this potentially erotic charge is
held in check by his luxuriant yet peculiarly
demure eyelashes, which shield his
downward gaze.

Wolfgang Tillmans
Chris Cunningham
1998
Color photograph

The fashionably artless, casual attire
of Peyton's sitters contrasts with the sheer
opulence of her palette. Many of her paint-
ings juxtapose colors that are at the outer
edges of being complimentary — violet and
brown (*Silver Tony,* 1999), buttercup yellow
and lilac grey (*Elliott in the Park*, 1999), sky
blue and orange (*Andre*, 2004), pea green
and scarlet (*Nick,* 2003). Again, the languid
detachment of her subjects, who rarely meet
the gaze of the viewer, contrasts with the
ravishing dazzle triggered by these juxtapo-
sitions. The picture surface arrests our gaze
just as her enigmatic subjects evade it. In the
notable *Flower Ben* (2002), the monochro-
matic and angular treatment of the figure is
almost overwhelmed by the vivid green stalks
and candy colored petals of a bunch of red,
yellow, and orange zinnias, snaking their
way out of the vase and diagonally across
the image. Their hothouse exuberance
contrasts with the hollow-eyed and tattooed
young man. Screened by the flowers, he is
closed in on himself, the hand buried behind
his neck adding to his self-absorption.

Like Francis Bacon, Peyton has looked
to photographs of English football for
inspiration.[3] *Michael Owen* (1998) shows
three footballers against a backdrop of the
grandstand. Two players tackle each other
and are momentarily united in a serpentine
dance, knees going one way, shoulders
another, their arms extended. The lime green
pitch at their feet slides downwards, topped
by a cascading bank of pointillist color.
Peyton heightens the fluidity of the figures
by setting them against the horizontal bands
of red, blue, and green. The location of the
player at the left-hand side of the picture and
the white posterior of the eponymous football
star add depth of perspective. And remark-
ably, the mosaic of colored blobs that offers
its own abstract picture plane also conveys
the overwhelming energy of a crowd and the
thrill of a packed arena. As with all her
paintings there is no hierarchy of surface.
There is an all-overness that makes each
particle of equal importance in the visual
apprehension of the work.

Across the vibrant profusion of Peyton's
oeuvre, we can see color playing a dual role
— creating a representation and generating a
pure, chromatic sensation. Even when its job
is purely literal, the choice of color adds reso-
nance to representation — why is the image
of Keith Richards arriving at Heathrow airport
executed entirely in violet? Peyton's transmu-
tation of the source black and white photo-
graph into a whole symphony of purples lifts
the archival and the documentary into the
space of reverie and even reverence. Her use
of color also leaps out of the constraints of
picture-making to offer a rich optical play that
takes on its own irreducible being.

Jean Auguste Dominique Ingres
Madame Duvaucey
1807
Oil on canvas
29 7/8 × 23 1/4 in (76 × 59 cm)

Peyton's figuration does not focus on the
physicality of the body, either naked or nude.
Aesthetic pleasure rests rather in the pattern
of a dress, the positioning of a limb, the arch
of an eyebrow. This insistence on surface
recalls Alex Katz's manifesto-like provoca-

tion on the importance of the superficial: "I prefer superficiality to Communism, academia ((Abstract Expressionist) or otherwise), Fascism, serious avant-garde, born-again religion, neo-Nazis, and French philosophers."[4]

Elizabeth Peyton's work takes its place in a specific genealogy of portraiture far from the realism of a painter such as Lucian Freud. Rather we might situate her within a trajectory that includes the somber yet plush plays of satin, jewelry, and piled coiffure in a painting such as Ingres' *Madame Duvaucey* (1807); the anguished eroticism of a poplin dress in Schiele's portrait of *Edith Schiele* (1915); David Hockney's painting of 1960s fashion designers Ossie Clark and Celia Birtwell, *Mr and Mrs Clark and Percy* (1970–71); or Alex Katz's tribute to lipstick and sunglasses in *Grey Day* (1990). These artists have all offered celebrations of style, of the richness of the visual world as expressed through the furnishings and fashions of an era, the visual manifestations of a civilization.

David Hockney
Mr and Mrs Clark and Percy
1970–71
Acrylic on canvas
84 × 120 in (213.4 × 304.8 cm)

Most avant-gardes provide us with a portrait of their milieu, the friends who are also the cultural protagonists of a generation. Elizabeth Peyton has painted many artists who, like her, became known in New York and London throughout the 1990s, including Maurizio Cattelan, Jake Chapman, Martin Creed, Angus Fairhurst, Rirkrit Tiravanija, and Piotr Uklanski. Peyton has also portrayed gallerists Colin de Land, Gavin Brown, and Pauline Daly, as well as musicians such as Jarvis Cocker and Liam Gallagher. She defines a period in transatlantic Anglo-Saxon culture in which a financial boom has coincided with an eruption of creativity in music, choreography, fashion, cooking, cinema, and art. The energy of the art scene (fired by the dynamism of some key art schools, globally informed artist-curators, entrepreneurial gallerists, graphically seductive art magazines, and a new generation of collectors) is on par with the heyday of Paris in the first half of the twentieth century. Peyton has por-

trayed those who define a sensibility in contemporary culture.

Yet these are not studies in the psychology of each individual. Like Hockney or Katz, Peyton draws on her social circle not only because of what they do, but also because of how they look. She is drawn to their physiognomy because it coincides with the delicate angularity that she can't help reproduce in her portraiture. (As Warhol once commented, "Even when the subject is different, people always paint the same painting."[5]) It is their style, posture, and attitude that she presses into the service of her very particular aesthetic process.

Photographs are almost Nature. And they drop onto our doormats, almost as uncontrived as reality but smaller.[6]
Gerhard Richter, 1989

Not all of Peyton's subjects are personally known to her. As well as portraying friends, she also draws on lives that are played out in the public arena of the mass media. Like many painters of the late twentieth and early twenty-first centuries, Peyton does not regard photography as a threat to or substitute for painting, but rather as a vast resource, a way of accessing the universal. She is aware of the mythic status that the omnipresence of the mass media can instantly confer on a few individuals. In any city in the world, the faces of a few celebrities from the worlds of music, fashion, or film are as ubiquitous as Coca-Cola. Their constant presence in the media and in advertising makes them both unattainable objects of desire and peculiarly familiar. Soap opera stars often comment that strangers will address them with the warmth of old friends.

Alex Katz
Grey Day
1990
Oil on linen
40 × 130 in (101 × 330 cm)

Peyton herself is drawn to this cast of characters — dead or alive — and includes them as honorary members of an extended family. Her choice of whom to portray is very specific. She has pictured Hollywood celebrities such as Chloe Sevigny and Leonardo DiCaprio; and rock casualties such as Sid Vicious and Kurt Cobain. She has also drawn on the family albums of the British House of Windsor, returning on numerous occasions to images of the young Prince Harry. These individuals are all painted in a way that makes them at once feminine and masculine, and sensual rather than sexual.

What connects them with people she know personally is their dandyism. As Baudelair commented, "Dandyism is a sunset; like th declining day star, it is glorious, without he and full of melancholy. The distinguishing characteristic of the dandy's beauty consis above all in an air of coldness which comes from an unshakeable determination not to I moved; you might call it a latent fire which hints at itself, and which could, but choose not to burst into flame."[7]

Her subjects are all made beautiful by th artist's own exquisite and generous aesthetic. In the way they are depicted, or in what we know about their lives, they are also alone, lacking animation or connection. He portrayals of young Prince Harry at a footba match, or on his first day at Eton, show him in the spotlight, demonstrating tremendou composure, yet unsmiling, detached, and somehow vulnerable. He is on duty, there b not there. The photographer Eve Arnold recounted going for a walk with Marilyn Monroe and becoming aware that no one on the street recognized her. Commenting on this, Monroe replied that she had not switched "Marilyn" on. She then visibly transformed into her screen self, at which point passers-by started to turn, stare, and beg for an autograph. Peyton's stars are all "switched off," on standby, retreating for a moment into themselves. Their beauty is innate, not projected. Peyton bypasses the poses demanded by the camera to transmu their unselfconscious beauty into paint.

Another overwhelming characteristic of Peyton's portraits is their emphasis on youth. To the young, life is infinite and therefore disposable. The Oedipal impulse relates not only to the family but also to society itself — the young reject industriou ness and good cheer, in a defiant embrace of inertia and depression. Freud recognize the allure of youth. Children and young people are unselfconsciously absorbed in a world of their own making. As tantalizing out of reach as Alice's looking-glass world the fascination this impenetrable sphere of existence exerts becomes a locus of desire

Peyton has made a drawing after a portrait of the writer Gustave Flaubert. Master of the evocation of obscure objects of desire, Flaubert was also mindful of that desire remaining unrequited, to avoid "the ironic chill of disenchantment." A passage from *Sentimental Education* could be a description of one of Peyton's paintings: "She would wear a dress of flaming red vel with a jeweled belt, and her wide sleeve, lined with ermine, would reveal her bare ar which would touch the balustrade of a stair case going up behind her. On the carpeted balustrade there would be a silver dish containing a bunch of flowers, an amber rosary, a dagger, and a casket of old, yellow ish ivory, overflowing with golden sequins;

me of these sequins would have fallen
the floor and lie scattered in a series of
ining drops, so as to lead the eye towards
e tip of her foot."[8]

Peyton has also sketched a scene from
s modernist masterpiece, *Madame Bovary*
357). Emma Bovary, Marie Antoinette as
visaged by Sofia Coppola, and the young
ana Spencer have all featured in Peyton's
uvre. These young women are connected.
vely but uneducated, indolent, credulous
d given to romantic fantasy, all existed as
phers. All three are manipulated and
timately destroyed. The poignancy of this
omed innocence is another leitmotif in
yton's work. Yet her portrayals of the
ung also encapsulate the imminence of
t-to-be realized promise, giving Peyton's
t the "what if" quality of the utopian.

Egon Schiele
Edith Schiele
1915
Oil on canvas
71 × 43 1/2 in
180 × 110.5 cm

Peyton has paid tribute to the historic
ltural figures she admires; they range from
anet, Flaubert, and Cezanne to Warhol,
ockney, and Truffaut. An exquisite recent
inting of the writer Susan Sontag, *Susan*
ntag (after H.C. Bresson's Susan Sontag,
ris, 1972) (2006) is part of this genealogy
influence. Painted with muted eau de Nil
d stony browns and grays, this elegiac,
ystalline study in contemplative solitude
something of a monument. But Peyton
so gives life to her heroes and heroines.
egardless of their historical moment, they
e given equal presence with her other
otagonists, in the here and now.

Portraiture is an act of celebration, tinged
th melancholy. It is interesting to note
w often Peyton portrays her friends when
ey are on crutches or wearing slings. The
rcelain fragility of their complexions and
e unnatural redness of their lips make them
once sensuous and vulnerable.

Peyton uses the historic genre of portrai-
re and the traditional mediums of oil,
atercolor, or print to distill the fragility of
e contemporary as it is encapsulated in
e young, the lovely, the iconic, and the
loved. The "excessive life" of modernity is
ught as it speeds towards oblivion, in
eting remembrances of things past.

1 Charles Baudelaire, "Le Peintre de la
Vie Moderne," 1863, *Curiosités esthétiques*,
Paris, 1868, translated by Jonathan Mayne
in *The Painter of Modern Life and Other Essays*,
Phaidon Press, London, 1998, p. 8.

2 Oskar Bätschmann and Pascal Griener,
Hans Holbein, Reaktion Books, London, 1997,
p. 151.

3 Francis Bacon collected hundreds
of sports photos from newspapers and
magazines, favoring "spot the ball"
competition stills in which the football
had been airbrushed out of the image and
the public were invited to locate it for
a cash prize. Bacon's focus, actually
indicated by incised lines, was firmly
on locating the players' genitals.

4 Alex Katz in conversation with Richard
Prince, *Journal of Contemporary Art*, vol. 4,
no. 2, Fall/Winter 1991.

5 Andy Warhol, *The Philosophy of Andy
Warhol (From A to B and Back Again)*, Harcourt,
New York, 1975, p. 149.

6 Gerhard Richter in conversation with Jan
Thorn Prikker, "Concerning the Cycle 18
October 1977," 1989, in *The Daily Practice of
Painting, Writings 1962–1993*, Thames and
Hudson, London, 1995, p. 187.

7 Charles Baudelaire, op. cit., p. 29.

8 Gustave Flaubert, *Sentimental Education*,
1869, translated by Robert Baldick,
Penguin Classics, London, 2004, p. 163.

Her Hand
Dipped
in Wisdom

John Giorno

Elizabeth Peyton is painting a portrait
of me. The first sitting was on Tuesday,
December 18, 2007. She had asked me about
two months before, and after a few e-mails,
as I was on several tours, when I got back we
did it. Elizabeth liked the idea of starting in
the old year. I went on my bicycle from 222
Bowery to her nineteenth-century clapboard
house on Stuyvesant; across the curving
street was the Pudding Lane Theatre. While
I was chaining the bike to Elizabeth's black
wrought-iron fence, I had a flash of the past:
in 1950, when I was thirteen years old, I went
to the Pudding Lane and saw Truman
Capote's *The Grass Harp* and Chekhov's *The
Cherry Orchard*, among other plays, before
there was an off-Broadway and an off-off-
Broadway, and before Circle in the Square,
before the Beats. I had gone desperately
seeking wisdom to escape from middle-
class America, the deadening affluence and
privilege which left a lot lacking, even though
I came from a loving, kind family. Literature
was my exit to freedom, my escape from
stifling bourgeois values. I rang the bell at
the black door in an old brick wall that led into
a garden. As I waited, there was another
flashback: in 1960, my ex-girlfriend had
rented an apartment on the top floor of the
house a few doors down on the corner of
Pudding Lane and Hawthorne. A fire that
started from a candle left burning had burned
off the roof of the historic building. In those
years my friends and I thought Elizabeth's
house and the twin house next door, con-
nected by a brick wall and garden, were
witches' houses, wonderfully so, because
they were worn and tattered American
Gothic like the ones in Salem, Massachu-
setts, smack in the middle of New York City.
Fifty-seven years later, it was a pleasure
going through the door. I really liked
Elizabeth. We had known each other slightly
for about eight years in a group of artist
friends around Gavin Brown's gallery.
I arrived at the house, Elizabeth made tea
in the kitchen, we talked and went up to her
studio. I sat for the portrait. I wasn't sure
what painting a portrait was: obviously not
a photograph, a totally different process.
I didn't know what that was, and it was not my
problem. I was supposed to sit, so I sat.
I treated it as a continuation of my meditation
practice. I am a Tibetan Buddhist, and do
practice, resting the mind, without any
concepts, recognizing thoughts as they
arise and not holding on to them, non-
thought, spontaneously present, just being
there. With a feeling that there was no one
sitting, no one making a portrait, and there
was no portrait, and with a happy feeling of
clarity. This is easy for me; I like doing it, and
it can be powerful. My eyes were half-open,
occasionally Elizabeth and I looked at each
other and smiled. We took breaks and burst
into wonderful conversations. Over four

months, Elizabeth did two paintings and
three drawings. At about the same time in t
fall of 2007, completely separately, Laura
Hoptman, a friend, asked me to write a piec
about Elizabeth Peyton for the catalogue of
her exhibition at the New Museum. "I am
delighted," I said, "I love her work." This wa
a slight problem for me, as I am a poet, and I
never learned how to write art criticism, and
never read it, except in newspapers on
airplanes. Elizabeth said happily, "Thank y
for doing it!" Sitting for the portraits, talkin
and being with each other in a profound wa
we became good friends.

"Your house is so great!" I said. "I'm ha
remembering what I heard: it was built in 18
by a baker, and the twin house was for his
daughter? What's the story?"

"In 1831. He was a dairyman," said
Elizabeth. "He lived in the other house and
built this house as an investment. He was
going to build a third house in between, but
he didn't, happily, and now we have the
garden in between. They say he was a
dairyman, but I don't think he ever saw a co
He just had them somewhere."

"Well, yes, of course," I said, "cows and
lots of land up in New York State. The cows
and those families are still there, in Delawa
and Sullivan Counties, among others, whic
is where our friends have bought places, ne
to dairy farms, land formerly owned by
farmers. Gavin in Callicoon, Rirkrit in
Hancock, Meredith Monk and countless
other artists, and Ugo and I in Barryville."

"You're up on the Delaware?"

"Yes, somehow we all ended up along
the Delaware River. When I was young, in t
1950s and 1960s, I spent a lot of time along
the Hudson River, Rhinebeck. Do you know
where the man who built this house
was from?"

"No, but maybe I can find out."

"Verne Dawson and Laura live on the
Delaware, too, Rutledgedale Road. The
Rutledge family is one of those cow-and-la
families who received a vast British land
grant in the eighteenth century, and now
there still are dozens of the families descen
ded with the name Rutledge who are dairy
farmers on the remnants of that land."

"The twin house where he lived is
unchanged," said Elizabeth. "Pretty much
the way it was, nothing much has been don
It's curious how we're all connected to this
old part of New York City and the rural
country in New York State, and not to cows

The first sitting, we sat in the living roon
on the second floor. Elizabeth started a
drawing, then a second drawing, then a thir
drawing, which she worked on for about tw
hours. When she was finished she held it u
it looked like me, but more important, it was
beautiful drawing. The second sitting was
Tuesday, January 8th, 2008. Elizabeth bega
the first painting. We did it on the top floor.

"I've just moved my studio up here."

"It's totally wonderful!"

I looked up at the big skylight and the rth light of a sunny winter day.

"The skylight, I just found out, is from [] nineteenth century," said Elizabeth.

It had extraordinary cast-iron gears and []eels.

"Oh, an artist's garret studio!"

[]e laughed.

"I first had my studio on the ground floor, []n't know why."

We were here for the portrait, and both of [] went back to it. I did meditation practice, []iding in the continual flow, and Elizabeth [] the drawing.

"When I was fourteen, I saw a TV mini-[]ries about Oscar Wilde," said Elizabeth, []e fabulous people of the Edwardian Era, [] mauve decade, and I said to myself []ese are the people I want to know!'"

"They were Andy Warhol's Factory," []id, "and our friends of their day."

Elizabeth is totally American, from []nnecticut, with a strong attachment to the [] Europe of London and Paris. During the []cond sitting, Elizabeth played Patti Smith []m an iPod. Patti is a friend from 1971, and [] perform often together. Patti was attra-[]d to and believed she belonged to a []eage of Baudelaire, Rimbaud, and []rlaine, direct descent. Elizabeth was []voted to them too, and to Patti. It was []nderful that they felt so connected; []t less so, though I loved them all. []tening to Patti was a pleasure, and the []ting went wonderfully.

"When did you start making portraits?" []sked.

"When I was four," said Elizabeth. "Paper []d pencil, crayon, magic marker, anything. []ally liked making portraits. I said to myself []is is what I want to do!'"

"This is very important!" I said. "Recogni-[]g your true nature. When you do someone []d you have a special feeling, it makes you [] a little brighter, an imperceptible bliss."

"Yes, I know," said Elizabeth.

"Congratulations, you recognized your []e nature as a painter at a very early age. []e cartoon is a light bulb in your head, but []lity is quite similar."

"I wasn't that good at it," said Elizabeth. []obody said, 'She is the greatest.' I liked []ing it."

"Something similar with me," I said.

"When I was thirteen in class the teacher []s teaching poetry, and one day she said []t for homework everyone should go home []d write a poem. I was shocked. I did it, and []ally liked doing it. I handed it in, and two []ys later she talked about everyone's []ems and read three out loud, and my poem []s the third poem. It made me feel really []od, and writing the poem had given me this []ra bright feeling. I said to myself, I want to

do this some more. And I did!"

"There's an idea," said Elizabeth, "that if you do something 10,000 times, something happens, and you begin to do it really well."

"Yes, 10,000, 100,000, hundreds of thousands, millions of repetitions produce something inexplicable, like magical powers come, self-arising. It is nonverbal and perfects great skills."

We were here for the portrait, and went back to it, me doing meditation, in and out of a state of non-thought. Elizabeth painted a thickly gessoed wood board, eight by ten inches, with dabs dipped from her palette on the table, mostly brown, yellow ochre, and umber. The third sitting was on Tuesday, January 15. Elizabeth continued working on the painting. Each sitting was about two hours, until after five, when the winter sun set at the end of the street that dead-ends at

Elizabeth Peyton
John Giorno
2008
Oil on board
10 × 8 in (25.4 × 20.3 cm)

the house, directly west of the window where we sat, and the light went out. I was very happy that Elizabeth was doing this. I loved her work, the brilliant use of Pop color and brilliant use of Pop brushstroke, the colors of Matisse in the style of dandyism. Elizabeth seemed to me to be a young Andy Warhol, the way he was in the early 1960s.

"I asked my school friends to sit for portraits," said Elizabeth, "as characters in the books I was reading: Baron de Charlus in Proust, *The Red and the Black* by Stendhal, *Lost Illusions* by Balzac. I painted made-up portraits."

"What a heroic thing to do!"

"In art school, I began painting from live models.... When I was twelve, I asked the teacher if I could use oil paint, which was about a year before the teacher taught it to the class."

At each sitting, besides tea, Elizabeth offered me fabulous chocolate truffles from Debauve & Gallais on Madison Avenue, which I really like. I was always high on chocolate.

"When I was twelve, I listened to The Jam, The Clash, David Bowie, Talking Heads, and Blondie while I painted."

The fourth sitting was on Thursday, February 21. Elizabeth did a drawing and began a second painting. The first painting was leaning against some things on a cluttered table on the far wall. The color of my long-sleeve shirt had changed from burnt sienna to black, and in the finished painting it was dark blue against a red book in the book-shelf, and was many layered. The painting had a riveting presence. A few days later, at a dinner party at her house, Elizabeth said, "I worked a little on the first painting, after you left." At each sitting, Elizabeth took a few photographs. And she took photos when I performed at Pati Hertling's event at Gavin's, and a week later at the Bowery Poetry Club with guitarist Javier Colis. Photos are a part of her process of making portraits. During one sitting, after having seen me perform, Elizabeth said softly, and quite seriously, "You're a rock star." She believed it, and it seemed quite funny. Elizabeth paints her friends, intimate friends, imaginary friends, poets, and famous people whose special qualities are so personal to us. Each person in each painting has the glamour and grace of a movie star. Even though you may not know who anyone is, each portrait is of a superstar, with whatever the qualities are that make you believe in them; each has perfect color and perfect poise, confidence and certainty, rock stars and royalty. Kurt Cobain in a tiara with stubble beard, the Baron de Montesquieu, who is dressed up as Ludwig II, who is dressed up as Louis XIV, caressing a bust of Marie Antoinette in Versailles, are reflections of our mind, are us looking in a mirror at ourselves, delusion inside delusion inside delusion. In the people she paints Elizabeth sees their special qualities as light, their vitality and accomplishments illuminating their bodies, an extra brightness in their form, deities in aggregates of color, gods almost transparent in shimmering light, their nature displayed in translucent radiance. It is as though her brilliant use of color and line are superb disguises, and the true portrait is the white background radiating primordial purity. Even though Elizabeth and I really liked talking and exchanging ideas, our true communication was nonverbal, beyond conceptualizations, and the results were miraculous paintings. Ink washes, frail pencil lines, blurred charcoal, pale oil, and small, her paintings are of deities in an ever-expanding heaven world, and Elizabeth Peyton, herself, is Sarasvati, goddess of painting, her hand dipped in wisdom.

Illustrated Works

All works are included
in the exhibition except
those indicated by an *

65

**Marie Antoinette Between
Germany and France on
Her Way to be Married**
1995
Oil on board
8 × 6 in
20.3 × 15.2 cm
Private collection,
Los Angeles

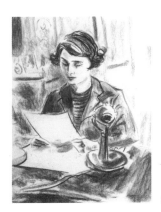
66

**Princess Elizabeth's First
Radio Address**
1993
Charcoal on paper
14 × 11 in
35.6 × 27.9 cm
Collection Karen and
Andy Stillpass

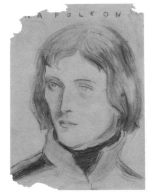
67

Napoleon
1991
Charcoal on paper
22 × 18 in
55.9 × 45.7 cm
Private collection
Courtesy Sadie Coles HQ,
London

Kings and Queens 68–9
1993
Ink on paper
12 × 17 in
30.5 × 43.2 cm
Collection Laura Stevenson
Maslon

70

Rirkrit, age 3 (Argentina)
1993
Ink on paper
5 1/2 × 3 3/4 in
14 × 9.5 cm
Courtesy the artist and
Gavin Brown's enterprise,
New York

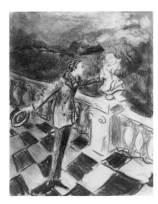
72

**Ludwig Caressing the Bust
of Marie Antoinette**
1993
Charcoal on paper
13 3/4 × 10 3/4 in
34.9 × 27.3 cm
Collection Karen and
Andy Stillpass

73

Ludwig in Versailles
1994
Charcoal on paper
16 1/2 × 11 3/4 in
41.9 × 29.8 cm
The Stephanie and Peter Brant
Foundation, Greenwich, CT

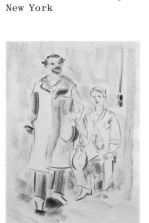
75

Ludwig with Josef Kainz
1992
Charcoal on paper
16 1/2 × 11 3/4 in
41.9 × 29.8 cm
Courtesy the artist and
Gavin Brown's enterprise,
New York

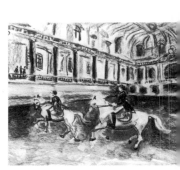

Ludwig II Riding to Paris
1993
Charcoal on paper
11 × 14 in
27.9 × 35.6 cm
Private collection

77

...wig II of Bavaria
...4
... on board
... 12 in
...2 × 30.5 cm
... Angeles County Museum
...Art, gift of Peter Norton

79

Rupert Brooke *
1994
Charcoal on paper
16 1/2 × 11 3/4 in
41.9 × 29.8 cm

80

Sidney
1995
Charcoal on paper
13 × 11 in
33 × 27.9 cm
Private collection

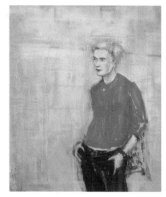

81

Dallas, TX (January 1978)
1994
Oil on canvas
20 × 16 in
50.8 × 40.6 cm
Private collection
Courtesy Sadie Coles HQ,
London

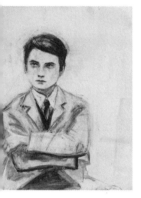

82

...oine Doinel *
...4
... on board
... 11 in
...6 × 27.9 cm

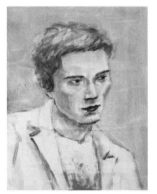

83

John Lydon
1994
Oil on canvas
12 × 9 in
30.5 × 22.9 cm
Private collection

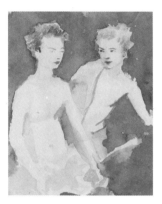

84

**John and Sid (John Lydon and
John Beverley) ***
1994
Ink on paper
9 × 7 inches
22.9 × 17.8 cm

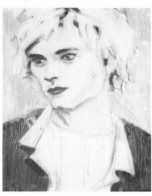

85

Zoe's Kurt
1995
Oil on board
14 × 11 in
35.6 × 27.9 cm
Collection Zoe Stillpass

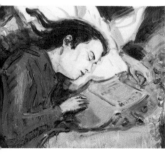

...t Sleeping 86–7
...5
... on board
... 14 in
...9 × 35.6 cm
...vate collection, New York
...rtesy Gavin Brown's
...erprise, New York

89

Alizarin Kurt
1995
Oil on canvas
24 × 20 in
61 × 50.8 cm
Private collection, New York

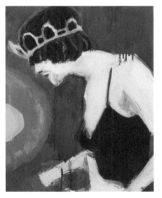

90

Princess Kurt
1995
Oil on linen
14 × 11 3/4 in
35.6 × 29.8 cm
Walker Art Center,
Minneapolis, T.B Walker
Acquisition Fund, 1995

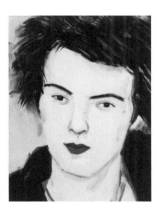

91

**John Simon Beverley
Ritchie (Sid)**
1995
Oil on board
12 × 9 in
30.5 × 22.9 cm
Museum of Fine Arts, Boston,
Contemporary Curator's Fund

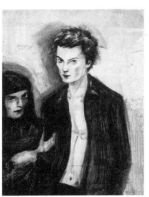

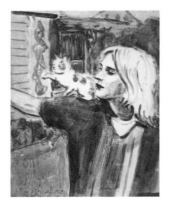

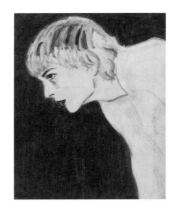

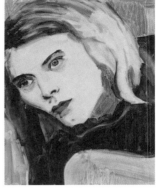

**Sid and his Mum
(John and Anne Beverley)**
1995
Oil on board
17 × 12 in
43.2 × 30.5 cm
Private collection
Courtesy Gladstone Gallery,
New York

93

Kurt with cheeky num-num
1995
Oil on board
14 × 11 in
35.6 × 27.9 cm
Collection Lisa and
John Miller

94

Blue Kurt
1995
Oil on canvas
20 × 16 in
50.8 × 40.6 cm
Private collection, New York

96

Kurt
1995
Oil on board
10 × 8 in
25.4 × 20.3 cm
Collection Glenn Fuhrman
Courtesy the FLAG Art
Foundation

9

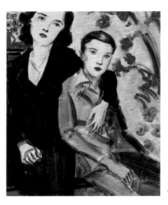

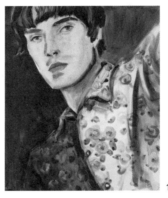

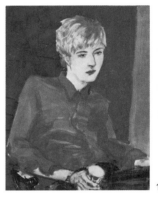

Piotr
1996
Ballpoint pen on paper
12 1/8 × 9 3/4 in
30.8 × 24.8 cm
Courtesy the artist and
Gavin Brown's enterprise,
New York

98

Gladys and Elvis∗
1997
Oil on canvas
17 × 14 in
43.2 × 35.6 cm

100

Flower Liam
1996
Oil on board
17 × 14 in
43.2 × 35.6 cm
Private collection
Courtesy Zwirner & Wirth,
New York

101

Piotr
1996
Oil on board
8 1/4 × 6 in
21 × 15.2 cm
Private collection, New York

103

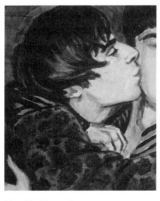

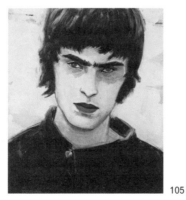

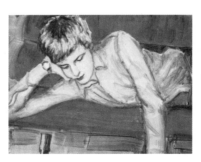

Earl's Court
1996
Oil on board
10 × 8 in
25.4 × 20.3 cm
Collection Nina and
Frank Moore, New York

104

Blue Liam
1996
Oil on board
17 × 14 in
43.2 × 35.6 cm
Private collection
Courtesy Gavin Brown's
enterprise, New York

105

Piotr on Couch 106–7
1996
Oil on board
9 × 12 in
22.9 × 30.5 cm
Seattle Art Museum,
gift of the William E. Weiss
Foundation, Inc.

Jarvis
1996
Oil on board
11 × 14 in
27.9 × 35.6 cm
Hort Family Collection

10

110

111

112

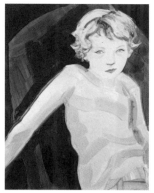

113

nstance Wilde and Son
6
cil on paper
2 × 6 in
1 × 15.2 cm
lection Neda Young

Jarvis on a Bed
1996
Oil on board
17 × 14 in
43.2 × 35.6 cm
Collection Laura and
Stafford Broumand

Jarvis and Liam Smoking
1997
Oil on canvas
12 × 9 in
30.5 × 22.9 cm
Collection Tiqui Atencio

Max
1996
Oil on board
12 × 9 in
30.5 × 22.9 cm
Private collection
Courtesy Gavin Brown's
enterprise, New York

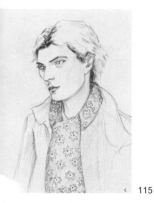

115

116

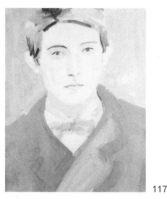

117

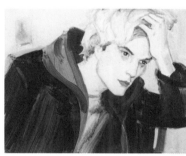

Craig 118–19
1997
Oil on canvas
14 × 17 in
35.6 × 43.2 cm
Collection David Teiger
Partial gift to the Museum
of Modern Art, New York

ig
6
cil on paper
7 in
3 × 17.8 cm
vate collection, New York
rtesy Gavin Brown's
erprise, New York

**Prince Harry's first day at
Eton, September 1998**
1998
Pencil on paper
11 3/4 × 9 in
29.8 × 22.9 cm
Austrian Collection

Silver Bosie*
1998
Watercolor on paper
30 × 22 1/4 in
76.2 × 56.5 cm

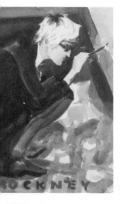

120

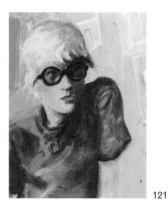

121

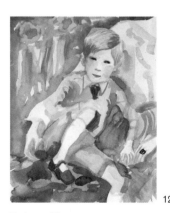

122

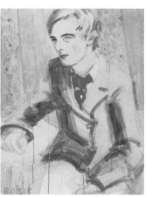

123

vid Hockney
7
ercolor on paper
1/2 × 7 in
7 × 17.8 cm
lection Nancy Delman
tnoy
rtesy Gavin Brown's
erprise, New York

**David Hockney,
Powis Terrace Bedroom**
1998
Oil on board
9 3/4 × 7 in
24.8 × 17.8 cm
Kunstmuseum Wolfsburg

Prince Harry
1997
Watercolor on paper
11 × 8 1/2 in
27.9 × 21.6 cm
Private collection

Silver Bosie
1998
Lithograph
29 1/2 × 22 1/2 in
74.9 × 57.2 cm
Courtesy the artist and
Gavin Brown's enterprise,
New York

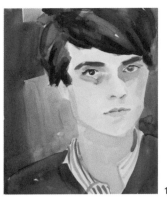

Craig
1998
Watercolor on paper
13 1/2 × 11 in
34.3 × 27.9 cm
Private collection

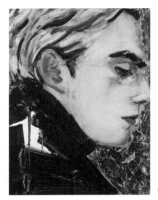

Palladium Martin
1999
Oil and palladium leaf on board
12 × 9 in
30.5 × 22.9 cm
The Stephanie and Peter Brant
Foundation, Greenwich,
Connecticut

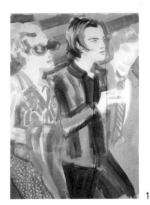

Celebrity (Leonardo DiCaprio)
1998
Watercolor on paper
60 × 40 in
152.4 × 101.6 cm
Collection Mima and
César Reyes, Puerto Rico

Roseland
1997
Oil on board
12 × 9 in
30.5 × 22.9 cm
Emanuel Hoffmann Foundation,
permanent loan to the
Öffentliche Kunstsammlung
Basel

Maurizio Eating
1998
Oil on board
12 × 9 in
30.5 × 22.9 cm
Collection Nancy Delman
Portnoy

Tokyo (Craig)
1997
Oil on board
10 × 8 in
25.4 × 20.3 cm
Ole Faarup Collection,
Copenhagen

Silver Colin
1998
Oil on board
10 1/4 × 8 1/4 in
26 × 21 cm
Private collection

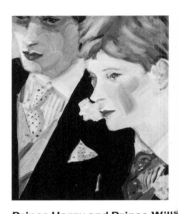

Prince Harry and Prince Will
1999
Oil on board
9 1/2 × 8 in
24.1 × 20.3 cm
The Musée national d'art
moderne, Centre Pompidou, Par

Panda Rob*
1999
Watercolor and glitter on paper
30 × 22 3/4 in
76.2 × 57.8 cm

Kiss (Tony)
2000
Lithograph
24 × 19 in
61 × 48.3 cm
Courtesy the artist and
Gavin Brown's enterprise,
New York

**Jackie and John
(Jackie fixing John's hair)**
1999
Oil on board
14 × 11 in
35.6 × 27.9 cm
Collection Mr. and Mrs.
Jeffrey R. Winter

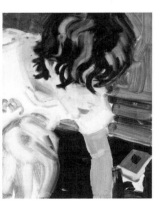

Silver Tony
1999
Oil on board
14 × 11 in
35.6 × 27.9 cm
Collection Byron R. Meyer

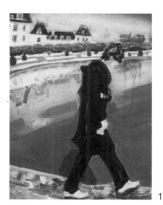

139

rthday, 20 December 1999
00
arcoal on paper
1/2 × 11 in
3 × 27.9 cm
vate collection
urtesy Gavin Brown's
terprise, New York

November (Tony)
1999
Colored pencil on paper
8 3/4 × 6 in
22.2 × 15.2 cm
Private collection, New York

140

Prince Eagle (Fontainebleau)
1999
Oil on board
12 × 9 in
30.5 × 22.9 cm
Private collection, New York
Courtesy Gavin Brown's
enterprise, New York

141

Savoy (Tony)
1999
Ballpoint pen on hotel
stationery
5 3/4 × 4 in
14.6 × 10.2 cm
Collection Patricia and
Morris Orden, New York

143

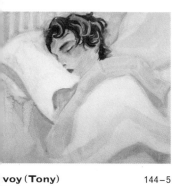

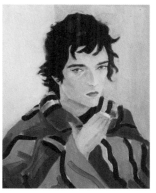

144-5

voy (Tony)
99
on board
× 16 1/2 in
6 × 41.9 cm
anuel Hoffmann Foundation,
rmanent loan to the
fentliche Kunstsammlung
sel

146

Pierre*
2000
Colored pencil on hotel
stationary
10 1/2 × 7 1/4 in
26.7 × 18.4 cm

Luing (Tony)
2001
Oil on board
14 × 11 in
35.6 × 27.9 cm
Collection Dianne Wallace,
New York

147

Berlin (Tony)
2000
Oil on canvas
40 × 30 in
101.6 × 76.2 cm
Private collection

149

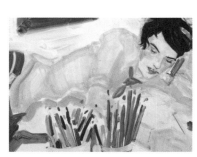

150

rosay (Tony)
00
on board
× 9 in
5 × 22.9 cm
nstmuseum Wolfsburg

Spencer*
1999
Colored pencil on paper
8 1/4 × 6 in
21 × 15.2 cm

152

Spencer Walking
2001
Oil on board
12 1/4 × 9 1/4 in
31.1 × 23.5 cm
Philadelphia Museum of Art,
purchased with the Adele Haas
Turner and Beatrice Pastorius
Turner Memorial Fund

153

Spencer Drawing
2000
Oil on board
9 1/4 × 12 in
23.5 × 30.5 cm
Collection Laura and
Stafford Broumand

154-5

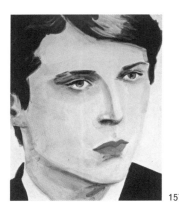

**Democrats are more beautiful
(after Jonathan Horowitz)**
2001
Oil on board
10 × 8 in
25.4 × 20.3 cm
Collection Laura and
Stafford Broumand

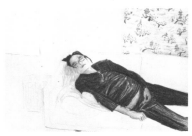

Poo (Rirkrit) 158
2001
Colored pencil on paper
5 7/8 × 8 5/8 in
14.9 × 21.9 cm
Private collection, New York
Courtesy Gavin Brown's
enterprise, New York

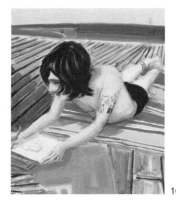

Ben Drawing 160
2001
Oil on board
10 1/8 × 8 1/4 in
25.7 × 21 cm
Carnegie Museum of Art,
Pittsburgh, A.W. Mellon
Acquisition Endowment

September (Ben) 161
2001
Oil on board
12 1/8 × 9 1/8 in
30.8 × 23.2 cm
Private collection
Courtesy Gavin Brown's
enterprise, New York

Breakfast (Adi) 162
2003
Oil on board
14 × 11 in
35.6 × 27.9 cm
Collection Sam and
Shanit Schwartz

Flower Ben 163
2002
Oil on board
10 × 8 1/4 in
25.4 × 21 cm
Collection David Teiger

Haircut (Ben and Spencer) 164
2002
Oil on board
12 × 9 in
30.5 × 22.9 cm
Private collection

Little Em (Eminem) 165
2002
Oil on board
12 × 9 in
30.5 × 22.9 cm
The Stephanie and Peter Brant
Foundation, Greenwich,
Connecticut

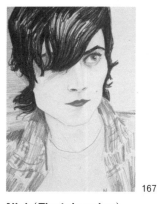

Nick (First drawing) 167
2002
Colored pencil on paper
8 3/4 × 6 in
22.2 × 15.2 cm
Collection David Teiger

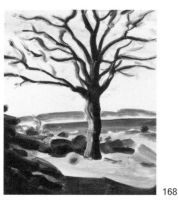

Orient 168
2003
Oil on board
10 × 8 in
25.4 × 20.3 cm
Courtesy David and
Monica Zwirner, New York

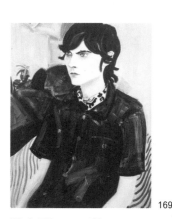

**Nick (Chateau Marmont,
Los Angeles, September 2002)** 169
2002
Oil on canvas
40 × 30 in
101.6 × 76.2 cm
Collection David Teiger

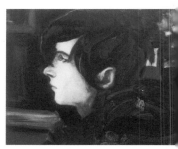

Nick (La Luncheonette 170
December 2002)
2003
Oil on board
7 1/4 × 9 in
18.4 × 22.9 cm
Collection Karen and
Andy Stillpass

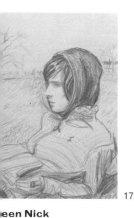

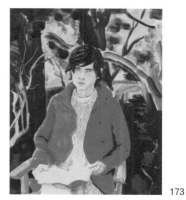

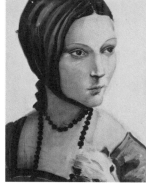

een Nick
03
lored pencil on paper
8 1/2 in
2 × 21.6 cm
llection Isa Genzken, Berlin

Nick Reading Moby Dick
2003
Oil on board
15 × 12 in
38.1 × 30.5 cm
Museum of Contemporary Art,
Los Angeles, partial and
promised gift of Mandy and
Cliff Einstein

Harry and Tittie
2003
Oil on board
9 × 7 in
22.9 × 17.8 cm
The Stephanie and Peter
Brant Foundation, Greenwich,
Connecticut

**Lady with an Ermine 1489-90
(After Leonardo da Vinci)**
2003
Oil on board
12 × 9 in
30.5 × 22.9 cm
Collection Matt Aberle,
Los Angeles

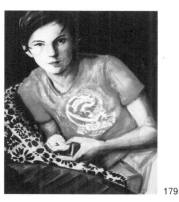

. (E.P.)
4
. on board
× 11 1/4 in
6 × 28.6 cm
vate collection,
omised gift to the Art
stitute of Chicago

Julian
2003
Pastel on paper
16 3/4 × 11 in
42.5 × 27.9 cm
Collection David Teiger

Live to Ride (E.P.)
2003
Oil on board
15 × 12 in
38.1 × 30.5 cm
Whitney Museum of American Art,
New York, partial and promised
gift of David Teiger in honor
of Chrissie Iles

Julian with a broken leg
2004
Oil on board
14 × 11 in
35.6 × 27.9 cm
Collection Beth Swofford

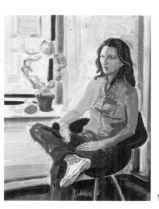

ian
4
. on board
× 11 in
6 × 27.9 cm
vate collection, New York
rtesy Gavin Brown's
erprise, New York

Marc
2004
Oil on board
10 × 8 in
25.4 × 20.3 cm
Private collection

Walt
2003
Colored pencil on paper
8 5/8 × 6 in
21.9 × 15.2 cm
Private collection, New York
Courtesy Gavin Brown's
enterprise, New York

Anette
2004
Oil on board
14 × 11 in
35.6 × 27.9 cm
Private collection

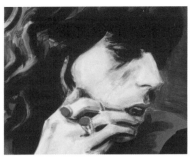

Keith 186–7
(From Gimme Shelter)
2004
Oil on board
10 × 12 in
25.4 × 30.5 cm
Solomon R. Guggenheim Museum,
New York, purchased with funds
by the International Director's
Council and Executive Committee
Members

188

Pete and the Wolfman
(From the NME)
2004
Pastel on paper
13 3/4 × 11 in
34.9 × 27.9 cm
Private collection, New York
Courtesy Gavin Brown's
enterprise, New York

189

Jeanne Moreau and Francois
Truffaut (The Bride Wore
Black)
2005
Oil on board
11 × 9 in
27.9 × 22.9 cm
Sender Collection,
Courtesy Levin Art Group

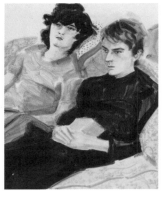

19

Ken and Nick
(Ken Okiishi and Nick Mauss)
2005
Oil on board
11 × 9 in
27.9 × 22.9 cm
Collection Glenn Fuhrman,
promised gift to Tate, London
Courtesy FLAG Art Foundation

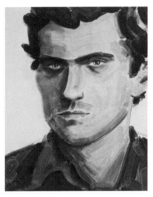

192

Jonathan (Jonathan Horowitz)*
2005
Oil on board
12 × 9 in
30.5 × 22.9 cm

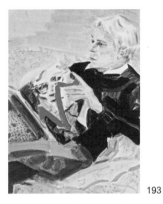

193

John (John Reinhold)
2005
Oil on board
10 × 7 in
25.4 × 17.8 cm
Private collection

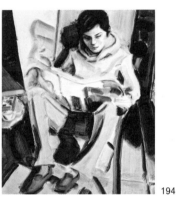

194

E.P. reading (self-portrait)
2005
Oil on board
10 × 8 in
25.4 × 20.3 cm
Collection David Teiger

195

Nick in Orient (Nick Mauss)
2004
Oil on board
12 × 9 1/4 in
30.5 × 23.5 cm
The Parrish Art Museum,
Southampton, New York, purcha
with funds contributed by the
Collections Committee

197

Frida (Frida Kahlo)
2005
Oil on board
9 × 7 in
22.9 x17.8 cm
Collection Tiqui Atencio

198

Jonathan Horowitz
2006
Oil on board
12 × 9 in
30.5 × 22.9 cm
Private collection
Courtesy neugerriemschneider,
Berlin

199

Liz and Diana
2006
Oil on board
12 × 9 in
30.5 × 22.9 cm
The Sander Collection

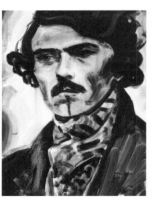

201

Eugène Delacroix, 1842
2005
Oil on board
9 1/4 × 7 in
23.5 × 17.8 cm
Collection Doug Inglish

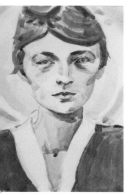

202

204

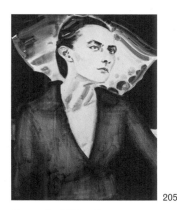

205

207

eorgia O'Keeffe
fter Stieglitz 1917)
06
tercolor on paper
1/4 × 10 1/4 in
.2 × 26 cm
llection James-Keith (JK)
own and Eric G. Diefenbach,
w York

Elizabeth and Georgia
(Elizabeth Arden and Georgia
O'Keeffe 1936)
2005
Oil on board
10 × 8 in
25.4 × 20.3 cm
Private collection, Berlin
Courtesy neugerriemschneider

Georgia O'Keeffe
after Stieglitz 1918
2006
Oil on canvas
30 1/8 × 23 1/8 in
76.5 × 58.7 cm
Collection David Teiger

Pete (Pete Doherty)
2005
Watercolor on paper
14 × 10 in
35.6 × 25.4 cm
Private collection

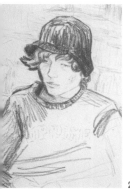

209

211

212

ax
07
stel on paper
1/2 × 6 in
.6 × 15.2 cm
ivate collection
urtesy Gavin Brown's
terprise, New York

Jonathan (Jonathan Horowitz)
January 2007
2007
Oil on board
9 × 7 in
22.9 × 17.8 cm
Private collection, New York
Courtesy Gavin Brown's
enterprise, New York

Picnic (M.A.) after Sofia
Coppola's Marie Antoinette
2006–07
Oil on board
13 × 10 in
33 × 25.4 cm
Collection David and Susan
Gersh, Los Angeles

Susan Sontag
(after H.C. Bresson's Susan
Sontag, Paris, 1972)
2006
Oil on board
9 × 7 in
22.9 × 17.8 cm
Collection Tia and David
Hoberman, Los Angeles

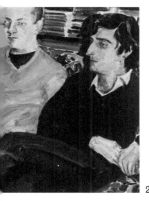

213

214

215

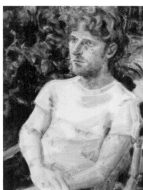

216

gus and Jonathan (Angus
ok and Jonathan Caplan)
06–07
l on board
× 8 in
.4 × 20.3 cm
llection Mandy and Cliff
nstein

Madame Bovary
(Vincente Minnelli, 1949)*
2007
Charcoal on paper
13 1/2 × 11 in
34.3 × 27.9 cm

Nick and Pati
(Nick Mauss and Pati Hertling)
2007
Oil on board
13 × 10 in
33 × 25.4 cm
Private collection

Joe (Joe Montgomery)
July 2007*
2007
Oil on board
12 1/8 x 9 1/8 in
30.8 x 23.2 cm

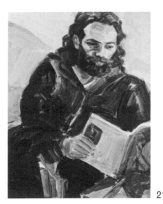

Gavin Brown February 2007
2007
Oil on board
11 3/4 × 9 in
29.8 × 22.9 cm
Collection Mitzi and Warren
Eisenberg

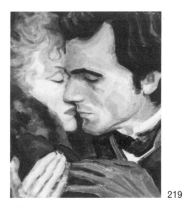

The Age of Innocence
2007
Oil on board
14 1/4 × 10 in
36.2 × 25.4 cm
Private collection, New York
Courtesy Gavin Brown's
enterprise, New York

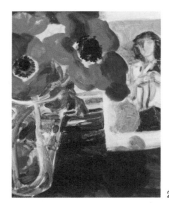

Pati
2007
Oil on board
9 × 7 in
22.9 × 17.8 cm
Private collection, New York
Courtesy Gavin Brown's
enterprise, New York

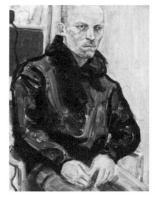

Matthew
2008
Oil on board
12 1/2 × 9 in
31.8 × 22.9 cm
Private collection

Flowers and Diaghilev
2008
Oil on linen over board
13 × 9 in
33 × 22.9 cm
Private collection

**West 11th Street, Greenwich
Avenue, and 7th Avenue,
New York City, 2008**
2008
Oil on board
9 × 6 in
22.9 × 14.2 cm
Collection Mitzi and Warren
Eisenberg

Biography

Elizabeth Peyton was born in Connecticut in 1965. She received her BFA from the School of Visual Arts, New York, in 1987. She lives and works in New York.

Peyton has exhibited regularly at the following galleries:

Gavin Brown's enterprise, New York,
 since 1995
neugerriemschneider, Berlin, since 1996
Regen Projects, Los Angeles, since 1997
Sadie Coles HQ, London, since 1998

Selected Solo Exhibitions

2007
Aldrich Museum of Art, Ridgefield,
 Connecticut (Larry Aldrich Award recipient)
Institut im Glaspavillon, Berlin

2006
Guild Hall, Easthampton, New York

2005
Glenn Horowitz Bookseller, Easthampton,
 New York

2002
Royal Academy, London
Salzburger Kunstverein, Salzburg

2001
Deichtorhallen, Hamburg

2000
Westfalischer Kunstverein, Münster
Aspen Art Museum

1999
Castello di Rivoli, Turin

1998
Georg Kargl, Vienna
Galleria II Capricorno, Venice
Kunstmuseum Wolfsburg, Germany
 (traveled to Museum für Gegenwartskunst,
 Basel, Switzerland)
Seattle Art Museum

1997
Gallery Side 2, Tokyo
Galerie Daniel Buchholz, Cologne
St. Louis Art Museum

1995
Cabinet Gallery at The Prince Albert, London
Burkhard Riemschneider, Cologne

1993
Hotel Chelsea, room 828, New York

Selected Group Exhibitions

2007
"The Painting of Modern Life,"
 Hayward Gallery, London

2006
"Surprise, Surprise," Institute of
 Contemporary Art, London
"Contemporary Masterworks: Saint Louis
 Collects," Contemporary Art Museum of
 St. Louis

2005
"Superstars: from Warhol to Madonna,"
 Vienna Kunstforum/Vienna Kunsthalle
"Getting Emotional," Institute of
 Contemporary Art, Boston

2004
"Likeness: Portraits of Artists By Other
 Artists," California College of Arts,
 Wattis Institute for Contemporary Arts,
 San Francisco (traveled to the McColl
 Center for Visual Art, Charlotte, North
 Carolina; the Institute of Contemporary
 Art, Boston; Dalhousie University Art
 Gallery, Halifax, Nova Scotia; and the
 University Art Museum, California
 State University at Long Beach)
"Whitney Biennial," Whitney Museum of
 American Art, New York

2002
"Cher Peintre, Lieber Maler, Dear
 Painter," Musée national d'art moderne,
 Centre Pompidou, Paris (traveled to the
 Schirn Kunsthalle, Frankfurt; and the
 Kunsthalle Wien, Vienna)
"Remix," Tate Liverpool

2001
"Drawing Now: Eight Propositions,"
 The Museum of Modern Art, New York
"Abbild: recent portraiture and depiction,"
 Landesmuseum Joanneum, Graz, Austria

2000
"Greater New York," P.S.1, New York

1999
"Examining Pictures," Whitechapel Art
 Gallery, London (traveled to Museum of
 Contemporary Art, Chicago, and Hammer
 Museum, Los Angeles)

1998
"Young Americans II," Saatchi Gallery,
 London
"Auf der Spur," Kunsthalle Zurich

1997
"Truce: Echoes of Art in an Age of Endless
 Conclusions," Site Santa Fe, New Mexico
"Projects 60," The Museum of Modern Art,
 New York
"Longing and Memory," Los Angeles County
 Museum

1996
"a/drift," Center for Curatorial Studies,
 Bard College, Annandale-on-Hudson,
 New York
"Universalis," São Paulo Bienal
"Wunderbar," Kunstverein Hamburg

1995
"Campo," Venice Biennale

1993
"Okay Behaviour," 303 Gallery, New York

Her work is represented in the
collections of:

Carnegie Museum of Art, Pittsburgh
Musée national d'art moderne, Centre
 Pompidou, Paris
Guggenheim, New York
Kunstmuseum Wolfsburg, Germany
Museum für Gegenwartskunst, Basel
Museum of Fine Arts, Boston
The Museum of Modern Art, New York
San Francisco Museum of Modern Art
Seattle Art Museum
St. Louis Art Museum
Walker Art Center, Minneapolis
Whitney Museum of American Art, New York

Bibliography

Selected Articles and Reviews

2008

Carlin, T.J., "In Life, Elizabeth Peyton Truly Finds Her Art," *Time Out New York*, May 14

Katz, Miriam, "Previews: Elizabeth Peyton at the Aldrich Contemporary Art Museum," *Artforum*, May

Robinson, Walter, "Elizabeth Peyton," *Whitewall*, spring

Rosenberg, Karen, "Art in Review: Elizabeth Peyton," *New York Times*, May 16

Saltz, Jerry, "Elizabeth II: Elizabeth Peyton Returns to Life," *New York Magazine*, May 11

2007

Coomer, Martin, "Very Abstract and Hyper Figurative," *Modern Painters*, June

Feldman, Melissa E., "An Artist and Her Alter Egos," *Art in America*, December

Hirsch, Faye, "Elizabeth Peyton at Guild Hall," *Art in America*, January

Kazanjian, Dodie, "Power Flowers," *Vogue*, June 2007

Krilanovich, Grace, "Celebrities and Unknowns," *LA Weekly*, March 22

Muñoz, José Esteban, "The Sense of Watching Tony Sleep," *South Atlantic Quarterly*, summer

Murray, Peter, "Freeze Frame," *Royal Academy Magazine*, autumn

Pagel, David, "Small Gestures Made Large," *Los Angeles Times*, March 16

Smith, Roberta, "It's Just Clay, but How About a Little Respect?," *New York Times*, September 7

2006

Herbert, Martin, "Monographs: Elizabeth Peyton," *Modern Painters*, May

Johnson, Ken, "Beautiful People Caught in Passivity," *New York Times*, August 18

Kazanjian, Dodie, "Art Goes Naked," *Vogue Nippon*, March

Lee, Carol, "Peyton Place," *Paper*, September

Nesbett, Peter, "New Prints Review," *Art on Paper*, November/December

Probst, Ursula Maria, "Superstars," *Kunstforum International*

Saltz, Jerry, "Portraits of the Artist as a Young Artist," *Village Voice*, January 18

Steeds, Lucy, "Surprise, Surprise," *Art Monthly*, September

Yablonsky, Linda, "Slides and Prejudice," *ARTnews*, April

2005

Garrett, Craig, "Elizabeth Peyton at Sadie Coles HQ," *Flash Art*, May/June

Holland, Charles, "Elizabeth Peyton at Sadie Coles," *Modern Painters*, June

Kazanjian, Dodie, "Body Language," *Vogue*, December

McCormick, Carlo, "Crazy in Love," *Paper*, February 2005

Packer, William, "Art with a Tantalizing Freshness," *Financial Times*, March 9

Rothkopf, Scott, et al., "Personal Affects," *Artforum*, April

Saltz, Jerry, "The Richter Resolution," *Modern Painters*, April

Siegel, Katy, "All Together Now: Crowd Scenes in Contemporary Art," *Artforum*, January

Wei, Lily, "The Sacred Precinct of Modernism," *ARTnews*, January

2004

"The Year in Prints: The First Annual New Prints Review: Technical Porn," *Art on Paper*, November/December

Bankowsky, Jack, "This is Today," *Artforum*, May

Collings, Matthew, "Getting Ahead in New York," *Modern Painters*, summer

Diez, Renato, "Alla Biennale del Whitney Torna la Pittura," *Arte*, April

Finch, Charlie, "Return to Peyton Place," *Artnet.com*, April 24

Griffin, Tim, "Electoral Collage: A Portfolio," *Artforum*, September

Griffin, Tim, "Out of the Past," *Artforum*, January

Heartney, Eleanor, "Report from New York: The Well-Tempered Biennial," *6*, June/July

Hoban, Phoebe, "7BRs, Ocn Vu, World Class Art," *New York Times*, March 14

Johnson, Ken, "The Hamptons, a Playground for Creativity," *New York Times*, August 6

Joselit, David, "Apocalypse Not," *Artforum*, May

Kazanjian, Dodie, "Peyton's Place," *Vogue*, October

Kimmelman, Michael, "Touching All Bases at the Biennial," *New York Times*, March 12

Kuhn, Thomas W., "Whitney Biennale 2004: A Wedding for a Hundred Brides," *Kunstforum International*

Lafreniere, Steve, "My Bohemia," *New York Times Magazine*, October 3

Pincus, Robert L., "Art House," *San Diego Union-Tribune*, April 18

Rothkopf, Scott, et al., "Many Happy Returns: Comments on the Whitney Museum of American Art's 2004 Biennial Exhibition," *Artforum*, May

Saltz, Jerry, "The OK Corral," *Village Voice*, March 15

Siegel, Katy et al., "American Pie," *Frieze*, May

Simpson, Bennett, "From Noise to Beuys: Bennett Simpson on Art and Pop Music," *Artforum*, February

Smith, Roberta, "Caution: Angry Artists at Work," *New York Times*, August 27

Wei, Lily, "Whitney Biennial 2004," *ARTnews*, May

Young, Paul, "Money, Power and Picasso's Bathroom," *V Life*, February/March

2003

Adams, Brooks, "Picabia, the New Paradigm," *Art in America*, March

Burnett, Craig, "50th Venice Biennale," *Frieze*, September

Burnett, Craig, "Paint it White!," *NME*, June 28

D'Amato, Jennie, "Image Conscious," *Art & Auction*, September

Drolet, Owen, "Drawing Now: Eight Propositions," *Flash Art*, January/February

ison, Mike, "Elizabeth Peyton: A Painter
ows in Long Island," *Index*, November

men, Reinhard, "Pittura/Painting,"
nstforum International

iffin, Tim, "Drawing Now," *Artforum*,
cember

ilenman, Diane, "'Reverie: Works from
e Collection of Douglas S. Cramer' at
eed Art Museum," *ARTnews*, October

ngo, Robert, et al., "Pencil Pushers,"
t on Paper, March

rton, Tom, "Elizabeth Peyton," *Frieze*, May

lman, Leah, "Icons of the Saints of
p Culture," *Los Angeles Times*, June 13

llack, Barbara, "Now is a Good Time,"
RTnews, April

oeber, Michael, "Painting Pictures,"
nstforum International

gel, Carol, "More Eyes on the Mix for the
itney Biennial," *New York Times*,
tober 27

2002

rawing Now?," *Flash Art*, December

nquête sur l'image peinte/What the
inters say," *Art Press*, July/August

y, Michael, "Elizabeth Peyton," *Tema
leste*, February

atnagar, Priya, Samuele Menin, Michele
becchi, and Valentina Sansone, "Focus
inting Part II: Contemporary Painting
day," *Flash Art*, November/December

utoux, Thomas, "Dear Painter: The Figure
nce Late Picabia," *Flash Art*, September

sh, Kate, "'Cher Peintre, Lieber Maler,
ar Painter,'" *Artforum*, October

ngeras, Alison, "Painting on the Move,"
tforum, November

oni, Massimiliano, "New York Cut Up: Art
agments from the Big Apple," *Flash Art*,
nuary/February

lle, Howard, "Papering the House,"
me Out New York, November 7

tzger, Rainer, "'Lieber Maler, Male
r...': Radikaler Realismus nach
cabia," *Kunstforum International*

tzger, Rainer, "Attitude und Modernität:
pekte des Kanonischen in der Kunst der
tzten Jahrzehnte," *Kunstforum International*

llack, Barbara, "Art Rocks," *ARTnews*,
cember

obst, Ursula Maria, "Elizabeth Peyton:
Artists," *Kunstforum International*

manelli, David, "Peyton Palace," *Vogue
ris*, June/July

ltz, Jerry, "Good on Paper," *Village
ice*, October 29, 2002

hjeldahl, Peter, "The Drawing Board:
w Directions for the Oldest Medium,"
w Yorker*, November 4

ith, Roberta, "Europe Shows the Staying
wer of Paint," *New York Times*, July 21

ith, Roberta, "Retreat from The Wild
ores of Abstraction," *New York Times*,
tober 18

ldez, Sarah, "Elizabeth Peyton at Gavin
own's enterprise," *Art in America*, March

lson, Ellen S., "New at Carnegie Museum
Art," *Carnegie Magazine*, March/April

2001

Aletti, Vince, "Elizabeth Peyton,"
Artforum, September

Herstatt, Claudia, "Elizabeth Peyton,
Wolfgang Tillmans: The Contemporary Face
from Pablo Picasso to Alex Katz,"
Kunstforum International

Johnson, Ken, "Art in Review: Elizabeth
Peyton," *New York Times*, November 23

Kay, Shara, "Just the Emperor: Elizabeth
Peyton's Portrait Series of Tony Just,"
ARTnews, September

Meinhardt, Johannes, "The Beauty of
Intimacy: Lens and Paper," *Kunstforum
International*

Roshani, Anuschka, "Schönheit ist das
Synonym für Liebe," *Brigitte*, September

Schjeldahl, Peter, "At the Museum:
Straightforward Paint," *New Yorker*,
December 17

Todd, Stephen, "Peyton's Place,"
Jalouse, September

Verzotti, Giorgio, "Elizabeth Peyton:
Deichtorhallen," *Artforum*, October

2000

"Elizabeth Peyton," *Brutus*, April

"Elizabeth Peyton," *Intervista*, summer

"Sub-Culture in Super Culture,"
Hanatsbaki, March

Close, Chuck, "About Face: Chuck Close in
Conversation with Elizabeth Peyton,"
Parkett, October

Danek, Sabine, "Die Aura der Entrückten,"
Kultur-Spiegel Online, July 25

Funken, Peter, "Malerei," *Kunstforum
International*

Gingeras, Alison, "Conjectures on
Conceptual Uses of Figurative Realism,"
Art Press, December

Gingeras, Alison, "Subversion du Kitsch,"
Art Press, December

Halle, Howard, "State of the Art," *Time Out
New York*, March 16

Harvey, Doug, "Elizabeth Peyton," *Art
Issues*, January/February

Kohler, Michael, "Narziss am Morgen,"
Frankfurter Rundschau, July

Kunitz, Daniel, "Pop Portraitists,"
Art and Antiques, summer

Lafreniere, Steve, and Rob Pruitt
"Elizabeth Peyton," interview, *Index*, July

MacAdam, Barbara A., "Greater New York,"
ARTnews, May

Miles, Christopher, "Elizabeth Peyton,"
Artforum, January

Moreno, Gean, "High Noon in Desire Country:
The Lingering Presence of Extended
Adolescence in Contemporary Art,"
Art Papers, May/June

Paul, Benjamin, "Elizabeth Peyton:
'Tony,'" *Kunstforum International*

Russell, John, "Making Pen and Ink Seem
Passé: The Proliferation of New Ways to
Draw," *New York Times*, August 18

1999

"Elizabeth Peyton; Bernard Frize;
Luc Tuymans; Eberhard Havekost,"
ART: das Kunstmagazin, December

Arning, Bill, "Elizabeth Peyton,"
Poliester, summer

Cooper, Jacqueline, "Heavy Emotion Invades
Contemporary Painting," *New Art Examiner*,
September

Gayford, Martin, "The New Portraiture,"
Art Quarterly, autumn

Grabner, Michelle, "Examining Pictures:
Exhibiting Paintings,"
Frieze, November/December

Kimmelman, Michael, "Elizabeth Peyton,"
New York Times, April 23

Kunitz, Daniel, "Changing Faces,"
ARTnews, March

Lewis, Jim, "Elizabeth Peyton: Pop
Culture's Mirror," *Interview*, June

Pagel, David, "Elizabeth Peyton," *Los
Angeles Times*, November 5

Peyton, Elizabeth, "Elizabeth Peyton's Top
Ten," *Artforum*, March

Philippi, Anne, "Elizabeth Peyton," *Park &
Ride*, July/August

Phillips, Christopher, "Art for an
Unfinished City," *Art in America*, January

Saltz, Jerry, "Getting Real," *Village Voice*,
April 20

Scott, Whitney, "Elizabeth Peyton's
Place," *Detour*, April

Tully, Judd, "The Contemporary Sales,"
Art & Auction, November

Vincent, Steven, "Impact Players,"
Art & Auction, May 15

Wong, Gloria M., "From the Desk of...,"
Bazaar, June

1998

"U.K. Artists Q & A: Elizabeth Peyton,"
Art Newspaper, March

Beil, Ralf, "Elizabeth Peyton,"
Kunstforum International

Burton, Jane, "Made in the U.S.A,"
The Daily Express, September 5

Christofori, Ralf, "Harry und Prinzessin
Di beim Fernsehen," *Frankfurter Allgemeine
Zeitung*, June 29

Concepción, Teresa, "Elizabeth Peyton:
Portrait of an Artist," *Heartbeat*, March

Coomer, Martin, "Young at Art," *Time Out
New York*, September

Darwent, Charles, "American Gothic,"
New Statement

Dorment, Richard, "A Brush with Young
America," *Daily Telegraph*, August 26

Fairbrother, Trevor, "Paint Pops,"
J17, November

Frederickson, Eric, "Fan's Eye View,"
The Stranger, January 22

Gayford, Martin, "The Art Game," *Spectator*,
September 12

Graw, Isabelle, "Eine andere Welt, die doch
jeder kennt: zu den Bildern von Elizabeth
Peyton," *Texte zur Kunst*, September

Hubbard, Sue, "Elizabeth Peyton," *Time Out
New York*, March 25

Januszczak, Waldemar, "Young Turk No More,"
New York Times Magazine, September 27

Karcher, Eva, "Im Auge Des Hurrikans,"
Elle Germany, September

Makogiannis, Eugenie, "Interview: Elizabeth
Peyton," *Art Newspaper*, March

Makogiannis, Eugenie, "Painter Explores
Dreamy Worlds," *Downtown Source*, January 5

Maloney, Martin, "The Art of Elizabeth Peyton," *Frank*, March

Muir, Robin, "Star Gazer," *Independent Sunday Magazine*, February 21

Negrotti, Rosanna, "States of Mind," *What's On*, October 7

Packer, William, "The Pointlessness of Irony," *Financial Times*, September 15

Pesch, Martin, "Im Schatten junger Männerblüte," *Die Tageszeitung*, June 3

Pilgrim, Linda, "An Interview with a Painter," and "An Interview with a Painter's Model," Rimanelli, David, "Unhappy Kings," Philip Ursprung, "In Praise of Hands: Elizabeth Peyton's Painting," *Parkett*, no. 53, September

Price, Dick, "Exhibition of the Month," *I-D*, March

Renton, Andrew, "A Continuous Displacement," *Flash Art*, summer

Saltz, Jerry, "An Ideal Syllabus," *Frieze*, November/December

Searle, Adrian, "The Infants Liam and Noel on the Sofa… Is This What Passes for the New American Dream?," *Guardian*, September 7

Swenson, Ingrid, "Not Just a Pretty Face," *Make*, March/May

Van de Walle, Mark, "Avant-Garde and Kitsch!: Why 'Bad Painting' is Hot," *Art & Auction*, May

Wakefield, Neville, "Elizabeth Peyton," *Elle Decor*, March

1997
Darling, Michael, "The Baggage of Time," *LA Weekly*, June 20–26

Dobrzynski, Judith H., "A Popular Couple Charge into the Future of Art, but in Opposite Directions," *New York Times*, September 2

Hayt, Elizabeth, "People are Talking About: Elizabeth Peyton," *Vogue*, September

Hickey, Dave, "Top Ten of 1997," *Artforum*, December

Knight, Christopher "Beguiled by 'Longing and Memory,'" *Los Angeles Times*, June 7

LaBelle, Charles, "Art Reviews: Longing and Memory," *Art/text*, November

McKenna, Kristine, "The Contemporary Not Temporary at LACMA," *Los Angeles Times*, June 7

Mitchell, Charles Dee, "New Narratives," *Art in America*, November

Pagel, David, "A Little Tenderness," *Los Angeles Times*, February 20

Rimanelli, David, "The Year in Review: John Currin, Elizabeth Peyton, Luc Tuymans," *Artforum*, December

Saltz, Jerry, "Elizabeth Peyton at Gavin Brown's enterprise," *Art in America*, May

Schwabsky, Barry, "Picturehood is Powerful," *Art in America*, December

Schjeldahl, Peter, "The Daub Also Rises," *Village Voice*, July 29

Schjeldahl, Peter, "Peyton's Place," *Village Voice*, March 25

Schjeldahl, Peter, "Pop Art," *New Yorker*, February 3

Smith, Roberta, "Project," *New York Times*, August 1

Smith, Roberta, "Art in Review: Elizabeth Peyton at Gavin Brown's enterprise," *New York Times*, August 4

1996
Bonami, Francesco, "Elizabeth Peyton: We've Been Looking at Images for So Long that We've Forgotten Who We Are," *Flash Art*, March/April

Herbstreuth, Peter, "Von Napoleon bis Kurt Cobain," *Der Tagesspiegel*, April 20

Savage, Jon, "Boys Keep Swinging: Jon Savage on Elizabeth Peyton," *Frieze*, November/December

Savage, Jon, "True Brits," *Guardian*, December 20

Schwendener, Martha, "Catch my Drift?," *Time Out New York*, December 12

Smith, Roberta, "Art After Fashion," *Vogue*, January

Smith, Roberta, "Finding Art in the Artifacts of the Masses," *New York Times*, December 1

Smith, Roberta, "Screen," *New York Times*, February 2

Stange, Raimar, "A Star was Born," *Kunst-Bulletin*, November

1995
Adams, Brooks, "Salon and On," *Artforum*, summer

Decter, Joshua, "Elizabeth Peyton at Gavin Brown's enterprise," *Artforum*, May

Muir, Gregor, "Elizabeth Peyton," *Frieze*, October 1995

Smith, Roberta, "Blood and Punk Royalty to Grunge Royalty," *New York Times*, March 24

1994
Ettal, Meicost, "Overture: Elizabeth Peyton," *Flash Art*, November

Saltz, Jerry, "Elizabeth Peyton at the Hotel Chelsea," *Art in America*, May

Selected Monographs, Catalogues, and Other Publications

2007
Like Color in Pictures, Aspen Art Museum, Aspen

Rugoff, Ralph, *The Painting of Modern Life: 1960s to Now*, Hayward Publishing, London

2006
Elizabeth Peyton: Prints 1998–2006, Gavin Brown's enterprise and Two Palms Press, New York

Elizabeth Peyton Paintings 1994–2002, Gavin Brown's enterprise and Gladstone Gallery, New York; Sadie Coles HQ, London

Borries, Friedrich von, and Florian Waldvogel, *Das grosse Rasenstück: Zeitgenössische Kunst im öffentlichen Raum*, Verlag für Moderne Kunst, Nuremberg

Bowman, Rob, and Jens Hoffman, *Surprise, Surprise*, ICA, London

Mullins, Charlotte, *Painting People: Figure Painting Today*, D.A.P., New York

Richer, Vanessa, and Matthew Rosenzweig (eds.), *No. 1: First Works by 362 Artists*, D.A.P., New York

2005
Baume, Nicholas (ed.), *Getting Emotional*, ICA, Boston

Bell, Kirsty, "Elizabeth Peyton," in *Art Now: Volume 2*, Taschen, New York

Brugger, Ingrid, and Matt Gerald, *Superstars: van Warhol bis Madonna*, Hatje Cantz, Ostfildern-Ruit

Dexter, Emma, et al., *Vitamin D: New Perspectives in Drawing*, Phaidon, London

Higgs, Matthew, et al., *Elizabeth Peyton*, Rizzoli, New York

Kantor, Jordan, *Drawing from the Modern 1975–2005*, The Museum of Modern Art, New York

Mauss, Nick, *Nick Mauss and Elizabeth Peyton*, Glenn Horowitz Bookseller, East Hampton

2004
Likeness: Portraits of Artists by Other Artists, CCA Wattis Institute, San Francisco

Corwin, Sharon, *Contemporary Painting: Richard Bosman, Cecily Brown, Maureen Cavanaugh, Peter Doig, Merlin James, Laura Owens, Elizabeth Peyton, Bill Saylor*, Colby College Museum of Art, Waterville

Longwell, Alicia Grant, *North Fork/South Fork: East End Art Now*, Parrish Art Museum, Southampton

Iles, Chrissie, Shamim M. Momin, and Debra Singer, *Whitney Biennial 2004*, Whitney Museum of American Art, New York

2003
Dreams and Conflicts: The Dictatorship of the Viewer, la Biennale di Venezia, 50th International Art Exhibition, Marsilio Editori, Venice

Painting Pictures: Painting and Media in the Digital Age, Kerber Verlag, Bielefeld

Reverie: Works from the Collection of Douglas S. Kramer, Speed Art Museum, Louisville

Bonami, Francesco, and Raf Simons, *The Fourth Sex*, Fondazione Pitti Immagine Discovery, Florence

...lis, Patricia, and Gianni Romano, *...tervista con la pittura = Interview with painting: ...ter Doig, Eberhard Havekost, Nicky Hoberman, ...ren Kilimnik, Udomsak Krisanamis, Elke ...ystufek, Kiki Lamers, Michel Majerus, ...rgherita Manzelli, Yan Pei Ming, Paul Morrison ...ntean Nicolai, Erik Parker, Elizabeth Peyton, ...lhelm Sasnal, Hiroshi Sugito*, ...stmediabooks, Milan

...ptman, Laura, *Drawing Now: Eight Proposi-...ns*, The Museum of Modern Art, New York

...freniere, Steve, *Elizabeth Peyton*, Roma, ...ma, Roma, Rome

...lker, John A., *Art and Celebrity*, Sterling, ...ndon

2002

...ll, Kirsty, and Hildegund Amanshauser, *...izabeth Peyton: 16 Artists*, Salzburger ...nstverein, Salzburg

...lix, Zdenek, *Elizabeth Peyton: Deichtorhal-...Hamburg*, Hatje Cantz, Ostfildern-Ruit

...ngeras, Alison M., *Cher Peintre... Lieber ...ler... Dear Painter: Peinture figurative depuis ...ltime Picabia*, Centre Pompidou, Paris

...01

...osenick, Uta, and Ilka Becker, *...men Artists in the 20th and 21st Century*, ...schen, Cologne

...ptman, Laura, *Drawing Now: Eight Proposi-...ns*, The Museum of Modern Art, New York

...yton, Elizabeth, *Prince Eagle*, ...werHouse Books, New York

2000

...w Work 1: Elizabeth Peyton, Aspen Art ...seum, Aspen

...ensheimer, Susanne, *Elizabeth Peyton, ...ny Sleeping*, Westfälischer ...nstverein, Münster

...bel, Dean, *Interventions: New Art in ...conventional Spaces*, Milwaukee Art Museum, ...lwaukee

1999

...nami, Francesco, and Judith Nesbitt, *...amining Pictures*, Whitechapel, London

...kesch, Peter, *Abbild: Recent Portraiture ...d Depiction*, Springer Verlag, Vienna

...emschneider, Burkhard, and Uta Grosenick ...ds.), *Art at the Turn of the Millennium*, ...schen, Cologne

1998

...ams, Brooks, and Lisa Liebmann, *...ung Americans 2: New American Art at the ...atchi Gallery*, Saatchi Gallery, London

...rbrother, Trevor, *Prime of Life*, ...attle Art Museum, Seattle

...ckey, Dave, *Elizabeth Peyton: Katalog/ ...atalogue*, Museum für Gegenwartskunst, ...sel

...yton, Elizabeth, *Craig*, W. König, Cologne

1997

...cost, Ettal, and David Rimanelli, *...izabeth Peyton, Live Forever*, Composite ...ess, Tokyo

...nami, Francesco, et al., *Truce: Echoes ...Art in an Age of Endless Conclusions*, Site ...nta Fe

...rbrother, Trevor J., *Elizabeth Peyton*, ...attle Art Museum

Hoptman, Laura, *Projects 60: John Currin, Elizabeth Peyton, Luc Tuymans*, The Museum of Modern Art, New York

Steiner, Rochelle, *Currents 71: Elizabeth Peyton*, Saint Louis Art Museum, Saint Louis

Zelevansky, Lynn, *Longing and Memory*, Los Angeles Museum of Art

1996

Schimmel, Paul, *Universalis, São Paulo Bienale*, São Paulo

1995

Bonami, Francesco, *Campo 95*, *Biennale de Venezia*, Allemandi, Turin

1993

Blau, Douglas, *Hotel Chelsea*, Gavin Brown's enterprise, New York

Acknowledgments

This exhibition and book have, from the beginning, been a collaboration with the artist, so thanks first and foremost must go to Elizabeth Peyton. She has been closely involved with all aspects of it, from the selection of the works, to the content of the book. It was a privilege to work with her when I first did so in the early 1990s, and it continues to be now. Her work has changed my life, and the lives of many others, and I am proud to be associated with its presentation to an ever-growing audience.

This is truly Elizabeth's show, but this is not to say that we have not had important collaborators. Amy Mackie, Curatorial Assistant at the New Museum, has played a crucial role in the organization of the show and the creation of this book. Her back-ground research on each of the objects in the exhibition (accomplished with the help of research intern Sarah Demeuse) is reflected in the essays and in the educational materials, and will be an important resource long after the exhibition has run its course.

Elizabeth and those who have worked with her at her galleries have close, long-standing relationships that, although they might not be unique in the contemporary art community, are increasingly rare. Gavin Brown and Corinna Durland of GBE, New York; Tim Neuger and Burkhard Riemschneider of neugerriemschneider, Berlin; Sadie Coles and Pauline Daly of Sadie Coles HQ, London; and Shaun Caley Regen of Regen Projects, Los Angeles, are part of the community of interesting, alive people that are Elizabeth's inspiration, as well as her subject matter. Not only are they contributors to her history, they are players in it, and all of them and their excellent staff, including Lisa Williams and Alex Zachary at GBE, Alexa Galea at Sadie Coles, HQ, Joseph Imhauser at Regen Projects, and Florian Seedorf at neugerriemschneider, have contributed enormously to this exhibition.

We were very fortunate to have been able to collaborate with the wonderful London-based design firm Graphic Thought Facility on this book. We are grateful to Andy Stevens and Huw Morgan, and particularly to Roland Brauchli and Paul Neale. GTF is gracious, fun, attentive, and wildly creative, and I know I speak for both the artist and myself when I say that we have loved working with them. Our guest essayists, Iwona Blazwick, the Executive Director of White-chapel Art Gallery in London, and John Giorno, poet, muse, and neighbor, have added richness and beauty to Elizabeth's oeuvre with their insightful and heartfelt contributions.

We have also been very lucky to have been able to continue the New Museum's fruitful collaboration with the publisher Phaidon Press. Richard Schlagman, Publisher, has been an enthusiastic and supportive partner, Craig Garrett an excellent and understanding Commissioning Editor, and Lupe Núñez-Fernández a helpful and efficient Project Editor. The Phaidon team, along with Karen Hansgen, the New Museum's Head of Publications, and Sarah Valdez, our in-house Editor, brought this complicated and many-faceted book to completion, and we are grateful to them all.

Melanie Franklin Cohn, our former Publications Manager, was also very helpful at the early stages of this project.

Jonathan Caplan, a New York–based architect and Elizabeth's friend, contributed a splendid exhibition design that was beautifully executed by our exhibitions staff, led by Exhibitions Manager Hendrik Gerrits.

Virtually everyone on staff at the New Museum has helped in one way or another on this show, so thanks are due to them all. This said, I must single out a few of my colleagues for special mention. Lisa Phillips, Toby Devan Lewis Director of the New Museum, has supported the idea of a Peyton survey from its very inception three years ago; indeed, if memory serves, she was the first to suggest a show of this kind. John Hatfield, Deputy Director, has worked tirelessly to make the numbers work for the show and to make its ambitious tour a reality. My colleagues in the Curatorial Department, Richard Flood, Chief Curator, and Massimiliano Gioni, Director of Special Exhibitions, have also been enthusiastic about the project, which could not have been undertaken without our interns Hannah Adkins, Sarah Demeuse, Claire Distenfeld, Joseph Gergel, Hilary Lee, and Sarah Needham, who provided much-needed research and administrative help on the curatorial side of things. Shari Zolla and Bobby Ives, our Registrars, have ably brought together this large exhibition, and Alice Arias, Jennifer Heslin, Perry Garvin, Angela Nevarez, and David Rager have each contributed within their individual expertise with good humor and professionalism.

Karen Wong, the museum's Director of External Affairs, Andrea Schwan, our Communications Consultant, Gabriel Einsohn, our Communications Director, and Keith Gray, Communications Assistant, supported this show with their creative outreach to our public as well as to the press. Our Education and Public Programs Department directed by Eungie Joo, curator of Education and Public Programs, also supplemented the show with their attendant programming.

A special place in this organizer's pantheon must be reserved for the New Museum's indefatigable, resilient, positive energy-radiating Director of Development, Regan Grusy, and our equally ardent and adept Corporate Sponsorship Consultant Fred Wodin. Regan and Fred were cheerleaders for this show from its very inception and it is no exaggeration to say that their hard work made it possible.

Our generous funders at Banana Republic have proven to be remarkably enthusiastic and flexible partners in this project from the very beginning. Tara Zane McCollum, Michelle Hellman, Chris Nicklo, and Jack Calhoun energized the curatorial process and were a pleasure to work with. Our heartfelt thanks for their crucial participation in bringing this project to fruition.

Although Banana Republic took the lead, other funders, institutional as well as individual, have provided significant help for the show, including the Lily Auchinclos Foundation and the Mimi and Peter Haas Fund.

Equally generous are the many lenders to the exhibition who have consented to part with their beloved paintings, drawings and prints for an extended American and European exhibition tour. Artist, curator, and museum are eternally grateful to them. They are listed elsewhere in the catalogue.

The New Museum is also grateful for the enthusiastic participation of our tour partners. Olga Viso, Director, Philippe Vergne, former Chief Curator and Deputy Director, and Betsy Carpenter, Associate Curator at the Walker Art Center, Minneapolis; Iwona Blazwick, Director, and Anthony Spira, Curator, at the Whitechapel Art Gallery, London; and Alexander van Grevenstein, Director, and Paula van den Bosch, Curator, at the Bonnefantenmuseum in Maastricht couldn't have been better colleagues. We look forward to seeing the show at these great institutions.

On a more personal note, my colleague Chrissie Iles, Ehrenkranz Curator of Contemporary Art at the Whitney Museum of American Art, and Ingrid Schaffner, Senior Curator at the Institute of Contemporary Art in Philadelphia, generously shared their experiences and advice on the subject of monographic exhibitions. The artist Douglas Blau and the gallerists Jack Tilton and Gavin Brown were all around at the beginning of Elizabeth's career in New York, and I am grateful to them for sharing their memories with me. Finally, my deepest thanks must go to my husband Verne Dawson, who introduced me to his friend Elizabeth Peyton in 1988, twenty years and a millennium of happy memories ago.

Laura Hoptman
Kraus Family Senior Curator

would like to thank the New Museum for
ommitment and support and would also
to especially thank Laura Hoptman,
in Brown, and Corinna Durland and
ryone at Gavin Brown's enterprise, as
as Franz Ackermann, Hope Atherton,
ette Aurell, Matthew Barney, Kirsty Bell,
na Blazwick and Anthony Spira of the
itechapel Art Gallery, Alexander van
venstein and Paula van den Bosch of the
nefantenmuseum, Max Brown, Ben
nnemer, Shaun Caley, Jonathan Caplan,
rizio Cattelan, Jake Chapman, Sadie
es, Sadie Coles HQ, Angus Cooke, Sofia
pola, Martin Creed, Pauline Daly, Sarah
neuse, Richard Flood, Hendrik Gerrits,
Gil, John Giorno, Barbara Gladstone,
phic Thought Facility, Daniel Haaksman,
en Hansgen, John Hatfield, Pati Hertling,
athan Horowitz, Marc Jacobs, Eric
nson, Tony Just, Sharon Lockhart, Amy
kie, Alisara Martin, Nick Mauss, Martin
Geown, Joe Montgomery, Tim Neuger,
gerriemschneider, Ken Okiishi, Phaidon
ss, Lisa Phillips, Richard Prince, Regen
ects, Rob Pruitt, John Reinhold, Nick
h, Burkhard Riemschneider, Anthony
a, Michael Stout, Spencer Sweeney,
rit Tiravanija, Piotr Uklanski, Philippe
gne and Olga Viso of the Walker Art
ter, Craig Wadlin, Diana Welch, Liz
ch, T. J. Wilcox, and Lisa Williams.

This book is dedicated to Paul Peyton.
Elizabeth Peyton

Contributors

Laura Hoptman is Kraus Family
Senior Curator at the New Museum, where,
in addition to "Elizabeth Peyton" (2008),
she curated "Tomma Abts" (2008) and co-
curated "Unmonumental" (2007). Previously
she was Curator of Contemporary Art at the
Carnegie Museum, where she organized the
54th Carnegie International (2004). From
1995–2001 she was Curator of Drawing at the
Museum of Modern Art in New York and
curated "Drawing Now: Eight Propositions"
in 2002. She has contributed to a range
of contemporary art magazines, including
Frieze and *Parkett*, and has written for
numerous exhibition catalogues and mono-
graphs, including *Yayoi Kusama* (2000).

Iwona Blazwick is Director of the
Whitechapel Art Gallery, London. As Head
of Exhibitions and Display at Tate Modern
(1997–2001), as Director of Exhibitions at
the Institute of Contemporary Arts, London
(1986–92), and as an independent curator,
she has realized many international exhibi-
tions of modern and contemporary art and
has published texts on numerous living
artists. From 1993–97 she was Commissio-
ning Editor for Contemporary Art at
Phaidon Press.

John Giorno is a poet, performance
artist and AIDS activist and fundraiser.
He met Andy Warhol in 1962 and become
a prominent figure of the Factory and the
subject of one of Warhol's best-known
films, *Sleep*. In 1965 he created Giorno
Poetry Systems as a way of connecting
poetry to new audiences through new
technology. Through his work, he has
long been an advocate of collaboration,
counting William Burroughs, Patti Smith,
Laurie Anderson, Philip Glass, Robert
Rauschenberg, Robert Mapplethorpe,
Keith Haring, and Ugo Rondinone among
his many associates.

Index